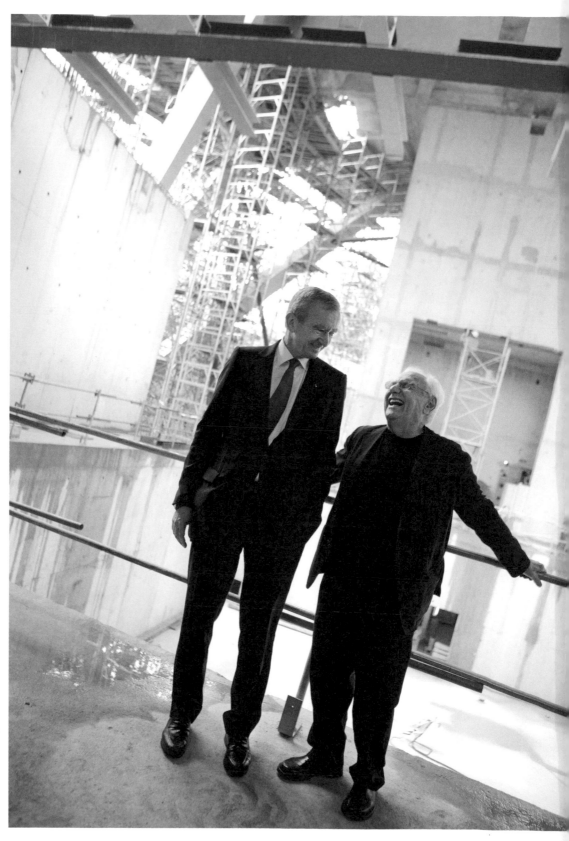

June 7, 2011

Bernard Arnault and Frank Gehry in the
building under construction.

A DREAM COME TRUE

Bernard
Arnault
—Chairman
and
Chief
Executive
Officer,
LVMH
Group
—President,
Fondation
Louis
Vuitton

The values of creativity, innovation, and savoir-faire cultivated by the different houses of the LVMH group, and by Louis Vuitton in particular, are part of the long history of our national heritage. They are sustained by the excellence of their creations; they are part of an authentic art of living that is intimately bound up with humanist culture.

Aware of how much the success of our houses is indebted to our artistic heritage, I wanted some of this success to be given back to artists, creators, and thinkers—in a word, to culture in general, to the public, and to future generations. As of 1991, LVMH became one of the leading corporate philanthropists in France thanks to its actions in support of artistic heritage and young people, and its humanitarian projects. This was also a way of uniting the teams at the LVMH group around a shared project.

My passion for the arts in all their forms and this long experience of supporting them led me to conceive the Fondation Louis Vuitton: an innovative space in Paris, open to today's artists and their work, and welcoming and accessible to all kinds of visitors.

Because he is one of the great architects of our time, I knew that Frank Gehry would rise to this challenge and create a project that was emblematic of the architecture of the twenty-first century.

Right from our first meeting, we shared the same dream: standing on the soil of the Jardin d'Acclimatation, in the Bois de Boulogne, Paris, a unique building that would respect its forest and garden setting while projecting into the future with its innovative forms. The idea was to enrich the architectural heritage of our capital with a founding act that had global resonance: the very first artistic gesture of the Fondation Louis Vuitton.

Frank Gehry proved a true visionary. Working in perfect harmony with Louis Vuitton's values of excellence, perfectionism, and performance, he made his project an extraordinary construction, a true masterpiece. With its play on transparency, this building—so airy and so alive to the light that it can be compared to a cloud—is something that can be felt as much as it can be contemplated. It is the culmination of a shared passion. It is underpinned by technical innovations that it conceals with the elegance of an haute couture dress. It introduces beauty and harmony into the incomparable site that is the Bois de Boulogne. It engages with artists, creators, and all those who identify with this emotional impulse towards the future.

Today, the Fondation Louis Vuitton is opening its doors to visitors from all over the world. This "glass vessel" reflecting domesticated nature, extending an urban metaphor on the edge of the Bois de Boulogne, has invented a singular vocabulary which imbues matter with an extraordinary energy, in a fascinating dialogue between technical innovation and artistic emotion.

I want to salute the involvement of all the shareholders and men and women of the LVMH group, who must be thanked for having supported and enabled such an accomplished philanthropic project.

So many talents came together here to achieve this feat. Engineers, IT specialists, technicians, artisans, and building workers cooperated for years on what has been a real collective adventure, changing the way the public looks at landscape, architecture, and art.

The Fondation Louis Vuitton now invites visitors from Paris, France, and all over the world on a new journey in this wonderful structure that began as a dream and is now a reality.

A HERITAGE OF DARING

Yves Carcelle —Vice President, Fondation Louis Vuitton

In 2006, shortly before the press conference and official announcement of the plan for a new foundation, Bernard Arnault phoned to tell me that this institution dedicated to contemporary art would be called the "Fondation Louis Vuitton."

This was a surprise for me, and an honor for the house that I directed at the time. Bernard Arnault had judged that, of all the LVMH brands, Louis Vuitton was the best qualified to lend its name to this ambitious project. Louis Vuitton has long had strong relations with artists founded on respect, trust, and exchange.

In the 1980s, the House engaged in productive and creative collaborations with César, Sol LeWitt, and Olivier Debré. These artistic entries into the world of Louis Vuitton have continued over the years, enriching the dialogue between the visual arts and the house's own creativity.

In 2006, for example, Olafur Eliasson designed all the Christmas windows. Not one product was on display. Original artworks commissioned by Vuitton have featured in our stores the world over, helping bring contemporary art to a broad audience.

The many exhibitions put on at the Espace Culturel Louis Vuitton on the Champs-Élysées in Paris have borne witness to Louis Vuitton's continuing role alongside living artists.

The presence of Marc Jacobs, too, has consolidated and further stimulated this closeness. Direct interventions by Stephen Sprouse, Takashi Murakami, Richard Prince, and Yayoi Kusama both on the monogram and the house's iconic creations have helped change the way Vuitton is perceived.

Today, the Fondation Louis Vuitton is adding to this heritage by preparing a new and exciting adventure.

REFOUNDING MODERNITY

Jean-Paul Claverie —Adviser to the Chairman of the LVMH Group —Member of the Board of the Fondation Louis Vuitton

"There is never a consensus that pre-exists innovation. You move forward impelled by a creative passion."—Edgar Morin

Bernard Arnault conceived and built the Fondation Louis Vuitton. As a man of culture, his ideas and determination played their full role at every stage of this project, while as an entrepreneur he created the conditions necessary for each talent to flourish. Aware of my privilege to have been, more than a witness, a protagonist at his side on this unique project— a project that nothing, except a real form of visionary spirit, compelled Bernard Arnault to carry through— I would like to discuss its context and share some of the thoughts inspired by this extraordinary adventure.

As I see it, this desire on the part of the chairman of LVMH to create a foundation reflects his desire to associate his group with a gesture that refounds modernity, both cultural and institutional. By offering the Fondation Louis Vuitton to Parisians, to the French, and to visitors from every other country, Bernard Arnault is confirming and giving permanent form to his engagement as both entrepreneur and patron. He is acting—and let's not hide behind words here—as a proponent of civilization.

His intention, no doubt, is to give the companies of his group, many of which go back a hundred years or more, a role in the contemporary arts in these early years of the twenty-first century. Repositories of culture, knowledge, and expertise that constitute a remarkable segment of French and Western culture and way of life, they are all driven by a spirit of creativity that will henceforth be extended by philanthropic patronage of a magnitude and power never before seen in France.

With this gesture Bernard Arnault is manifesting his optimism about the future, and the ability of the LVMH group to play its own role in positioning Paris on the international cultural and artistic map. Further, it expresses his confidence in the capacity of individual talent to think and construct the world, a world in which material wealth is no longer necessarily unconnected from the almost spiritual wealth of artistic creation. Without a shadow of doubt, the Fondation Louis Vuitton has brought into being a utopian idea. More alert than anyone else to the power of the image that any action projects into our contemporary civilization, Bernard Arnault wanted the Fondation Louis Vuitton to have an emblematic, visionary building, one that would inspire emotion and enthusiasm by virtue of a transformative innovation, acutely aware that he had to risk making a break, or even a certain deviance from codes and forms. I would even go as far as to say that Frank Gehry has managed to create that "antidote to the ephemeral" that, without explicitly formulating it, Bernard Arnault was intuitively looking for. I am happy to have played a role in their encounter and to have contributed to the creation of the Fondation Louis Vuitton, from its birth to its culmination. Like everyone else who worked on it, something of me, something very profound, is enclosed in the Fondation walls.

EMBODYING THE VALUES OF LVMH

Bernard Arnault has always considered the exceptional global success of the houses of the LVMH group, and of

Louis Vuitton in particular, to be anchored in France's cultural, artistic, and social heritage. As he says in *La Passion créative*, "One is never better equipped to build the future than when one cultivates one's heritage. The LVMH group has always drawn on values that are at once universal and specific to its history."

Dynamic vectors of an authentic way of life, the houses of LVMH mobilize their historic know-how in contemporary creations that are constantly renewed. They stand for emotions and aesthetic pleasures whose effect defines a cultural field close to that of art itself, making them living symbols of our contemporary societies. It therefore seems legitimate and, indeed, natural, that they should actively contribute to the vitality of current artistic creation and the transmission of culture through a foundation dedicated to contemporary art.

This project thus had its roots in and took its coloration from the values of the group, while its development was shaped by two great, forward-looking principles: the determination to conceive a new kind of artistic patronage, and the desire to promote the position of Paris in the field of artistic creativity. Serving artists from France and all over the world, and the broadest possible audience, the Fondation's mission will be to forge direct links between them, regardless of frontiers. It will put in place dynamics of creativity for the long term, establishing an original synergy with corporate culture and the values of a unique international group, and especially Louis Vuitton.

WHY A FOUNDATION?

"Patronage was a fundamental decision. I wanted the group's economic success—its artisanship, its creativity, an elevated sense of quality rooted in venerable traditions—to be able to translate into useful engagements, real solidarities. The sense of the public interest is no empty concept. It is a fundamental reality." (Bernard Arnault, *La Passion créative*.)

It was at my very first meeting with Bernard Arnault on August 28, 1990, at a lunch he had invited me to, that the idea of a foundation originally came up. At the time, I was an adviser to the French minister of culture, Jack Lang. A few months later, Bernard Arnault asked me to join him at the LVMH group. In the course of the many discussions that followed, what emerged were the broad outlines of an ambitious philanthropic project in the public interest that would express the values of LVMH in France and throughout the world by unifying staff from the various houses. The group's economic success made it possible to offer strong support to the art world, to youth, and also to humanitarian and social actions.

The idea of a foundation was already clearly formulated as the means of implementing, supervising, and ensuring the longevity of this cultural and educational program. But the dream took nearly a quarter of a century to come true. Before it could be put in place, LVMH began engaging diverse philanthropic activities outside the group in 1991, and these have defined the identity of the foundation project. Support for art and culture aimed at a very wide audience, and especially the young, set out to make known major artists and movements as well as key phases in the history of art. The scope of these actions has made LVMH one of the leading corporate supporters of the arts in France today.

Beyond the institutional patronage aspect, Bernard Arnault also wanted this project to affirm a new idea of luxury: fulfillment through freedom—the freedom of his choices, the freedom to express his convictions, the freedom to affirm an identity: an approach manifesting his desire to be part of emerging creativity. In this way the Fondation would be evoking the very core of the group's values, the stabilizing base on which would be built an adventure of creativity and passion. And the fact of endowing Paris, a capital of so many symbols, with a new emblematic space, would represent a major founding act.

The decision to create a foundation was also based on a radical change in the method and in the objectives of philanthropic activity. The project would go beyond the patronage that LVMH had been practicing for twenty-five years, whereby the group engaged with cultural players through exhibitions, books, and commissions. With the Fondation, the group was now taking on a role as a full-fledged cultural and artistic player in its own right.

In addition to the well-established general interest dimension, then, there was the desire to attain new frontiers by arousing real curiosity, by cultivating a sense of surprise, by rejecting indifference. The role of the Fondation Louis

5 Vuitton will be to dialogue not only with artists but with participants in the wider creative sphere, including philosophers, writers, historians, scientists, researchers and teachers, and designers.

AN EMBLEMATIC EDIFICE

For Bernard Arnault, there could only be one setting for such an ambitious project: Paris. We spent years looking for an emblematic site where the dream of the Fondation could be built. In this sense, the Jardin d'Acclimatation in the Bois de Boulogne, at the western end of Paris, always represented a real opportunity. Grounded in the popular image of Paris, the garden is a symbolically potent site evoking the magic of the world of childhood. It has a rich emotional heritage, with a wealth of events, sustained by constructions as extraordinary as the wondrous Palmarium. Another aspect of the garden's complexity and unique character is the scientific and educational function it was assigned at its inception in 1860. LVMH held the concession of the Jardin d'Acclimatation thanks to its acquisition by Marcel Boussac in the 1950s, not long after his own encounter with Christian Dior in 1947 and the creation of his famous "Maison." I suggested that a study be made of the rules governing the development of this place so close to the heart of all Parisians. It emerged that the only way we could build on this listed site would be by demolishing existing buildings and replacing them with something new, square foot for square foot.

This was the conclusion of the analysis: restrictive, certainly, but nevertheless affording a real opportunity. The amount of space suitable for reuse—because occupied by aging buildings that were impossible to restore or that had become a real public hazard—only became significant in 2001, with the acquisition of an insalubrious and asbestos-riddled building, the Bowling de Paris, on Avenue du Mahatma-Gandhi, on the southern side of the site, facing the Bois de Boulogne. In all, we were able to bring together some 11,000 square meters (118,000 square feet) of land out of the total twenty hectares (50 acres) of the site. In developed form, this constitutes the exact overall area of the spaces comprising the Fondation, built on the exact location of what, under Napoleon III, were the aquarium and the Palmarium, a giant glasshouse comparable to the Grand Palais, a building that has not only preserved all its original splendor, but that inspired Frank Gehry on this project.

BERNARD ARNAULT, THE BUILDER

"I build only living stones: they are men," said Rabelais. This famous motto of Renaissance humanism reminds us that an enterprise is a work of architecture, and an entrepreneur an architect. This is the yardstick by which we can measure Bernard Arnault's considerable capacity for "human architecture," as a "builder of living stones," which enabled him to construct an industrial group bringing together the exceptional houses that now make up LVMH.

The son of a renowned industrialist in the field of construction, Bernard Arnault has a passionate love of architecture. Promoting its practitioners as a higher category of "living stones," he has always sought to ensure that the LVMH group commissions creative, innovative architects, putting his faith in the new generation in Asia, Europe, and the United States. Some of them have been awarded the famous Pritzker Prize, the "Nobel Prize for Architecture."

For example, the Maison Dior in Tokyo was entrusted to Kazuyo Sejima of the Sanaa architectural firm, well before he asked them to renovate the Samaritaine department store. Also in Tokyo, he called on Jun Aoki for the Louis Vuitton building. Bernard Arnault chose Christian de Portzamparc for his first project in New York, the LVMH Tower in the heart of Manhattan. In Paris, the Fondation building would be the latest manifestation of this passion for architecture.

Personally, it occurred to me that there was a deep affinity between the work of Frank Gehry and Bernard Arnault's vision of the building that between ourselves we were already referring to as "La Fondation." I was anxious that these impressions should not remain a mere intuition, and was constantly trying to arrange for him to discover Bilbao and the Guggenheim Museum. And so it was that, on November 24, 2001, we visited the museum built by Frank Gehry in the Spanish Basque Country.

FRANK GEHRY: A DECISIVE ENCOUNTER

It was a Saturday morning, the sun piercing through the light mist that rolled in from the ocean. Bernard Arnault was discovering the titanium building. A sensation. For me, it was like witnessing a kind of conversion. I can still hear him exclaiming as he grabbed my arm, "But how could someone imagine something so incredible? And, above all, build it?" It was like a revelation. Years of thought, from personal constructions to diagrams and sketches, were concentrated in that one moment of decision. The Fondation Louis Vuitton, as a building by Frank Gehry in the Bois de Boulogne, no doubt came into being from the aesthetic and emotional epiphany of that precise moment. On the way back to Paris, he told me he wanted to meet Frank as soon as possible.

The meeting between Bernard Arnault and Frank Gehry took place a few weeks later, in December 2001, in New York. Their exchange of views, their agreement on a general approach, were the fertile preliminaries to the considerable ensemble now constituted by the history of the building's elaboration. This first encounter was the starting point of so many years of trusting, productive dialogue! By means of a kind of mutual spiritual and intellectual construction, they became each other's "living stones." When the two men parted, Frank left with an invitation to come to Paris.

This trip, made by the American-Canadian architect in February 2002, was the second, decisive phase. He was delighted with the Jardin d'Acclimatation, won over by the charm of this return to the nineteenth century and to the imaginary world of childhood. I was able to glimpse the extent of Frank's familiarity with French culture when he mentioned Proust and the idea of recapturing the past, along with the great iron and steel structures of the century of the Industrial Revolution, such as the Grand Palais.

Although won over—or rather, in order to transcend his emotions—Frank decided to forget the rest of Paris, although he loved and knew it well from having lived there for two years in the early 1960s, just before he set up his architectural practice in Los Angeles. He put a damper on his general curiosity and focused uniquely on this new dream to be built: "The virgin, the vivid, and the beautiful in today's world," as Mallarmé might have suggested to him.

For that, he had to empty himself. Inwardly become a blank page, a photographic film on which to print the spirit of the place, by listening with his eyes. For Frank, a landscape speaks primarily in volumes, lines, and figures. Before intervening in a place, he wants first to explore it, to reconstruct it, to come and visit it, like a real person. Out of politeness. The architect's first encounter was given over to this silent exchange, in the intense tranquility of a "non-will to possess," as defined by Roland Barthes, following on from Buddhism. Frank told me that he wanted to take possession of the place, but gently, harmoniously. He had great ambitions for this project which, already,

he sensed was exceptional.

The third phase began in the plane taking Frank back to Los Angeles, with a flurry of sketches filling a whole book in the course of the eleven-hour flight. These were his first reactions to the dialogue with the Bois de Boulogne. Frank vouchsafed to me that these first sketches, to a large degree spontaneous, came to him from a kind of inner "photographic film." He was careful not to hinder them or filter them through excessively dogmatic assumptions. Intelligence is in the hand. The hand knows. Drawing as automatic writing.

"I simply look at what is before my eyes. Afterwards, I simply react. Drawing makes me happy." These words of Frank's evoke so many of our wonderfully collegial conversations together. "After that, you go to the model, then comes the computer and, finally, the studio," he concluded.

Finally, I would like to remark on what I think is the very quality of human relations that Frank sought to develop with everyone involved here. I can speak for my own experience, but I think I am speaking for many others. A comment by Frank sums it all up: "If you are happy, it makes me happy."

Such generosity, confirmed by actions, by his actions, at each encounter, is impressive on the part of a figure who sits atop the Olympia of celebrity. The doubt, the freedom that he allowed himself to doubt and therefore to construct with us a new "emotional adventure" made a deep impression on me from the outset. I am always moved, whenever I think back to it.

MIRROR, TRANSPARENCY,

AND OVER-HANGS

Greco-Roman culture makes no distinction between art and technique. Just as *poiésis*, our "poetry," originally meant "to make, to produce," so the Greeks had a single word, *tekhnè*, for both art and technology. And it remains the case, even today, that the best architects are those who manifest the truth of this alliance between artistic inspiration and technical know-how.

For this decisive modern act, which I believe is what the Fondation is all about, Frank Gehry has been both artist and, through his use of the most advanced technologies, artisan. With this new masterpiece he has demonstrated the fact that "there is for art a higher technique, one that attains the essential: simplicity." So wrote Leonardo da Vinci, another genius who at any given moment was always both artist and technician.

Elevating the qualities and values of craftsmanship is precisely the logic that Bernard Arnault has instilled into, and disseminates through, the different houses of the group. Their unifying logic. He asks, for the sake of modernity, and thanks to modernity, that each LVMH brand should maintain the character and know-how of artisanship. Many a time I have been witness to his unfailing, vigilant determination to draw attention to the presence of the word "art" at the beginning of that fine word "artisan."

If Bernard Arnault, a graduate of the prestigious Polytechnique engineering school and builder of a group founded on a concept of modern artisanship, and Frank Gehry, an artist-*cum*-architect fascinated by technologies, so quickly found a common language, it is because they share these values, this vision of the world. Their understanding was built along the wavelength of a modern, boldly modern revival of the idea of transmutation of art by technology, and of technologies by the arts.

In the course of the meetings between the client/patron and the architect, the project that took shape became increasingly captivating and seductive. Frank lent a sensitive, attentive ear to Bernard Arnault's ideas. Then he translated questions and formal constraints, such as the regular shapes of the exhibition rooms and the choice of material—glass, Ductal, Burgundy stone, wood, steel—into a visual artistic proposition. His architectural gesture was expressed freely and with full artistic coherence. He was able to assimilate constraints and turn them into assets. A real bond developed between the two men and the two teams. Thanks to this harmony, a utopian project became a reality.

Building the Fondation Louis Vuitton was a real technological performance. A mass of breaks, forms, and transparencies, the construction conceived by the architect was technically very difficult, if not impossible to realize, especially since unconventional materials were to be used and everything, down to the glass cladding, would conform to exacting environmental standards.

The building is constituted by two ensembles cleverly interlocking like a Russian doll: the "Iceberg," a magic mountain covered with sides of white Ductal, is clad in twelve glass sails marked with white "pixels," small silkscreened dots limiting the radiance of the sun inside the building but above all giving the building its overall chromatic unity, a cloudy sail smoothing and concealing the overlapping of the load-bearing structures that the architect left visible through the interstices and that seem to let in the wind to "swell" the aforesaid sails.

The specific marking of the glass sails, allowing a twofold play on transparency and on a reflective, mirror effect led to much discussion about the density and thickness of these millions of little dots, between Frank Gehry and Bernard Arnault. At each stage a prototype was made; with each step, the project gained in precision and quality.

In the end, the thousands of glass panels, assembled like a mosaic, achieved an extreme, almost natural visual fluidity. This is unprecedented. Processed on computer one by one, formatted panel by panel, in specially made kilns, they were made possible by the development of unprecedented, patented techniques marking a unique technical advance in glass architecture, going beyond the "faceted" forms that had been possible before.

These examples remind us that, in order to keep material obstacles from deforming this shared dream, at every stage the decision was made to engage powerful human and technological resources and put in place an extraordinary innovation plan. Teams of outstandingly virtuosic engineers and computer technicians were formed under the leadership of Christian Reyne, a talented and skilled project

manager who directed the overall construction of the building. New solutions were found, and no less than thirty projects and patents were developed—a rare amount, indeed, for just one project. We were the enthusiastic spectators of the triumph of a utopia. A triumph made possible by Bernard Arnault, who gave the artist Frank Gehry the means to follow his dream.

A FUTURISTIC CARAVEL BETWEEN EARTH AND SKY

The ongoing personal dialogue with Bernard Arnault continued during the following stages, as work groups forged ahead in Paris and Los Angeles. Frank fully espoused his vision of offering a living space for art and culture. He took great care to match the building with its museum function, and was always attentive to the expert views of Suzanne Pagé, who was named artistic director of the Fondation in 2006, after serving as director of the Musée d'Art Moderne de la Ville de Paris. The architect thus designed amply and generously proportioned interior spaces—the exhibition rooms—that were also restrained and functional, so that the eleven galleries could host all kinds of works and creations, facilitating the dialogue with artists.

Throughout the implementation process, the project met with enthusiasm and approval from all quarters, including the decisive support of the mayor of Paris, Bertrand Delanoë, and the highest state authorities. The few difficulties encountered en route are now long forgotten. Today, the Fondation is complete: a vast vessel of 11,000 square meters (118,000 square feet), it stands as a pure, sculptural gesture.

Here, reflecting in a poignantly beautiful way "the clouds, wondrous clouds" celebrated by Baudelaire, the lofty glass sails capture the thousand nuances of blue and gray of the clouds and sun as they follow their metamorphoses and their journey, like a host of free butterflies and mirrors held up to the changing sky. Further down, towards the earth and the green, the totally fluid building dialogues harmoniously with its plant and aquatic surroundings. In a subtle interweaving, it intertwines with the Bois de Boulogne, the Jardin d'Acclimatation, and the pool of water where the Iceberg is moored with its twelve glass sails, swollen with the breath of the spirit animating this new space.

There, the glass sails constituting the east facade looking toward Paris, in the form of a prow, overlook the pool, giving an impression—just an impression!—of broken balance, of a switch and therefore of movement, the feeling of a taking flight, of a leaping motion from the ground toward the sky.

Everywhere, Frank Gehry's architecture produces both aesthetic emotions and a host of surprising discoveries. Delicate yet also lyrical, it allows the play of paradox, creating a true futuristic caravel.

A ROUGH DIAMOND AND A MARVEL

The building of the Fondation Louis Vuitton is thus the first aesthetic gesture of a foundation dedicated to contemporary art and artists: it magnifies them in advance, exalts them. It gives them a superior aura with its splendor, like a rough diamond.

Thanks to the Fondation, LVMH has a new star, and Paris a new emblematic building. The Fondation Louis Vuitton is also a sign of confidence and an act of great generosity toward future generations: in a few decades, the building will become the property of Parisians. It is the gift of a patron of the arts in which he has expressed all his passion for creativity, and of a business leader who has mobilized human talents and material resources to bring his contemporaries something truly soul-enriching.

Roland Barthes wrote in 1968 that "a text's unity lies not in its origin but in its destination." It is possible to believe that the total artwork created by Frank Gehry and Bernard Arnault will find its unity in the broad audience for which it is destined, a public that we hope will find much delight here.

LUMA.

F GEHRY APR. 06

Paris, Jan 05

ODE TO LIGHT

An interview with architect Frank Gehry

What was the initial inspiration for this project? An image? An object? A concept? The city? The landscape?

It was clear from the beginning that to construct a building in the Bois de Bologne, near the Jardin d'Acclimatation, it had to be very special and full of respect for the environment, it had to be a garden building.

When and how did this inspiration take shape?

Bernard Arnault, on my first visit with him, took me to the Jardin. He showed me the site and tears came to my eyes as I realized that this was certainly a place where Marcel Proust played as a child. So, I felt that the location was loaded with history. I thought about this and discussed it with M. Arnault.

Did you conceive the edifice as a work of art?

I never presume to think of my work as a work of art. There is so much debate in the press about whether architecture is art or whether it should just be a functional container. Throughout history, great architects have made buildings that have lasting qualities through the ages. I aspire to being ageless, but I am very happy working in the present.

What role have the various constraints—the site, its history, nature, the building's vocation, the town-planning regulations—played in the creative process?

Mostly, I have wanted to make sure that we were appropriately respecting the location in Paris, the role of the museum for the future, and M. Arnault's dream. The regulations were respected and did not conflict or compromise the design process. If anything, the constraints helped make a better design.

How did you choose your building materials? What criteria guided your choice?

There are really two buildings—the museum, of necessity, needs solid enclosure; the public spaces for the museum are in the form of glass sheets or "verrieres." These verrieres catch the light and play off the solid shapes that create the museum interior. M. Arnault liked the whiteness of the design model, and we agreed that Ductal was the right material. It gave us a lot of freedom in shaping the exterior walls.

Did new technologies—including 3D—affect the way you conceived and designed this building?

I have a separate company, Gehry Technologies, that worked in conjunction with my architects and with the rest of the project team. On the design side, we use a three-dimensional modeling tool called Digital Project, which allows us to create very accurate 3D models of the design that are used to engineer, fabricate and construct the building. We also have a tool called GTEAM that was actually developed for this project. It facilitated the functional collaboration around this 3D mode—we had thousands of people in many different locations collaborating with one model. It ensured that everyone was using the most up-to-date information.

What role do you assign to technological inventiveness? How do engineers take part in the creative process? What are the benefits of these new approaches?

It is very important to stay on top of the latest technological innovations. Tools are becoming powerful ways to collaborate and to efficiently drive projects. We are finding that just by coordinating the data better using our tools, our team can save

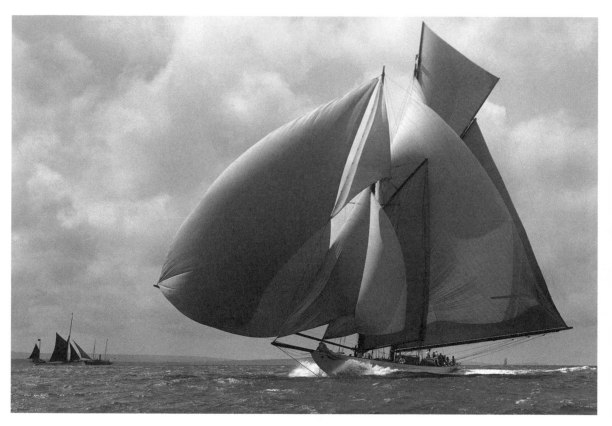

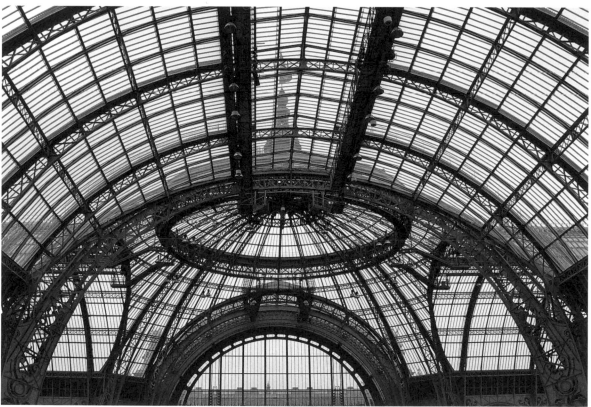

The yacht *Susanne*, and the glass roof of the Grand Palais:
two images that inspired Frank Gehry's design.

20—30 percent on costs. They can speed up engineering time, they can reduce change orders, etc. When architects and owners are in charge of the data, better buildings can get built for significantly less cost.

Your architectural project was accompanied by drawings and a multitude of models in various scales. Do you apply this method to all your projects? Which are the most important stages?

It's an intuitive process, using drawings and models to create the various stages of evolution toward the final stage of design. It's the way I've worked all of my professional life.

Are these developments the result of personal reflection, technical constraints, or discussions with the client?

All of them, really, though I really value the client interaction during the design process. The modeling process allows the client to participate more actively than they could with only 2D drawings. I find this leads to richer solutions and conclusions that get as close as possible to the client's dream.

At what point does the project assume its final form?

Ninety-five percent of the decisions are made before the construction documents are started. It is a tried and true way for us to manage the design and to manage cost control.

Is there a big difference between the initial idea and the end result?

The basic sculptural strategy was there from the beginning, based on a very complete project program. As the design evolved, it revealed opportunities that were unexpected. As they were incorporated, they enriched the functional needs of the building. In the end, the building has the same values as the original design models, but it usually looks different.

What role does light play in this building?

The verrieres are glass sails that create sculptural and natural lighted public spaces. These are indoors and outdoors. They create many opportunities for showing outdoor sculpture and let the visitor experience the ever-changing Parisian light, which is the tradition in France since the Romanesque. The interior galleries have skylights which are flexible—they can be opened or closed depending on the installation.

Do you dislike straight lines?

I love all geometry.

You have produced an edifice in motion. Is it a way of rooting your architecture in modernity?

Modernity is a passing experience. It continues to change. I am interested in conveying motion in building as a means of human engagement and expressing humanity. The inspiration for which goes back to the Greeks and the Indian dancing figures.

Do you think architecture should evoke an emotional response? Should it allude to sensuality?

Architecture should enhance our feelings and our emotions, our comfort, our sense of wonder and sense of place and inspiration.

How do you envision the interplay between architecture and the art works on display?

In my lifetime, creating galleries for art has undergone a lot of discussion and folklore. The sterilized model of making art galleries has been misunderstood as neutral, when in fact its quasi perfection is as confrontational to the art as anything else. In many cases, it is without feeling and not good for the art within it. In our building, I hope that the artists will engage with the galleries and public spaces, as I know they are wont to do. The entire building is for art.

20 Are there any priorities when
 it comes to creating a building
 intended to host art events?
 If so, what are they? The artists?
 Their work? The public?

An architect has to prioritize all of them—
the art, the building, and the people
coming to visit all need to work in concert
with each other.

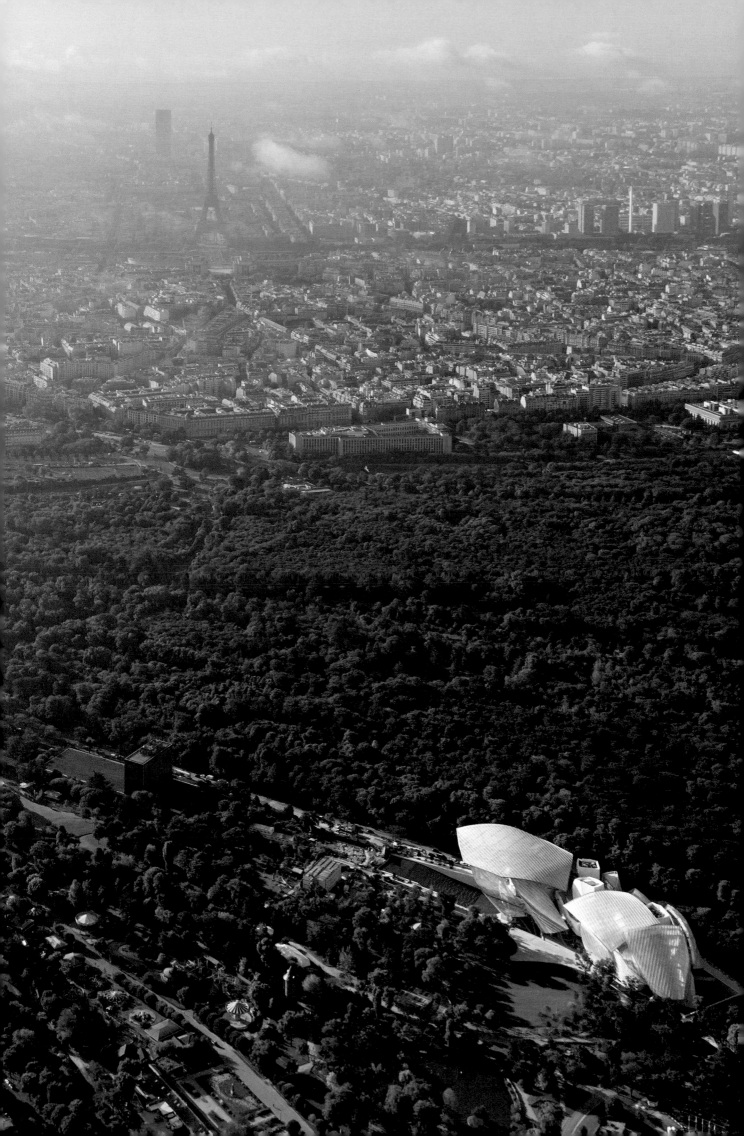

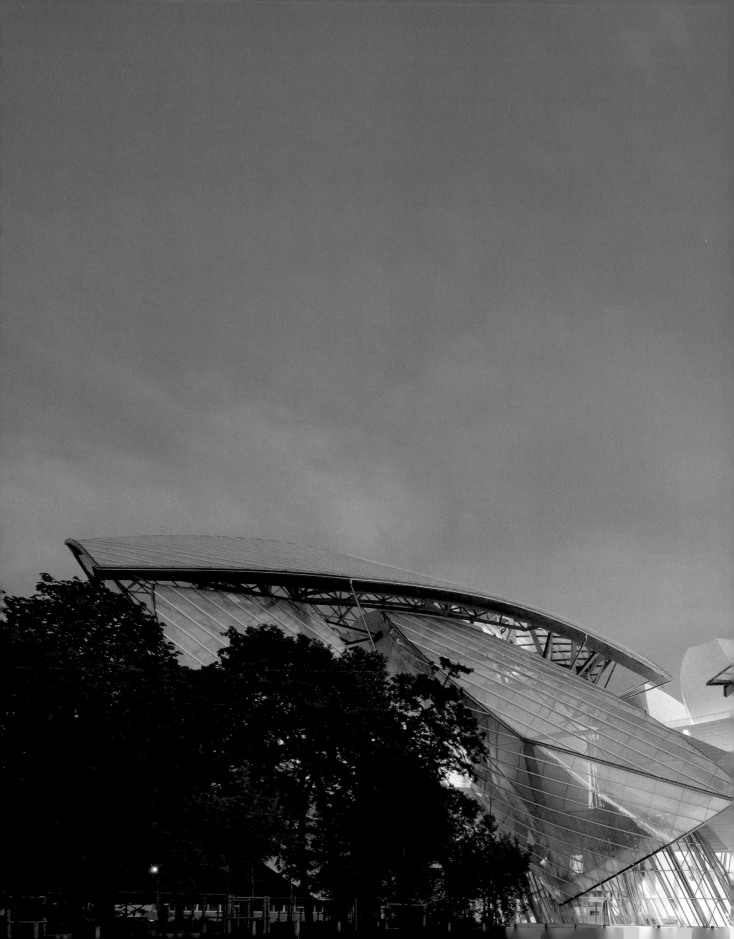

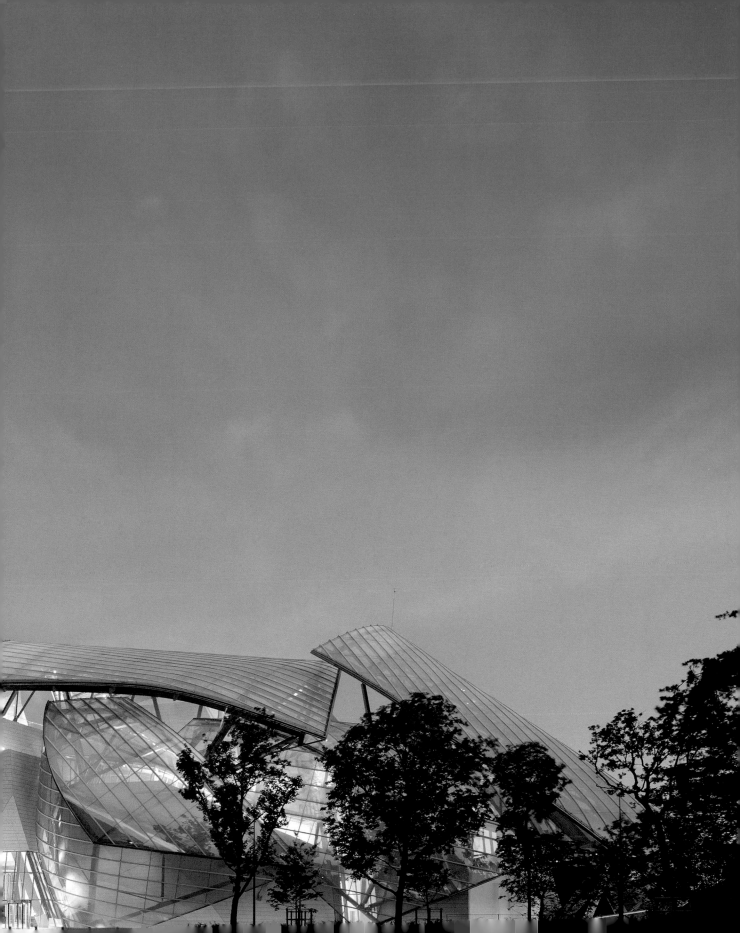

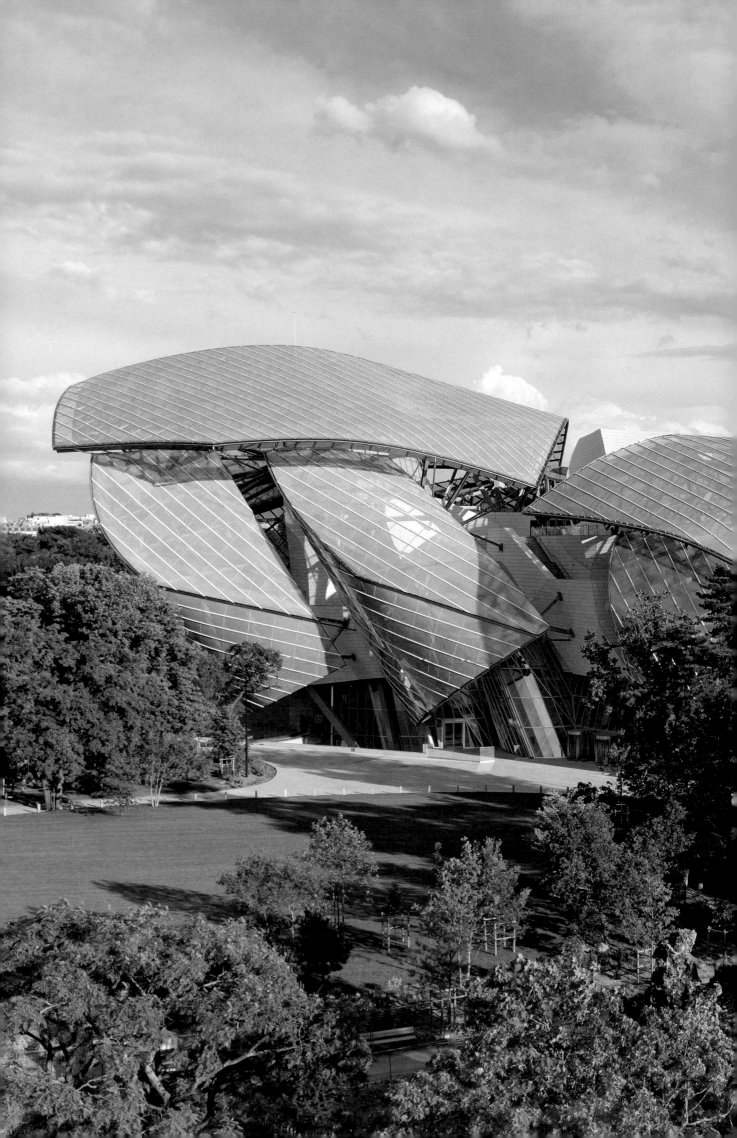

PLANS AND PLANTS

Philippe
Deliau
—Landscape
architect,
ALEP

SPIRIT OF PLACE

Our story begins in the seventeenth century. Three hundred years ago, André Le Nôtre designed the Tuileries, Versailles, and the gardens of La Muette. The Bois de Boulogne was a royal hunting estate crisscrossed by bridle paths. The forest was planted with tall common and sessile oaks. Their descendants, together with black pines from Austria planted in the nineteenth century, constitute our matrix.

Today, these outstanding features from that original landscape still dot Avenue du Mahatma-Gandhi and form dense groves throughout the southern part of the Jardin d'Acclimatation.

In 1855 the landscape architect Jean-Pierre Barillet-Deschamps came to Paris from Bordeaux at the call of Jean-Charles Alphand, chief engineer of the capital's Service des Promenades, to create the city's finest parks.

This was the birth of public promenades, and of those green lungs of Paris, the parks and green spaces emblematic of the Second Empire art of gardens, familiar from our childhoods: the Boulogne and Vincennes woods, the Monceau, Montsouris and Buttes-Chaumont parks, the Parc Borely in Marseille, the Rocher des Doms in Avignon, etc.

This landscaped heritage has a distinctive style inspired by English gardens, with a picturesque overall composition, curving paths, hollows, and belvederes carved from the ground, rocks being used to recreate natural scenes.

Compared to the English model, however, the vision of nature developed by Barillet-Deschamps with Alphand and Baron Haussmann was less purist. The parks and gardens created for the city of Paris were designed to showcase architectural elements (kiosks, fountains, pavilions, bridges).

Elements of furniture were designed by the head architect Gabriel Davioud. The first line of garden furniture was created for the "Empire."

It was in this modernist context, when government was trying to improveliving conditions and change the way citizens related to their city, that the Bois de Boulogne and Jardin d'Acclimatation were created.

The oak forest was transformed into a park: lakes were dug, pines planted, waterfalls and pavilions created. The first concessions were granted in order to diversify the facilities available to the public.

The Société du Jardin Zoologique d'Acclimatation was founded by leading naturalists. Barillet-Deschamps designed an "exhibitions park" organized around a big, oval avenue, the Allée Alphand, over nearly 20 hectares (50 acres). At the center, a river flowed into a lake. On the fringes, a succession of enclosures and buildings housed animals from around the world and exotic plants.

The Jardin d'Acclimatation was inaugurated in 1860 by Empress Eugénie, the wife of Napoleon III. Its several major features have marked the history of the site up to the present day: the Palmarium, the aviary, the tropical aquarium, the monkey house, the stables, and the rocky outcrop with its deer. After the two world wars, and as society developed, the Bois de Vincennes became home to the big animals while the Jardin d'Acclimatationbecame more of a garden and space for play. The enchanted river ride, the miniature railway, and the funhouse mirrors amused generations of visitors. With the arrival of the Fondation Louis Vuitton, the site was entirely redefined, returning to the spirit of the original landscape asa place of surprises, invention, and emotion.

ARCHITECTURE AND

LANDSCAPE

The choice of the Jardin d'Acclimatation as the site for a new creation by architect Frank Gehry was a wonderful opportunity: the oneiric and picturesque garden has inspired organic and fantastical architecture.

Collaborating with one of the greatest architects in the world is an extraordinary adventure. Landscape designers and architects worked hand in hand, each following their specific logic in their respective fields. On one side, there is creation that is ultra-contemporary, and on the other, a picturesque world steeped in history. The point of the landscape design for the Fondation was not simply to surround the building but to redefine a logic, a sequence, and a setting that relates to the different facets of the building.

The first sketches were more interested in the general landscape than in interfaces with the parapet, in a "remote" version, working to recreate a relation between the different garden spaces around the building. The main subject being architecture, we had to find a common language. We love this "deconstructed" architecture, this way of bringing a landscape into being and thus creating a universe. The idea was not to develop the concept of a garden but to take advantage of the prodigious power of this architecture in order to prolong the history of the site.

The question of the building's mise-en-scène was the starting point for the exchanges between those in France and Gehry's team in Los Angeles.

In order to establish a landscaping strategy on a par with the architecture, we began by extending the architect's approach: an edifice emerging from the border between wood and garden, a building crossing the space, a pool outside the building, like the main lake, and vegetation weaving itself into the architecture, with roof gardens.

A garden is above all a place to stroll around in, a natural place with walks offering vistas and approaches, ways of crossing it, of experiencing its various ambiences and sensing its atmosphere.

Following or extending Barillet-Deschamps's historical design, new itineraries have been created that are conducive to a kinetic approach to the building: the visitor must have a vision of the "object" as a surprise in a succession of changing views, as he or she moves through the garden.

Large, winding avenues are designed to link the different entities, leading up to a promontory, going around a grove, offering views through the trees. A vault is created under which the building emerges. This network forms "full" and "empty" spaces.

Echoing the Fondation, the great clearing has become the central element, a vast open space in front of the building, in line with the bridge crossing the river and not the building itself, which deliberately "juts out."

Around the big wavy carpet of grass surrounded by discreet paths that are sunken so as not to be visible from a distance, a series of "nature scenes" come successively into view: the woods, the bandstand, the rockery, the outcrop with deer, the Neuilly belvedere, the fountain.

Each one generates a particular atmosphere and landscape, a way of experiencing space and a staging of the different constructions in the garden.

STAGING THE FONDATION

Whereas most of Frank Gehry's projects are set in urban contexts, in the Bois de Boulogne architecture and landscape are intimately linked. The trees are often close to the glass sails that clad the building. They are reflected in them, and in some cases actually occupy it, growing on the terraces.

This benevolent proximity is visible from inside the Fondation, when one crosses the main hall. Visitors can always see trees in the distance. Outside, the different paths leading to the building on the garden side are organized in successive stages.

Walkers arriving from Les Sablons metro station initially view the Fondation in a distant perspective on the edge of the enchanted river, then approach it via dense trees that frame the view up to the Gandhi entrance. They then follow the stone terrace that descends toward the bridge giving onto the pool over which the building stands.

When approaching from the north, from the river, the clearing is seen at first through a narrow gap and then through a wide visual opening as visitors take in the

whole northern facade of the building, this being the only vista from which the building can be viewed in its entirety.

Coming from the Neuilly entrance to the west, the approach leaves the main avenue and leads up toward the Rocher aux Daims ("Deer Rock"). The Fondation is seen as a curtain rising, and the gaze homes in on the suspended glass walls.

From outside the Jardin d'Acclimatation, taking the winding Avenue du Mahatma-Gandhi, the Fondation emerges suddenly, behind the long parapet commensurate with the basin.

THE ROOF GARDENS

From the start, Gehry's project included three terraced gardens, either sheltered by the glass sails or exposed to the open air.

This reference to the old Palmarium, built to protect plants from other countries, is an invitation to travel. In these three gardens we were guided by the relation to the architecture, working to create three landscapes that echo the building.

The western garden huddles against a monumental cube supporting a vertical window opening onto one of the exhibition rooms. Maples and cherry trees in clusters of coppice shoots, which are very colorful in the autumn, frame the building in order to create a kind of shadowy vault for the "window" of the exhibition hall.

The garden on the central terrace is in the open air. Against the "Iceberg," forming a long, wide, shaft, plants with big, jagged leaves (Chilean gunnera) stand out against the blades of Ductal. A persistent bamboo-leaf oak with light, narrow leaves grows in the center of the composition, evoking the forests of its native Asia.

The garden under the biggest glass roof houses Australian tree ferns. They are from the same family as the ones planted in the Palmarium a hundred and fifty years ago, but they are more rustic than their elders. This high garden is lined with low, evergreen ferns.

From each terrace, views give onto the Jardin d'Acclimatation which, seen from above, looks like a model. The canopy of the Bois de Boulogne and the great monuments of Paris appear in the distance. Emerging from the wood, the Fondation becomes a raft amid the treetops.

GAMES AND ANIMALS

The Jardin d'Acclimatation is an original, atypical place. Here are children's games, animal enclosures, a Punch and Judy show, attractions, vegetable gardens, and artistic installations. Our remodeling of the site consisted mainly in developing a landscape identity for the games and enclosures.

The "Aventures Forestières" create a forest atmosphere and offer tree-swinging activities for youngsters. "Islands" planted like copses grow between play structures made of trees stripped of their bark and a dislocated sequence with games made up of tangled trunks. The benches are built from strips of wood and the ground covered in woodchips.

The aurochs enclosure is an allegory: its mixed trees are characteristic of the kind of forest most commonly found in northern Europe two thousand years ago. In *The Gallic Wars*, Julius Caesar describes hunting the aurochs in the dark forests and clearings where the animals grazed. From this high point, views are afforded of the great landscape and the "prow" of the Fondation, which appears in the distance between two big black pines.

The Rocher aux Daims has recovered its original layout with, in the center of the enclosure, a giant rockery forming a grotto. At its foot, small inserts marked by lines of stones trace out successive terraces where animals can fit comfortably and be admired by visitors. Around this mossy imaginary mountain, a dark pine forest forms a large grove leading to Allée Alphand.

To separate the wild animals from the public, a ha-ha wall in sandstone supports a promenade around the enclosure, which becomes a garden open to the exterior.

A large, lively fountain precedes the Fondation basin. This large body of water feeds the big waterfall and water mirror at the foot of Gehry's building. It creates

a foreground over which the gaze slides. The water disappears or appears suddenly, mists over or churns. This dreamlike world, like a baroque garden, greets visitors before they enter the interior landscapes of the museum.

THE PLANTS IN THE GARDEN

When it was created, the Jardin d'Acclimatation was a park with the same vegetation as the Bois de Boulogne. Exotic trees were used only to underscore certain key features—to punctuate an intersection, map a river, mark out a rock, set off high points.

We have maintained that intention by mixing trees from the Paris region with "exotic" varieties that have long been acclimatized in the parks of the capital (Asian chestnut trees, Japanese cherry trees, American tulips, black pines from Austria, etc.).

The trees are planted in groves so as to afford small clearings and are mixed in order to create varied edges. Everything possible has been done to ensure a balance of the "constructed" and the random, transitions between order and disorder. The overall effect is designed to be meaningful and create continuities in the visitor's experience of the place.

Under the trees, a procession of shrubs and ground-cover plants underscores the edges, outlines the sunken paths, or emphasizes a loop around intersections.

Between the edgings of trees and shrubs, grass offers spacious lawns for walking or contemplating the meadows that flower every year. This score will evolve over time, be enriched by spontaneous seedlings, and grow mixed and profuse. The dominant forms and colors will develop in random fashion, as screens thicken and treetops meet.

THE GROUND

AND THE FURNITURE

The physical, carnal link between Frank Gehry's building and the garden is expressed even in the design of the ground trodden by visitors. The Fondation connects to the site via its two forecourts (toward the Bois de Boulogne and the Jardin d'Acclimatation), with its high walkways and its lateral stairways.

The flooring of these different spaces is in stone. Inside, as in all this architect's projects, the slabs are large and staggered in the famous "earthquake" pattern.

This layout changes gradually as one moves away from the building: the large, regular, sawn slabs are diffracted into small, split stones and then merge with the paths covered with stabilized sand. We used this design for the sidewalk along Avenue du Mahatma-Gandhi, in order to maintaina distinctive flooring, a subtle transition between the nature-oriented vocation of the Bois de Boulogne and the organic architecture of the Fondation.

The furniture around the Fondation is a contemporary take on the traditional nineteenth-century bench. By extending the wooden seat to match the curves of the new paths, the benches of the Jardin d'Acclimatation are positioned to afford users the finest views.

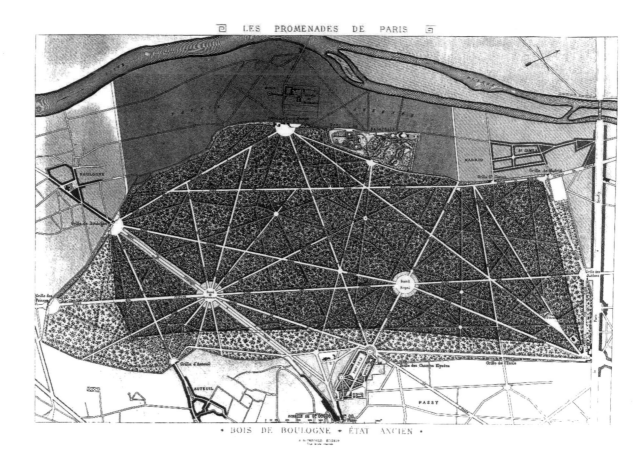

The Bois de Boulogne in the seventeenth century, from *Les Promenades de Paris* by A. Alphand, drawings by E. Hochereau (Paris: J. Rothschild, 1867–73).

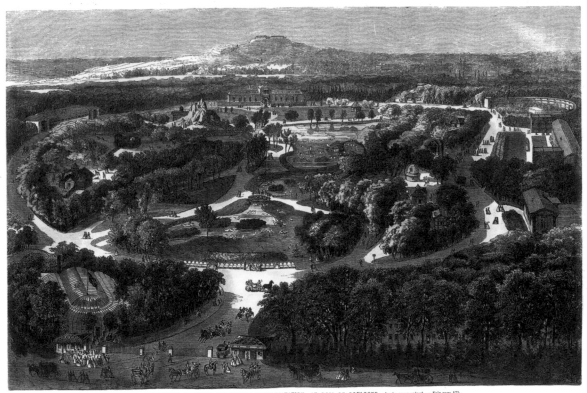

VUE GÉNÉRALE DU JARDIN ZOOLOGIQUE D'ACCLIMATATION, AU BOIS DE BOULOGNE; dessin communiqué. — Voir page 175.

1, 2, 3. Grande porte et pavillons d'entrée. — 4. Bâtiments de l'administration et magasins. — 5. Magnanerie. — 6. Grande volière. — 7. Poulerie. — 8. Marsupiaux. — 9 à 13. Autruches et autres échassiers. — 11. Parc des bêtes laitières. — 15. Écuries des grands mammifères. — 16. Lamas; rochers artificiels. — 17. Aquarium. — 18. Antilopes. — 19. Enclos des cerfs. — 20. Grande serre ou jardin d'hiver.

The Jardin d'Acclimatation, engraving from *L'Univers illustré*, March 17, 1866 (colorized at a later date).

31

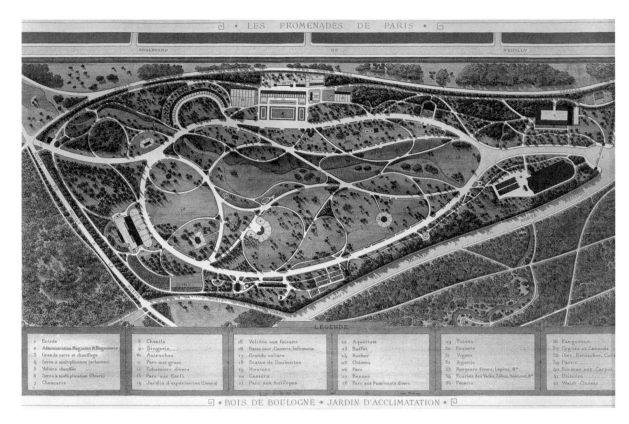

The Jardin d'Acclimatation, plan from *Les Promenades de Paris* by A. Alphand, drawings by E. Hochereau (Paris: J. Rothschild, 1867–73).

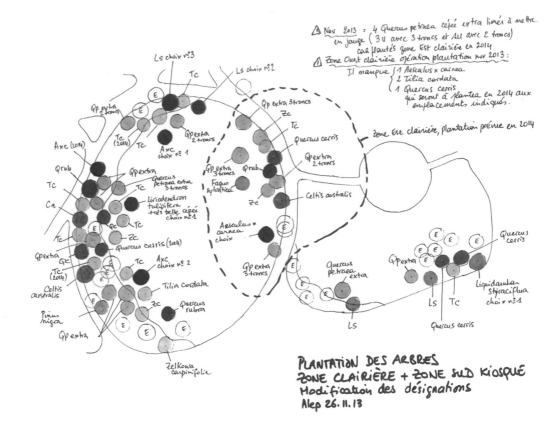

Plan drawn by Philippe Deliau showing the gardeners where
to plant the different varieties of trees.

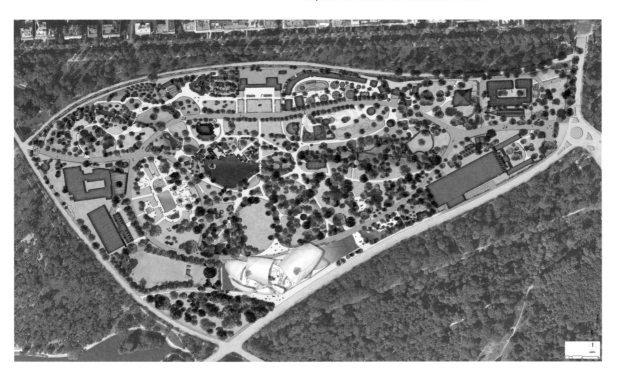

Overall landscape plan.

LAKE

Cascade
Water fall

Belvédère
Belvedere

ROCHER AUX DAIMS
DEERS' ROCK

Specifications book: surface covering on the southern terrace.

THE PALETTE OF PLANTS

TREES

Acer campestre
or field maple
Acer cappadocicum
Acer saccharinum
or silver maple
Aesculus × carnea
American tulip
Asian chestnut tree
Betulautilis
or Himalayan birch
Black pine from Austria
Celtisaustralis
Fagussylvatica "Purpurea"
Fraxinus excelsior or ash
Japanese cherry tree
Juglans nigra
Liquidambar styraciflua
Liriodendron tulipifera
Pinusnigra austriaca
Pinus sylvestris
or Scots pine
Populus tremula or aspen
Prunus padus or bird cherry
(hackberry)
Quercus cerris
Quercus petraea
Quercus rubra
Salix alba
or white willow
Sorbust or *minalis*
Tilia cordata
Tilia platyphyllos
Zelkova carpinifolia

SHRUBS

Abelia × grandiflora
"Prostrata"

Agastache foeniculum
Andropogon
or beard grass
Aruncus dioicus
Asplenium trichomanes
Astilbe × arendsii
"Brautschleier"
Buxussem pervirens
Campanula lactiflora
Campanula latifolia
"Macrantha Alba"
Carex grayii
or Gray's sedge
Carpinus betulus
or hornbeam
Centranthus ruber
Choisy aternata
Clematis vitalba
Cornus alba "Elegantissima"
Cornus alba "Ivory halo
Bailhalo"
Cornus alba "Kesselringii"
Cornus canadensis
Cornus rugosa
Cornus stolonifera
or red osier dogwood
Cortaderia selloana
or pampas grass
Corylus avellana
or common hazel
Cotinus coggygria
Dicentra spectabilis
Dryopteris filix-mas
or male fern
Equisetum hyemale
or rough horsetail
Filipendula rubra
Filipendulina rubra
Gaura lindheineri
Hebe brachysiphon
Hedera helix "Green Feather"
Helianthus salicifolius
Helleborus argutifolius
or Corsican hellebore
Hippophaer hamnoides
or sea buckthorn
Hydrangea paniculata
"Kyushu"
Hydrangea quercifolia
"Snow Queen"

Ilex alaska or holly
Ligustrum vulgare
or wild privet
Lonicera pileata
Lunaria annua
Lythrum salicaria
or purple loosestrife
Mahonia aquifolium
"Apollo"
Miscanthus sinensis
"Adagio"
Miscanthus sinensis
"Gracillimus"
Miscanthus sinensis
"Silberfeder"
Miscanthus sinensis
"Variegatus"
Moliniacaerulea
or purple moor grass
Osmanthus × burkwoodii
Pennisetumalopecuroides
"Japonicum"
Pennisetum orientalis
Phalarisarundinacea
or reed canary grass
Polygonum (or *Fallopia*)
aubertii (on wire mesh)
Primula florindae
Prunus lusitanica
"Angustifolia"
Rhamnus frangula
or alder buckthorn
Ribessan guineum
"King Edward VII"
Rosa canina
Salix purpurea "Nana"
Salix rosmarini folia
or rosemary-leaved
willow
Sambucusnigra
or elder
Sarcoccocaruscifolia
or sweetbox
Saxifraga paniculata
Sedum album
Sedum reflexum
Solidago shortii
Sorbaria sorbifolia
Sorbus torminalis
or checker tree

Spiraea prunifolia
"Plena"
Stipa brachytricha
Stipa tenuifolia
or angel hair
Symphoricarpos × chenaultii
"Hancock"
Syringa microphylla
"Superba"
Viburnum opulus
Viburnum opulus
"Compactum"
Viburnum plicatum
"Mariesii"
Viburnum plicatum
"Shasta"
Viburnum tinus
"Gwenllian"
Viburnum × burkwoodii

Hypericum polyphyllum
or St. John's wort
Hystrix patula
Imperata cylindrica
"Red Baron"
Lamium maculatum
"White Nancy"
Ligustrum vulgare
"Lodense"
Liriope muscari
or lilyturf
Lonicer apileata
Parthenocissustri cuspidata
or Virginia creeper
Polygonum aubertii
Polypodium vulgare
Rubus or Chinese bramble
Saxifraga paniculata
Sedum album
Sedum reflexum
Stipatenuifolia
Vinca acutiloba
or mauve periwinkle
Vinca major
Vinca minor

GROUND-COVER PLANTS AND PERENNIALS

Aegopodium podagraria
"Variegata"
Anemone sylvestris
Asplenium trichomanes
Bergenia cordifolia
or heart-leaf bergenia
Epimedium × versicolor
Euphorbia amygdaloides
"Purpurea"
Perennial geraniums:
Geranium × cantabrigiense
"Biokovo"
Geranium macrorrhizum
"Spessart"
Hedera helix
"Green Feather"
Hedera helix
"Hibernica"
Hedera helix
"Little Diamond"
Helictotriconsem pervirens
"Saphirsprudel"
Helleborus argutifolius
Helleborus purpurascens
Heracleum mantegazzianum
or giant hogweed

Austrian black pines punctuate the Bois de Boulogne. Planted in the nineteenth century, they form a dense, regular canopy throughout the woods.

Autumn is the season when the Bois de Boulogne's variety of trees is most evident, as their varied colors form a succession of planes and highlight the forms and textures in pictorial compositions.

"The tree with the forty ecus," as the Asian *Ginkgo biloba* became known in France, is at its richest in the fall, when its distinctively shaped leaves turn a jewel-like golden yellow.

The autumnal yellows of the gingko and sugar maple are similar, but their leaves are very different, the former rounded and fan-like, the latter more jagged. The contrast is impressive and striking.

The Jardin d'Acclimatation is shaped by wide, gentle undulations, characteristic of the Second Empire art of gardens. The vegetation forms pleasant glades which, when on higher ground, become belvederes with views over the landscape.

The growing trees of the "Enchanted River" gradually blocked out the original central vista. In recent years, the gardeners have begun regularly raising the top bevels and thinning the crowns of the denser specimens so as to afford new views onto the water.

The staghorn sumac is a small tree that gains in presence over the seasons, beginning with its blossom and then fruits, but climaxing with its fine autumnal colors. Shifting from yellow to orange-red and then fawn, it brings touches of color to the thickets of the Neuilly belvedere.

After the profuse blossom of spring, the leaves of the cherry trees turn
a rich mix of reds and oranges, lighting up the oaks in the background.

The trees of the Jardin d'Acclimatation are a subtle mix of conifers and broad-leafs. Beneath their variety of textures, tall grasses spread their luminous sprays. In the distance, autumn-red bald cypresses signal the lake.

Ailanthuses (or "trees of heaven") are lemon-yellow in November. Their spreading tops and dense, pinnate leaves add a touch of exoticism and set up a magnificent play of light and shade on the meadows.

The euphorbias with their handsome bluish leaves form dense bushes beneath the pines and on the edge of the woods. In the spring great, yellow-green bracts shoot forth from the leaves.

Cogon grass, also known as "Japanese bloodgrass," has fine leaves that are green in spring and blood-red in summer. They underscore borders and mark out paths.

These tall bald cypresses were planted around the lake in 1860, when the Jardin d'Acclimatation was created. Their soft-green, needle-like leaves turn fawn in autumn. This gradual coloring of their silhouette is a winter marker: the leaves fall suddenly with the first frosts.

The tall miscanthus grass is cut down every winter and grows back generously every spring. The garden offers many different varieties, forming handsome compositions thanks to the subtle differences between their leaves and plume-like flowers.

Over a hundred years old, tall sessile oaks rise up all around the garden.
They mark the intersections of paths or form groves of three or five.

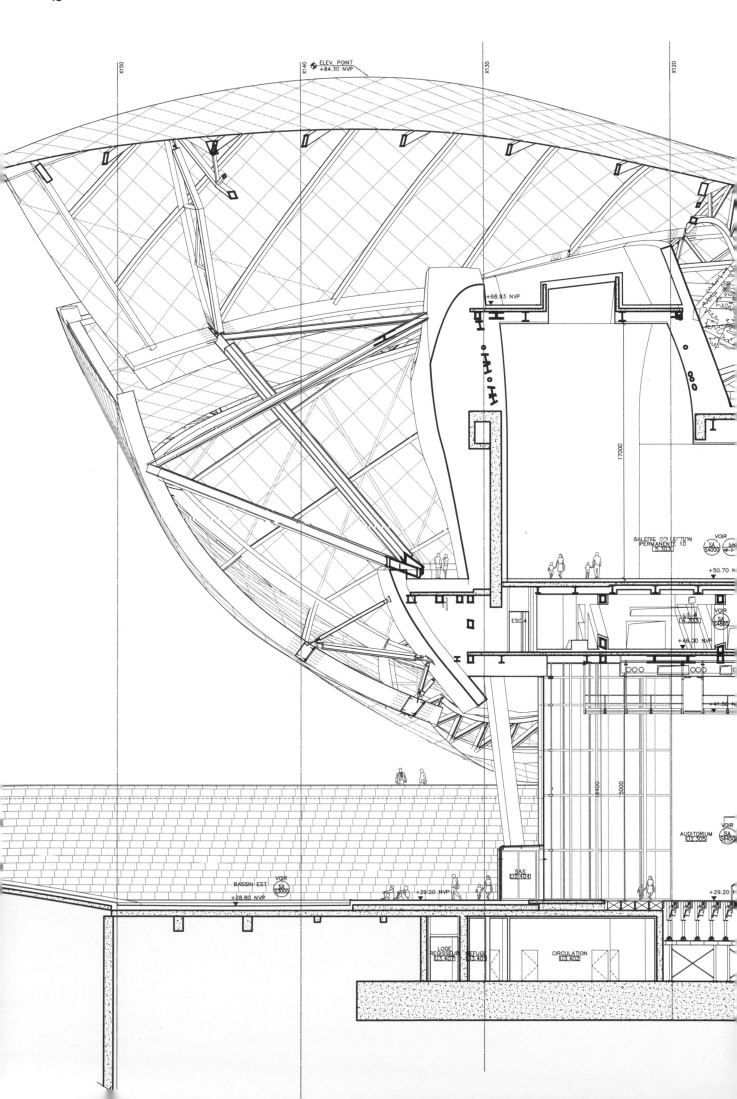

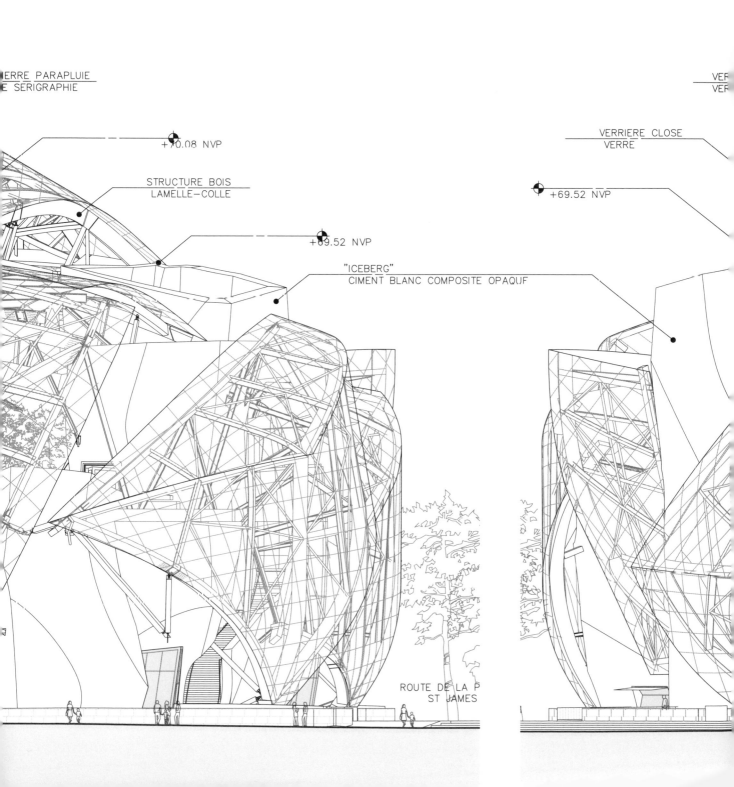

ERRE PARAPLUIE
E SERIGRAPHIE

VER
VER

+70.08 NVP

VERRIERE CLOSE
VERRE

STRUCTURE BOIS
LAMELLE−COLLE

+69.52 NVP

+69.52 NVP

"ICEBERG"
CIMENT BLANC COMPOSITE OPAQUE

ROUTE DE LA P
ST JAMES

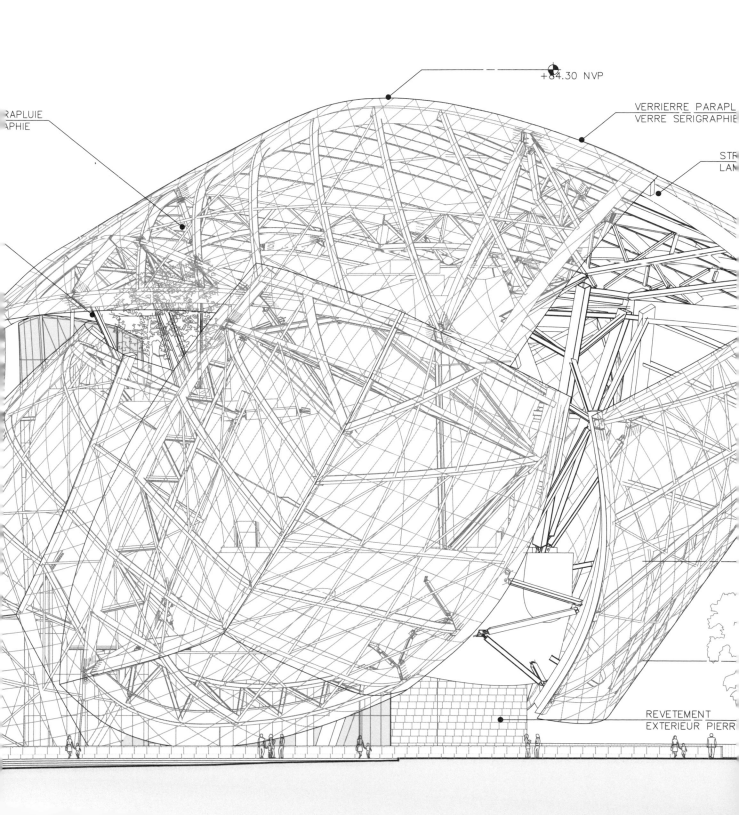

+84.30 NVP

RAPLUIE
APHIE

VERRIERRE PARAPL
VERRE SERIGRAPHIE

STR
LAM

REVETEMENT
EXTERIEUR PIERR

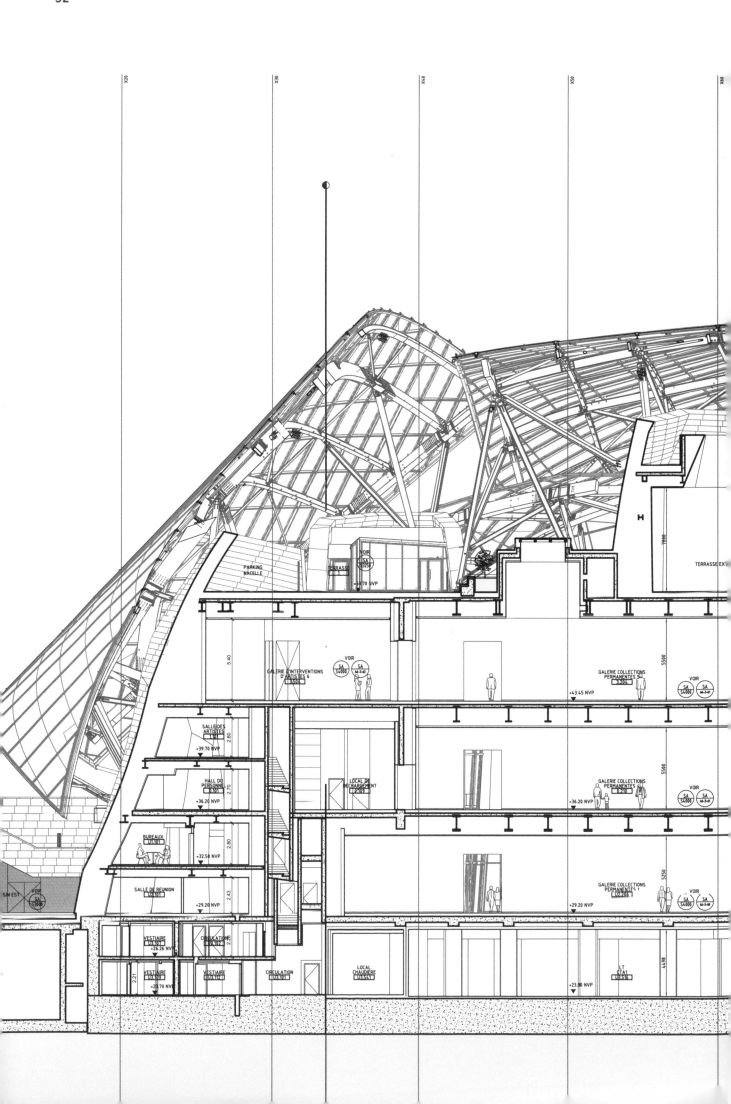

PARKING
NACELLE

VOIR

TERRASSE

TERRASSE EXT

+44.70 NVP

GALERIE D'INTERVENTIONS
D'ARTISTES 6

VOIR
SA
S4000
SA
A6-3-43

GALERIE COLLECTIONS
PERMANENTES 5

VOIR
SA
S4000
SA
A6-3-41

+43.45 NVP

SALLE DES
ARTISTES

+39.70 NVP

HALL DU
PERSONNEL

LOCAL DE
DECHARGEMENT

GALERIE COLLECTIONS
PERMANENTES

VOIR
SA
S4000
SA
A6-3-41

+36.20 NVP

+36.20 NVP

BUREAUX

+32.50 NVP

SALLE DE REUNION

GALERIE COLLECTIONS
PERMANENTES 1

VOIR
SA
S4000
SA
A6-3-41

+29.20 NVP

+29.20 NVP

VESTIAIRE

+26.26 NVP

CIRCULATION

VESTIAIRE

+23.70 NVP

VESTIAIRE

CIRCULATION

LOCAL
CHAUDIERE

LT
CTA1

+23.80 NVP

SIN EST

VOIR
SA
S4000

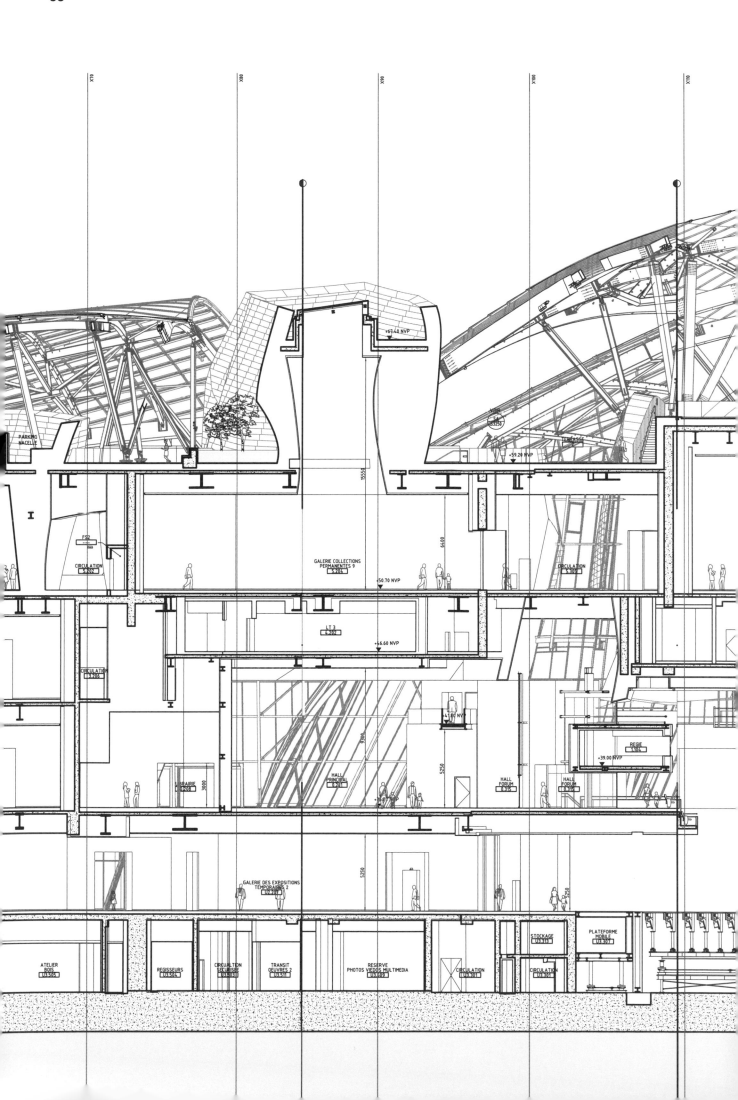

PARKING
NACELLE

+67.40 NVP

15550

VOIR
54
+33250

TERRASSE

+59.20 NVP

FS2

CIRCULATION
S.202

GALERIE COLLECTIONS
PERMANENTES 9
5.204

6400

CIRCULATION
S.303

+50.70 NVP

LT 3
4.202

+46.60 NVP

CIRCULATION
U3.205

9350

+41.60 NVP

REGIE
1.104

+39.00 NVP

LIBRAIRIE
0.208

3000

HALL
PRINCIPAL
0.201

5250

HALL
FORUM
0.315

HALL
FORUM
0.315

GALERIE DES EXPOSITIONS
TEMPORAIRES 2
1.220

5250

STOCKAGE
U3.315

PLATEFORME
MOBILE
U3.307

5250

ATELIER
BOIS
U3.505

REGISSEURS
U3.504

CIRCULATION
SECURISE
U3.503

TRANSIT
OEUVRES 2
U3.511

RESERVE
PHOTOS VIDEOS MULTIMEDIA
U3.603

CIRCULATION
U3.301

CIRCULATION
U3.301

54

G"
BLANC COMPOSITE OPAQUE

VERRI
VERF

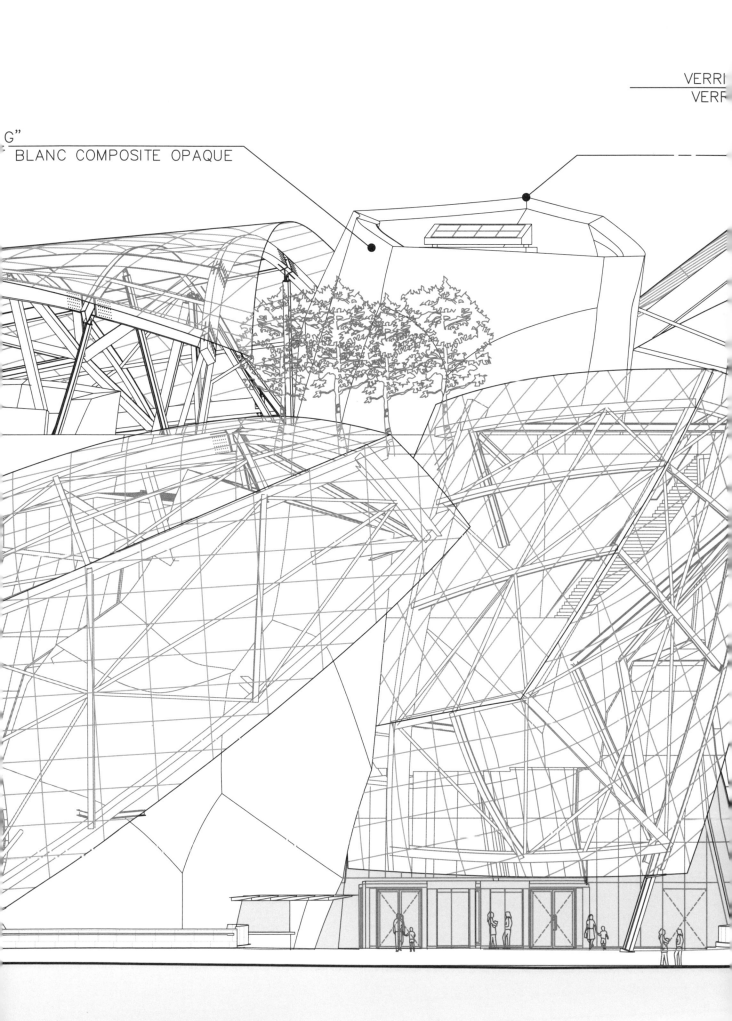

DECONSTRUCTED BAROQUE

An interview with architect Paul Chemetov

You have put your name to a number of emblematic buildings, including the Ministry of Finance and the Grande Galerie de l'Évolution at the Muséum National d'Histoire Naturelle, both in Paris. What view do you take of this one by Frank Gehry?

Many emblematic buildings have been created over the centuries. From the Taj Mahal to the cathedrals of Christianity, all went beyond strict necessity or strict functionality. After all, you could easily have fitted the faithful into a barn! What need was there to put up 150-foot vaults, to erect towers or cupolas, except to signify something other than the construction itself? A building always bears witness to permanence by entering into a pact with eternity. For the patron and for the architect, it is a way of projecting into the future. There are numerous examples of this in France for the twentieth century. Everyone knows that Georges Pompidou didn't like the architecture of the Beaubourg arts center in Paris, yet it bears his name, it is world-famous and, with time, it has become part of French history and culture. François Mitterrand fought against massive opposition in his choice of the Bibliothèque Nationale's new buildings, constructed on difficult terrain, knowing only that by giving them his name he would enter eternity.

Frank Gehry's building institutes the same relation to the future both for the architect and for the Fondation Louis Vuitton, as it becomes an integral part of the history of Paris.

How did he manage this?

By inventing a total stylistic freedom. If constructions in a forest are not recent— remember Chambord and other "balconies in the forest"—it is clear that this building is singular. It is the fruit of an experience arising from the desire of the patron and the visionary daring of the architect. In my opinion, the worst thing that can happen to it is that it will be copied, because its avatars will never manage to attain the same level of excellence.

How might it be positioned in the history of architecture?

Obviously, you would have to mention Le Corbusier's Ronchamp among the major influences. However, Gehry's origins —Central Europe—are part of his imaginary world, as I see it. There is something baroque about this architecture, but it's a deconstructed baroque, almost destabilized, because Gehry is a man of his times. Going beyond these influences, one could mention the habitable sculptures of Dubuffet and Niki de Saint Phalle. Gehry has created a unique "sculptural building." I would describe this construction as one of strips, successive layers of different materials, that the air seems to link together, as "trans-referential," rather as a literary text would be "trans-textual." Gehry's building is just as much an artwork as the home of a foundation. It is therefore as important as the works that will be exhibited there.

But still, its role is to receive the public.

Its intelligence and singularity lie precisely in that duality, and Gehry's strength consists, precisely, in knowing what role to give the building and what role to give the sculpture. He has built a clever articulation between the rectangular rooms constituting the fundamental part and the scales of the outer skin. By creating an

intermediary structural technical part, he gets the ensemble to cohabit in space. This intelligence is quite clear in the plans, which are superb. I haven't seen many drawings that beautiful. They really are like engravings.

How does contemporary architecture fit into an artificially natural historical site, and how is such a building compatible with the place?

Apart from primeval forest, there is no such thing as a purely natural milieu. The Bois de Boulogne, like the Bois de Vincennes, is an artifact. Now the former will have its high point, the reflective and transparent Fondation, just as the latter has its rock.

Thus, each of the two big artificial woods of Paris will have its "natural artificiality." Gehry's building fits perfectly into the tradition of these wholly fabricated places for promenading, while also being a remarkable architectural object.

What, in your view, is the key to success on this kind of project?

The quantity of resources put in play and, above all, the trust and support of the patron. You need to have a great passion for architecture to see this kind of project through. We can observe that the building is just as inventive and magisterial in terms of engineering as it is on the architectural level. It's also important to emphasize that Gehry's creation is generous, quite apart from the financial input. This building is a gift, an exchange between visitors and the architect's vision.

How does this building inflect the initial role of the Jardin d'Acclimatation? Does it change it? Enrich it?

Inevitably. The construction adapts to the place, and conversely. The architecture is inscribed in historical time, modifying the site, playing a role in the public imaginary, in its memory. The Eiffel Tower, the Pompidou Center, and the Fondation Louis Vuitton are iconic buildings and architectural promenades. By telling a new story, they offer the public new keys for new interpretations.

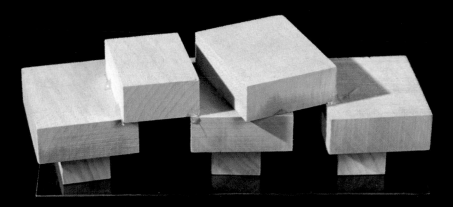

During the design phase, the architect used
wooden blocks to stake out the future forms of the Fondation.
These first models were used to get an idea of
the interactions between the building's different spaces.
1:500 model.

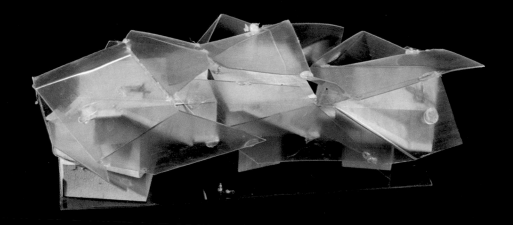

The glass sails appeared early on in the design process.
Frank Gehry and Bernard Arnault pictured a transparent building
in glass, in harmony with the site and its heritage yet
offering completely new forms. 1:500 model.

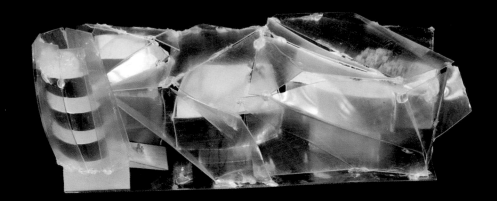

Under the glass canopy, Frank Gehry originally thought of using
colored forms for the exhibition spaces. Their layout
has not changed since the first models. Between the glass sails
and the museum spaces, the architect considered installing
a garden and works of art. 1:500 model.

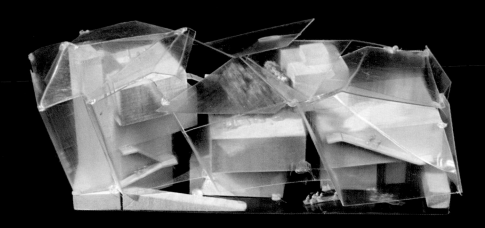

In this model Gehry represents the circulation areas.
In keeping with regulations for the site,
the building has a single floor, which is divided into three parts:
west, center, and east. Because these are on different
levels, they shaped the volume and soon established the need
for vertical circulations. 1:500 model.

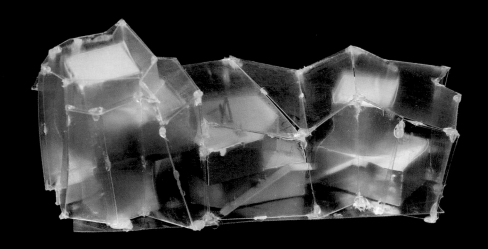

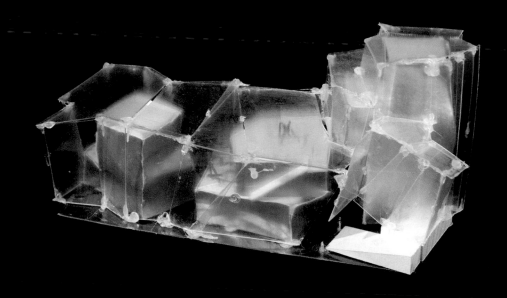

In order to bring light into the exhibition spaces,
the architect designed light wells above the galleries. Located to
the east, west, and center of the building, the galleries
are represented in three distinct colors. The building is closed by
a glass canopy comprising broad, flat surfaces. 1:500 model.

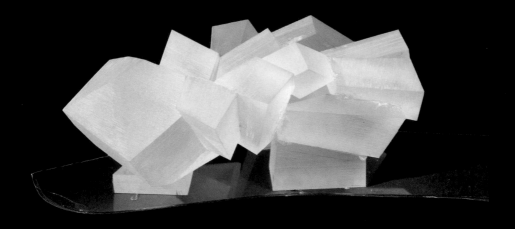

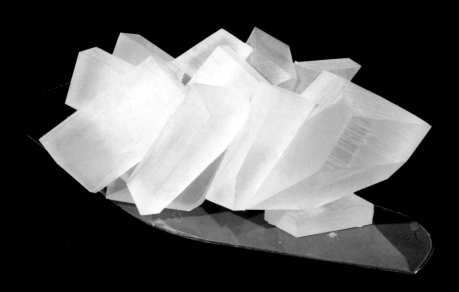

In this model the angular character of the glass canopy is
highlighted, with the building standing over a pool.
This is where the general idea of a transparent building placed
on water took shape. 1:500 model.

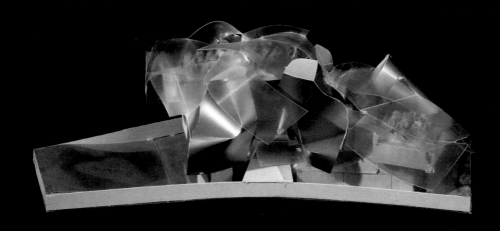

The glass sails now no longer close the building, but leave
the interior volumes of the building visible. The idea of two distinct
skins is much more pronounced here. The glass sails are
now curved, contributing to the dynamism of this remarkable
structure. At this stage, Frank Gehry was thinking in terms
of colored titanium for the walls. 1:500 model.

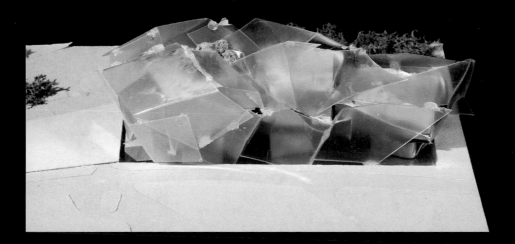

By now, the architect's models are placed within
representations of the site: the Jardin d'Acclimatation to the north,
the Bois de Boulogne to the south. The glass canopy,
the museum spaces, the site, the circulations: all interact
and enrich each other. Frank Gehry mixes interior and exterior
spaces. 1:500 model.

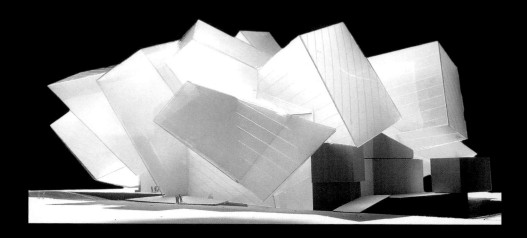

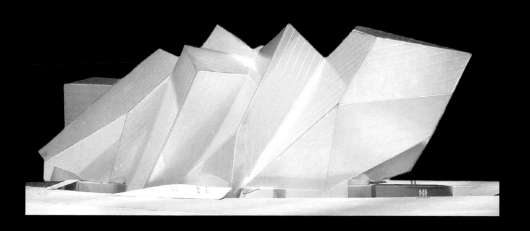

The lines of a grid appear on the glass sails in order to heighten a sense of movement. White dominates. The glass needs to have reflective properties in order to opacify the surfaces. 1:200 model.

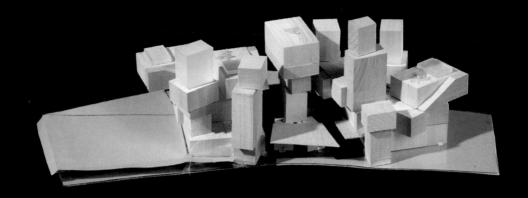

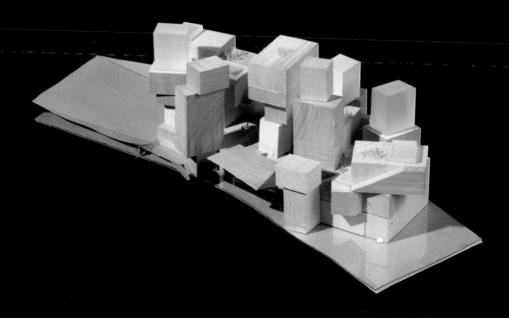

Frank Gehry represents each function: galleries, light wells,
auditorium, vertical (elevators, stairs) and horizontal circulations.
Empty and full volumes form a complete architectural promenade.
This "programmatic" model makes it possible to embrace every facet
of the project. 1:100 model.

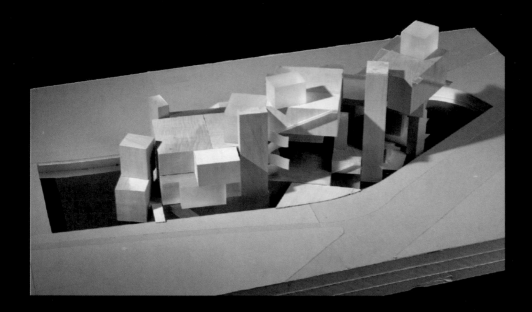

This model represents with great precision the way
in which spaces communicate. Vertical circulations are clearly
identified and make it possible to move fluently
through the building. The auditorium claims its position
and grows. The pool is located below the garden level.
1:100 model.

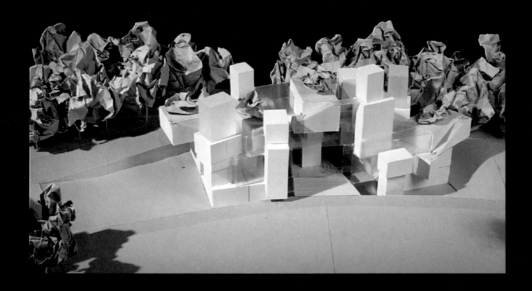

The empty spaces created by the reception hall,
the auditorium, and the terraces form powerful connections
with the landscape. Not only does Gehry's architecture
fit into the site and its general surroundings, but it creates
a new dialogue between the garden and the wood
on either side of the Fondation.
1:100 model.

HERITAGE AND MODERNITY

Michel Brodovitch
—Architect, general inspector of sustainable development, —Rapporteur to the Commission Supérieure des Sites

Instituted in the form we know today in 1930, the category of *sites classés* was created as a complement to the list of historic monuments to help protect sites of remarkable artistic, historical or scientific, legendary or picturesque interest. It includes the Bois de Boulogne and Bois de Vincennes, whose contemporary form originated when Napoleon III donated these spaces to the people of Paris for exercise and relaxation.

Because of the emblematic character of these spaces authorization for projects there lies with the environment ministry, which consults with the departmental and national commissions. Before pronouncing, the environment minister,who is in charge of these sites, can consult with the Commission Supérieure des Sites, Perspectives et Paysages. Comprised of experts, members of parliament, representatives of associations and of the administration, this commission gives its opinion on the submitted projects'compatibility with the preservation and showcasing of the site.

In the case of the project for the Fondation Louis Vuitton, which it was my privilege to present to the commission, the central question concerned the appropriateness and legality of such a realization on a listed site. What response would have been given to a similar demand made regarding Central Park in New York or Hyde Park in London? If we cannot rule out the possibility of a negative answer in the United States or the United Kingdom, in France the answer was positive, which, it seems to me, demonstrates the openness of our country in its desire, even

in an extremely confined protective context, to allow space for the exception that is artistic creation. Openness aside, the commission also recommended that such an undertaking not be repeated in the form of other projects in the two Parisian woods, in order to preserve the unique and emblematic character of this one. It also made its agreement conditional on the restoration of the whole of the historic garden laid out by Jean Charles Alphand and Jean-Pierre Barillet-Deschamps in the nineteenth century.

Today, the progress made by the two projects, the restoration of the garden and the Fondation, shows how they are mutually complementary and create reciprocal vistas: the garden offers a setting for the great glass vessel, which itself affords views over the garden. The insistence that the garden and Fondation project be handled together was the one and only constraint imposed on the project by the commission. Hence the requirements with regard to the long rail forming the base of the building, which is highly visible from the garden.

During the construction process, our role at the oversight meetings required by the environment ministry was limited to observations on the capacity of the builder and client to anticipate our questions about the modalities of implementation of different parts of the project.

The exceptional character of this building and the treatment of its surroundings were, more than other circumstantial, environmental, or "virtuous" criteria, the reasons for our validation of the project. In terms of this exceptional quality, the oversight of the operation lived up to our expectations: by the quality of the project supervision, by the technical feats of the engineers in this realization, and by the tenacity of the client who, right to the end, took responsibility for the technical and financial consequences of their architectural choices.

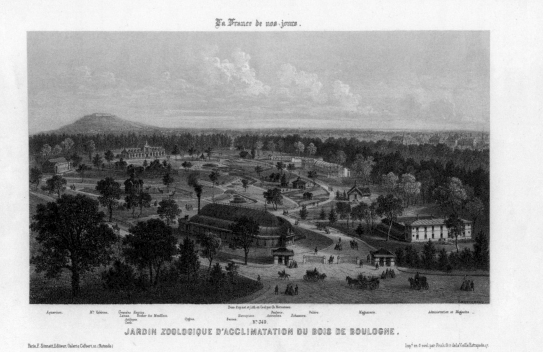

The Jardin d'Acclimatation zoo (Bois de Boulogne) in
La France de nos jours, late nineteenth century.

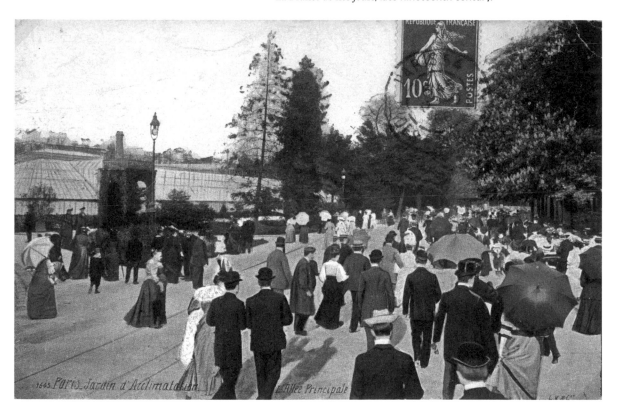

The main park lane through the Jardin d'Acclimatation.
Postcard, circa 1900.

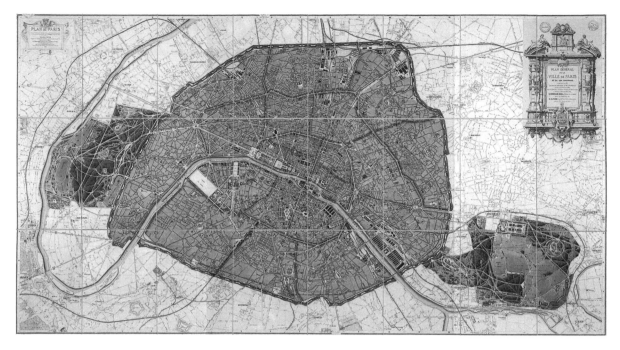

"General plan of the City of Paris including the Bois de Boulogne and Bois de Vincennes,"
edited by Jean-Charles Alphand, 1878.

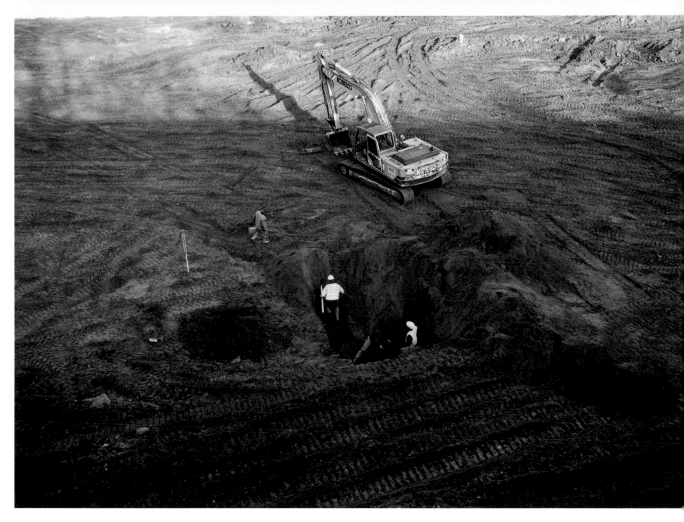

November 25, 2008 the team is preparing the site to start the construction.

November 28, 2000 the molded wall delimiting the ground space of
 the building goes 75 feet underground.

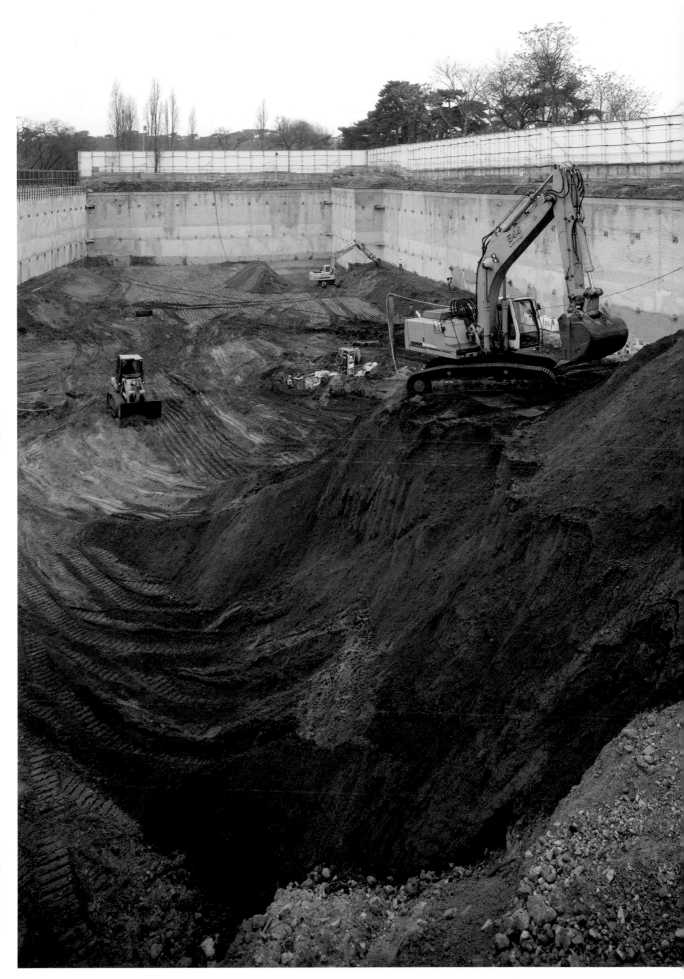

digging.

December 15, 2008

December 19, 2008 completion of the digging.

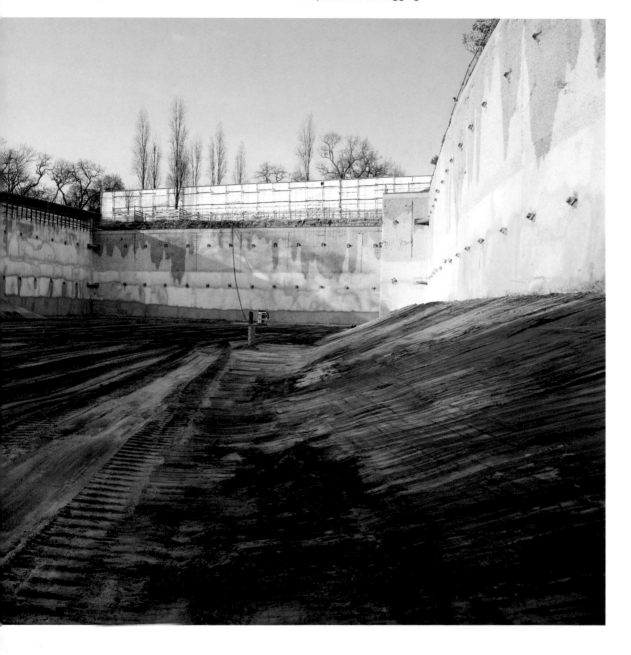

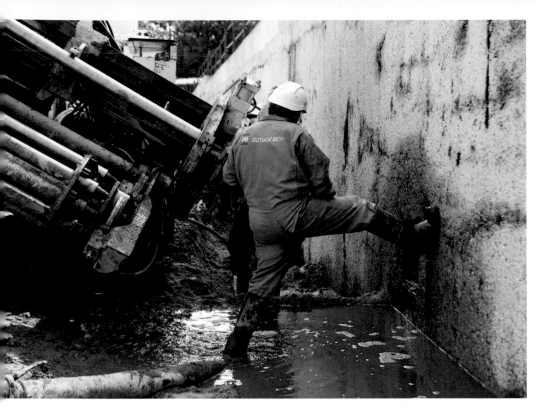

September 4, 2008 digging for the braces to support the molded wall.

placing the braces to support the molded wall.

November 28, 2008

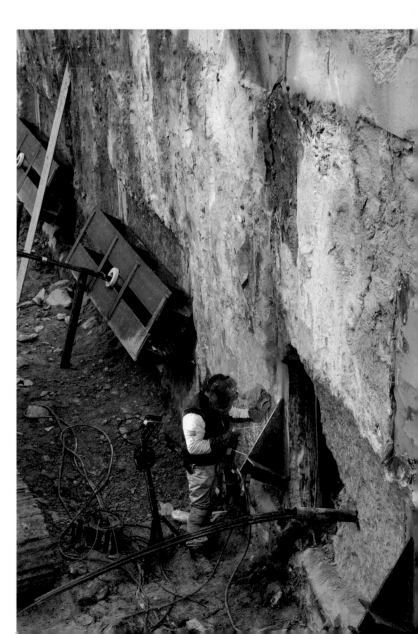

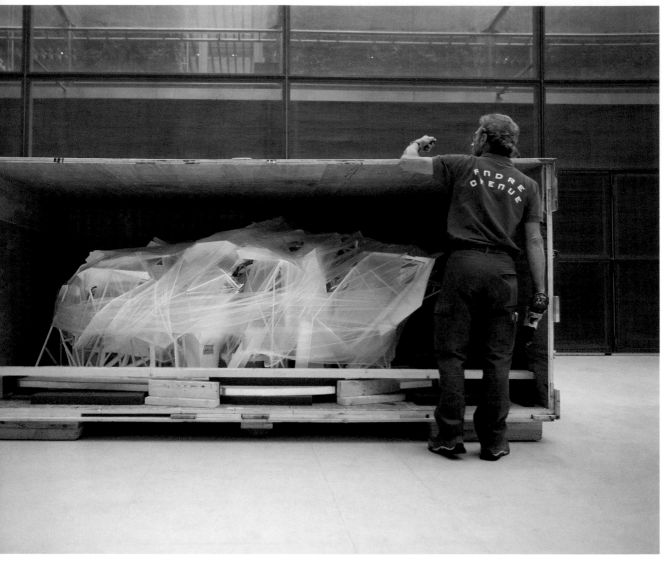

July 8, 2008 installation of the 1:50 model at the head office of the LVMH group in Paris.

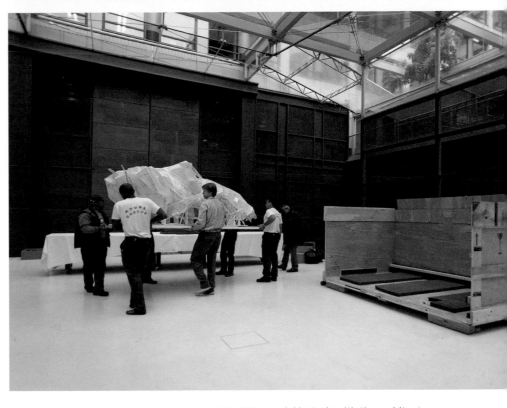

July 8, 2008

arrival of the model in Paris with the architects
of Gehry Partners.

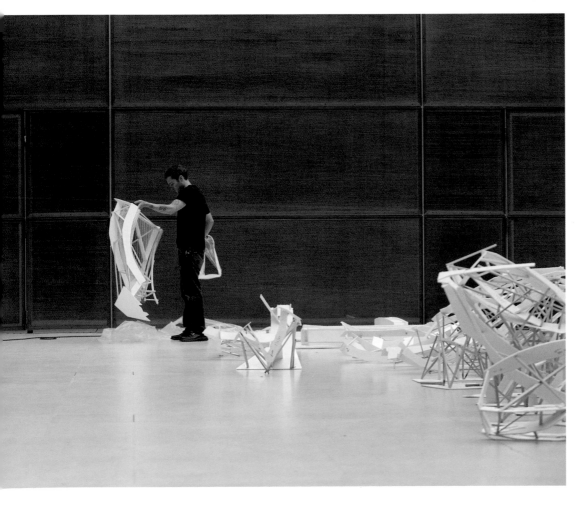

unpacking the elements of the 1:50 model.

July 8, 2008

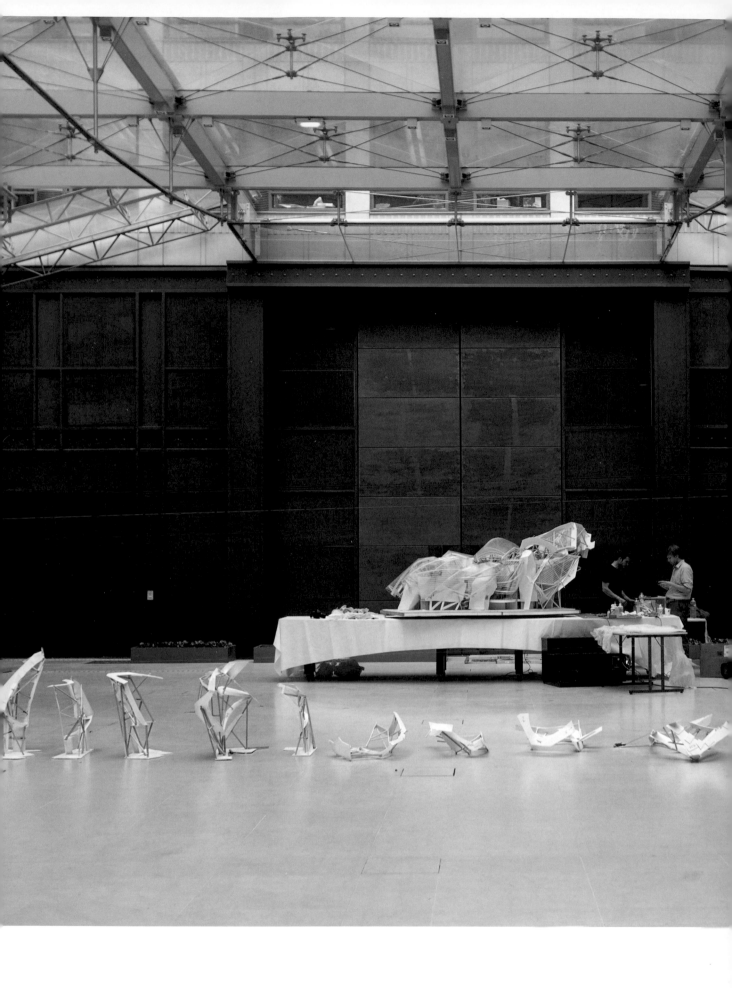

assembling the model.

July 8, 2008

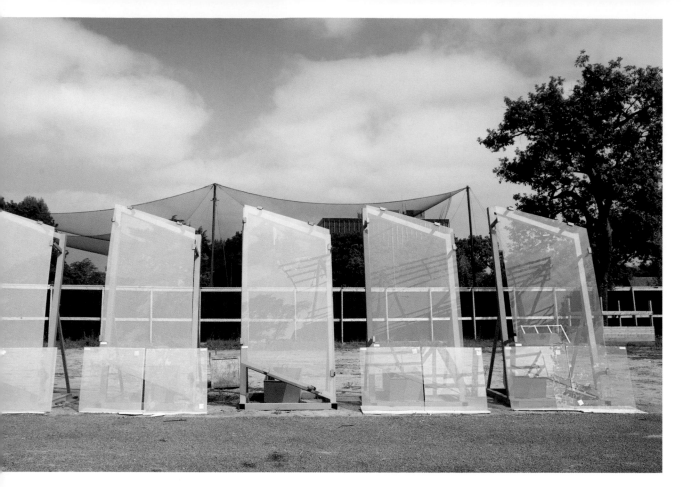

August 29, 2008

the first samples of glass arrive on the construction site.
Checking the opacity and reflectivity of the panels that will constitute
the building's twelve sails.

Detail of actual-size prototype. The ties for the glass panels
are still being perfected. Their size changed over
the course of the project.

August 29, 2008

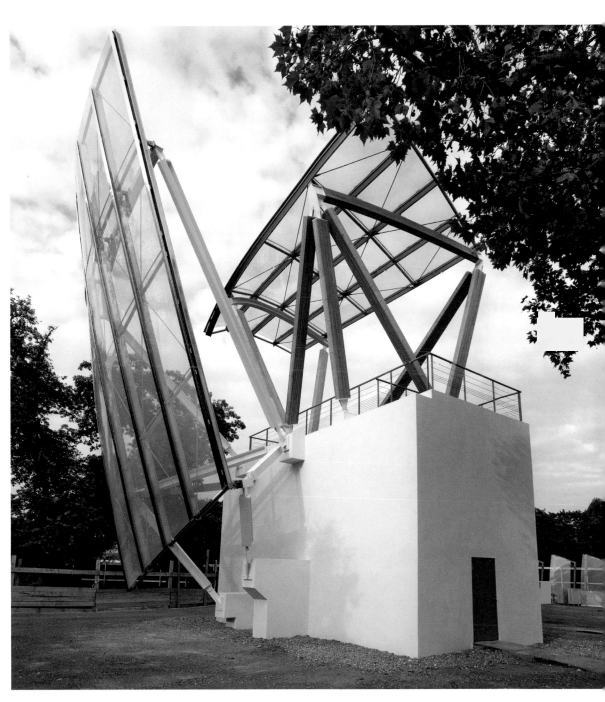

September 29, 2008 the actual-size prototype tests and validates the initial studies.

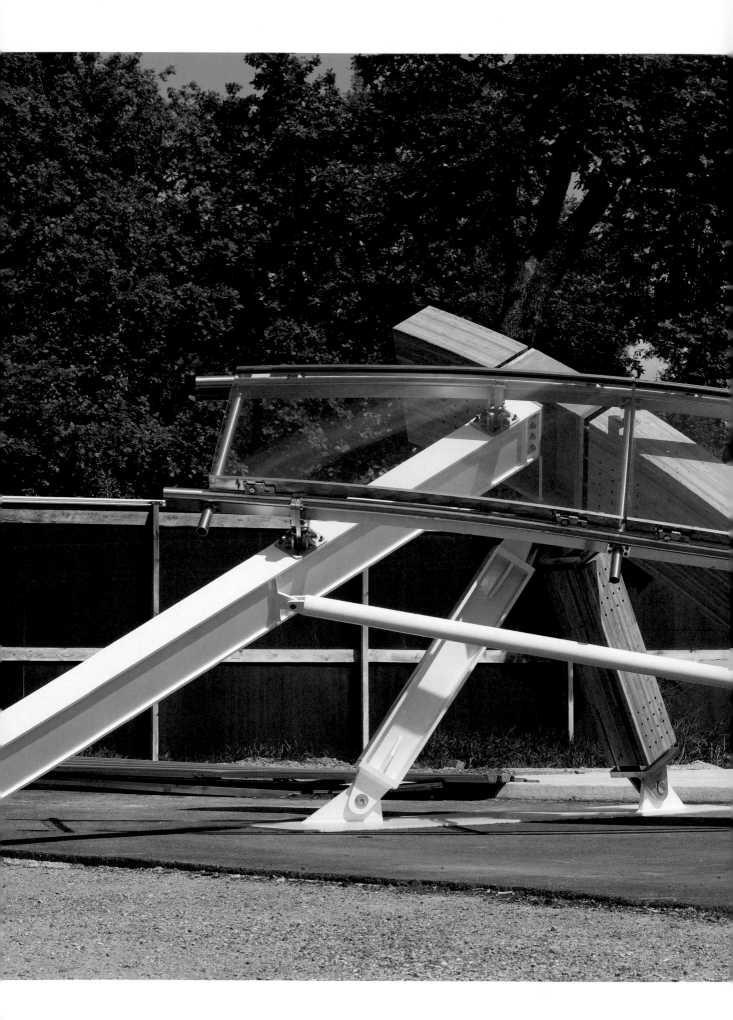

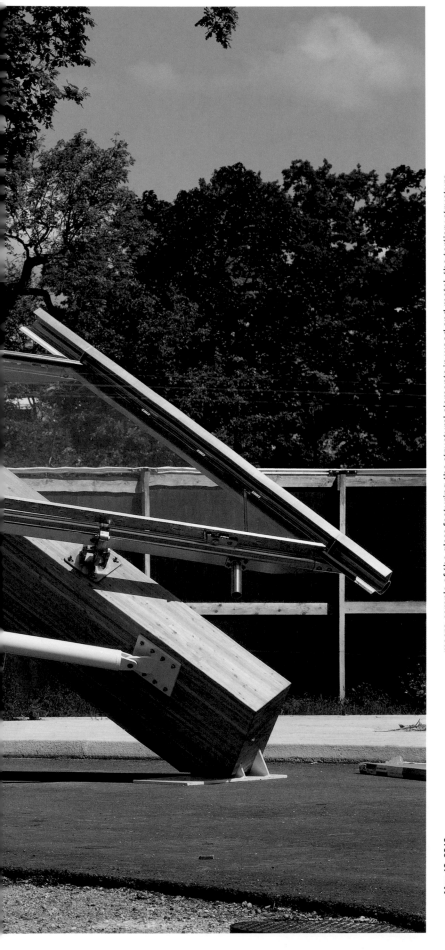

May 18, 2010

macro-sample of the glass featuring the structural elements in wood and metal, the tertiary structure in stainless steel, and the glazing (without serigraphic treatment).

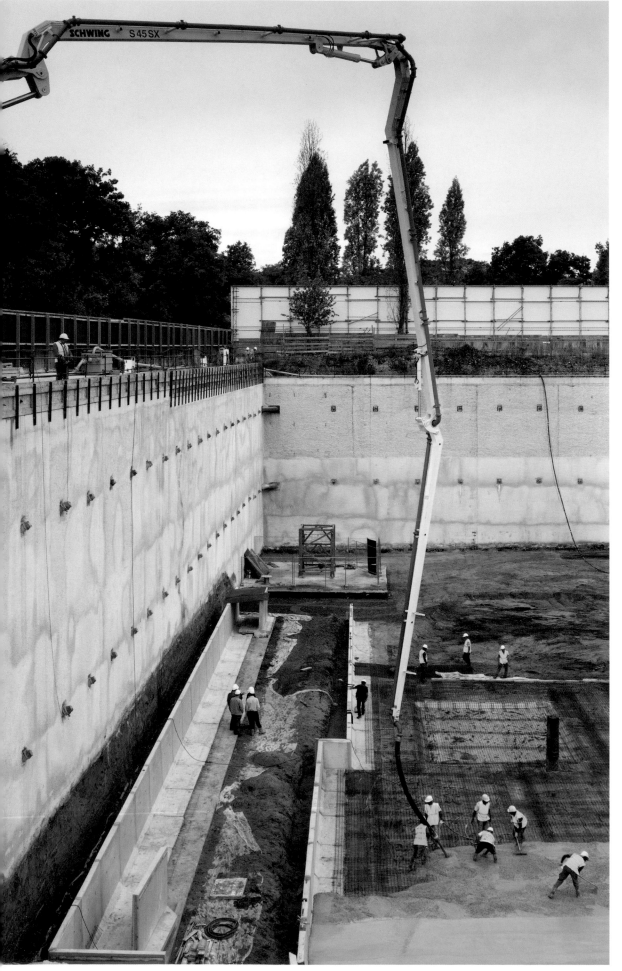

September 2, 2009

for the foundations, the "cleanness" concrete is flowed in so as to give the building tightness.

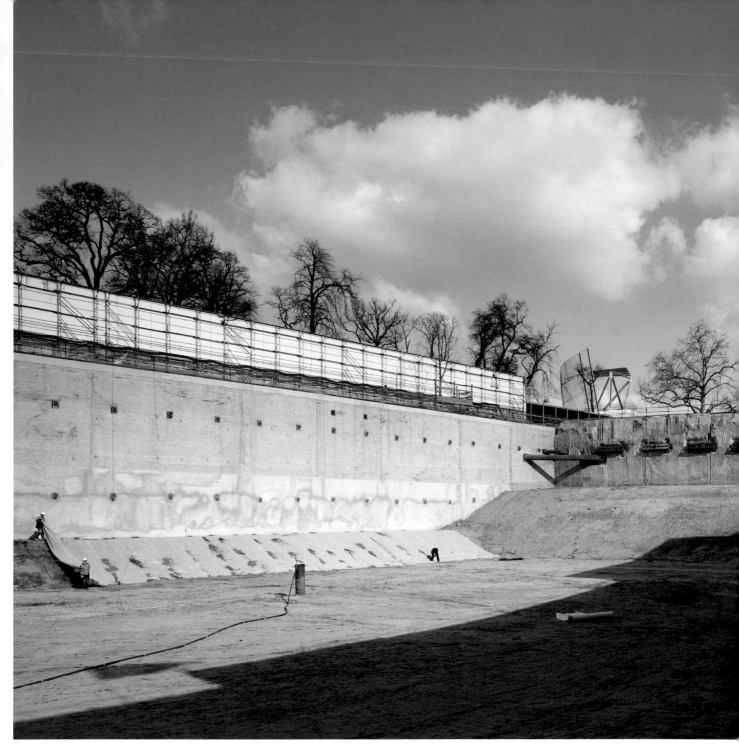

March 2, 2009 installation of the protection of the berm, bracing the molded wall installed at the end of the hole.

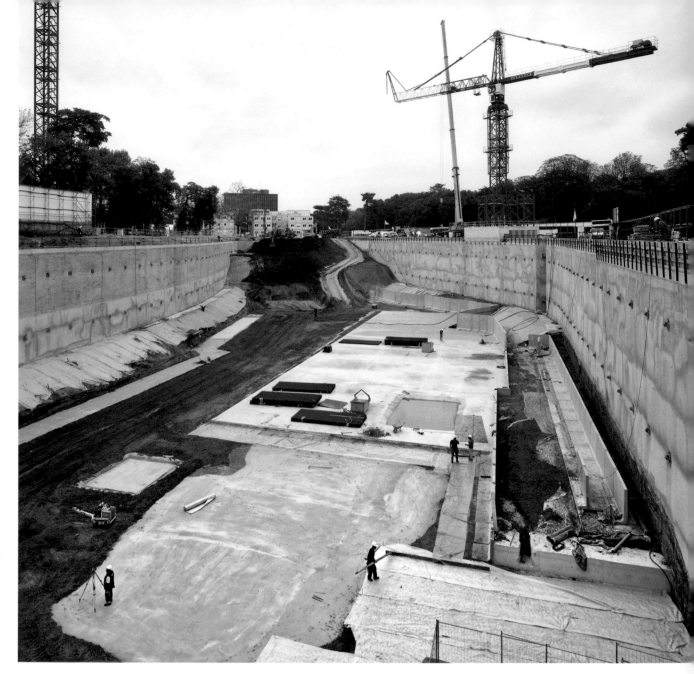

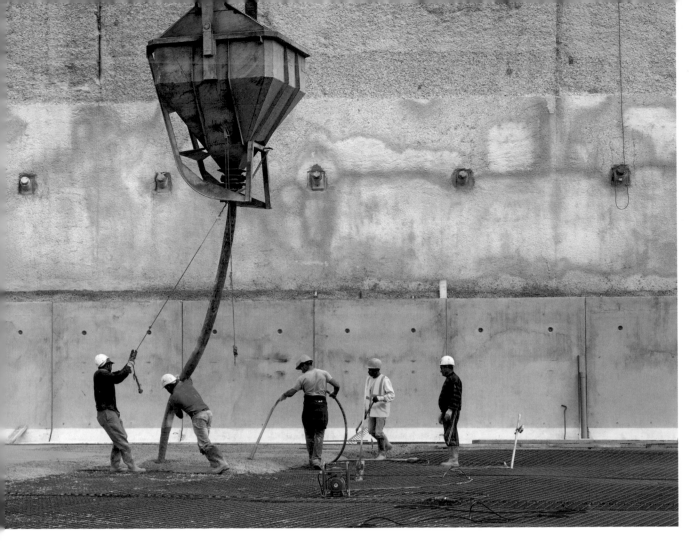

September 15, 2009 flowing of the layer preceding the bottom slab.

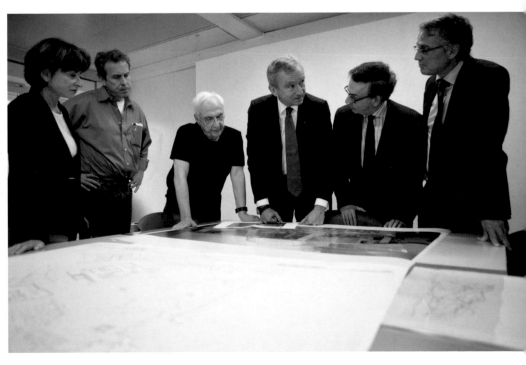

January 20, 2010 from left to right: Suzanne Pagé, Artistic Director of the Fondation, Larry Tighe, Partner at Gehry Partners, Frank Gehry, Architect, Bernard Arnault, Chairman and Chief Executive Officer of the LVMH Group, President of the Fondation Louis Vuitton, Jean-Paul Claverie, Adviser to the Chairman of the LVMH Group, and Christian Reyne, Executive director of the Fondation.

October 8, 2009

protection of the infrastructure by a double tightness layer in bitumen.

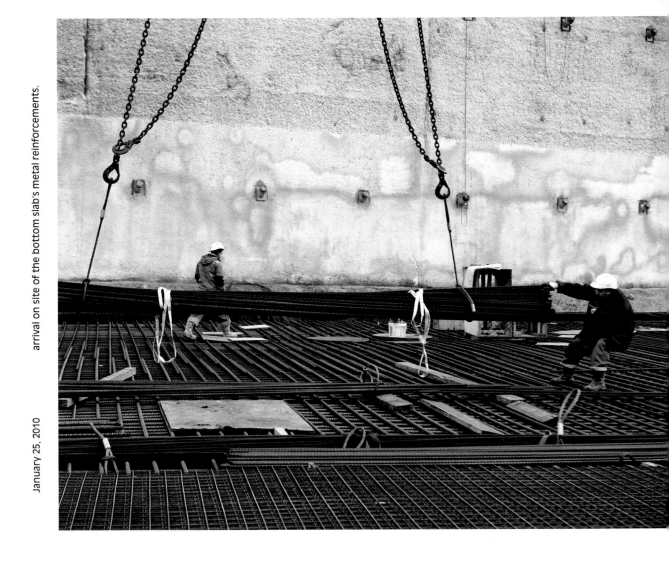

January 25, 2010

creation of the iron structure for the building's bottom slab, 2.6 meters (8.5 feet) thick, with an area of 4,000 square meters (43,000 square feet).

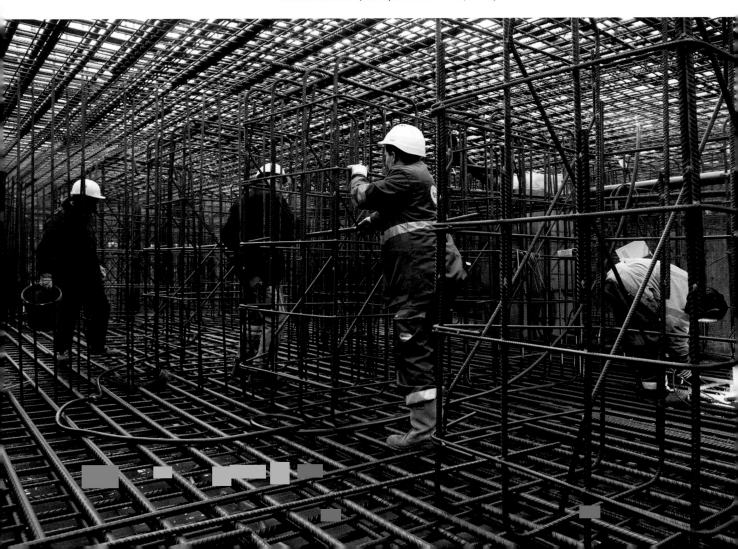

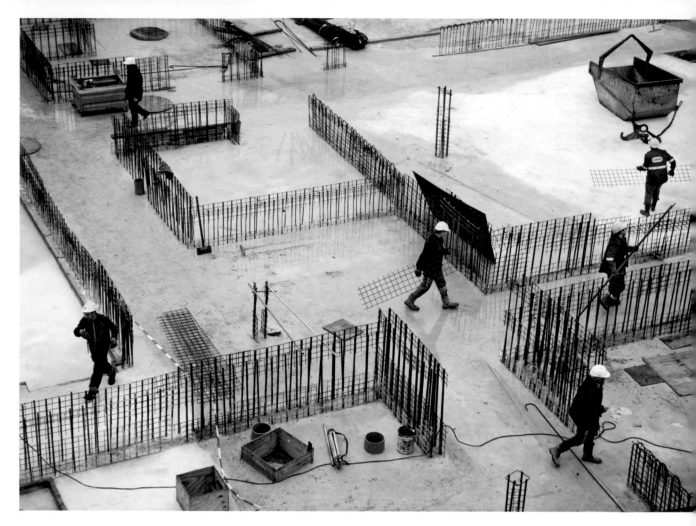

February 24, 2010 completion of the reinforced concrete base on which the building will be placed.

sealing of the bottom slab under the molded wall.

April 15, 2010

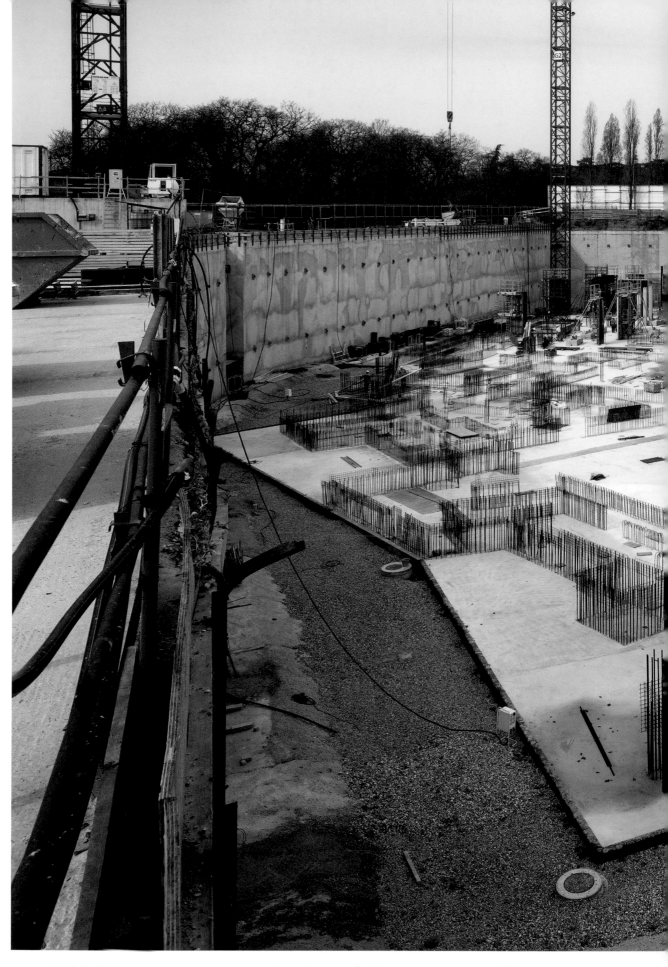

March 24, 2010

general view of the construction site with the posts and the form panels
used to mold the concrete walls.

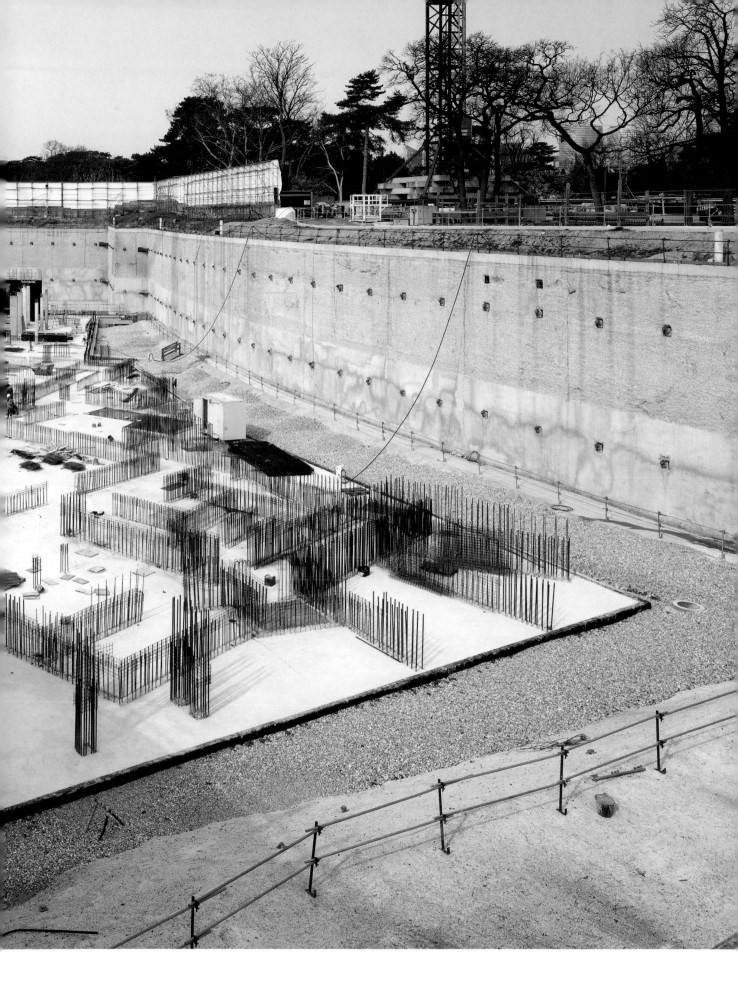

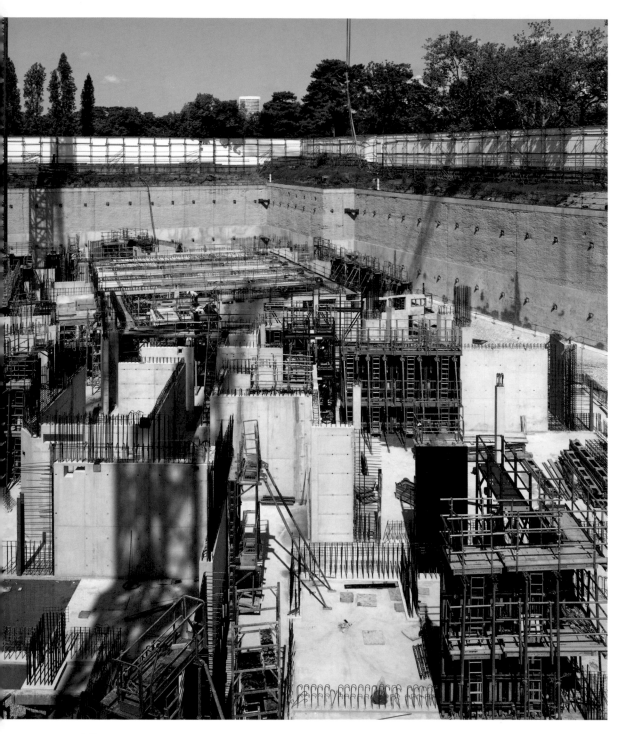

May 18, 2010 laying out the technical spaces, below the pool level.

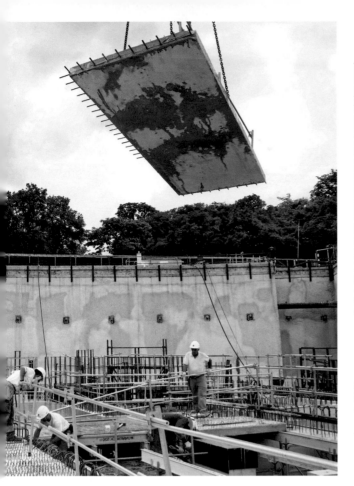

placing the concrete slabs forming the base of the pool around the Fondation building.

June 8, 2010

construction of the Fondation basements.

March 18, 2010

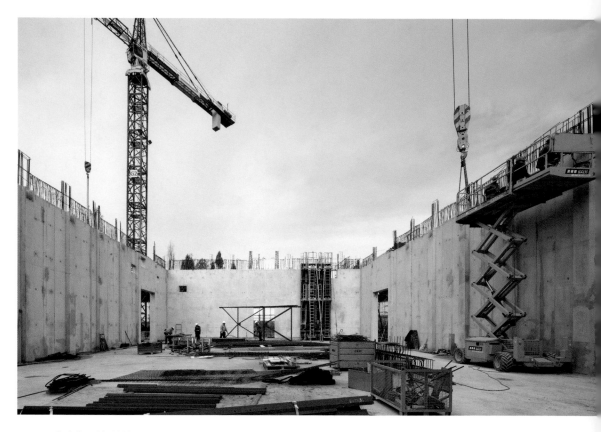

October 19, 2010

the walls of gallery 4.

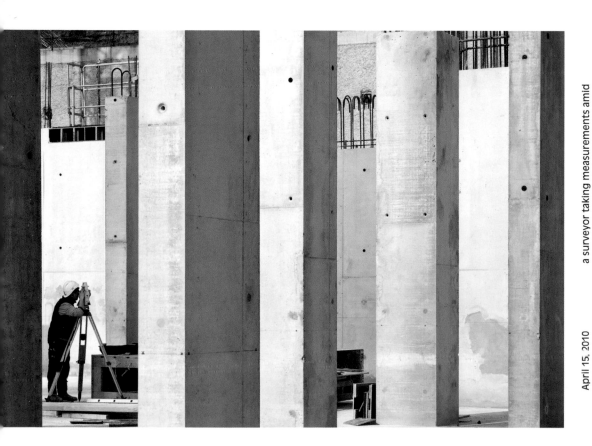

a surveyor taking measurements amid the concrete infrastructure.

April 15, 2010

January 28, 2011

form panels, scaffolding, and shoring add height to the work.

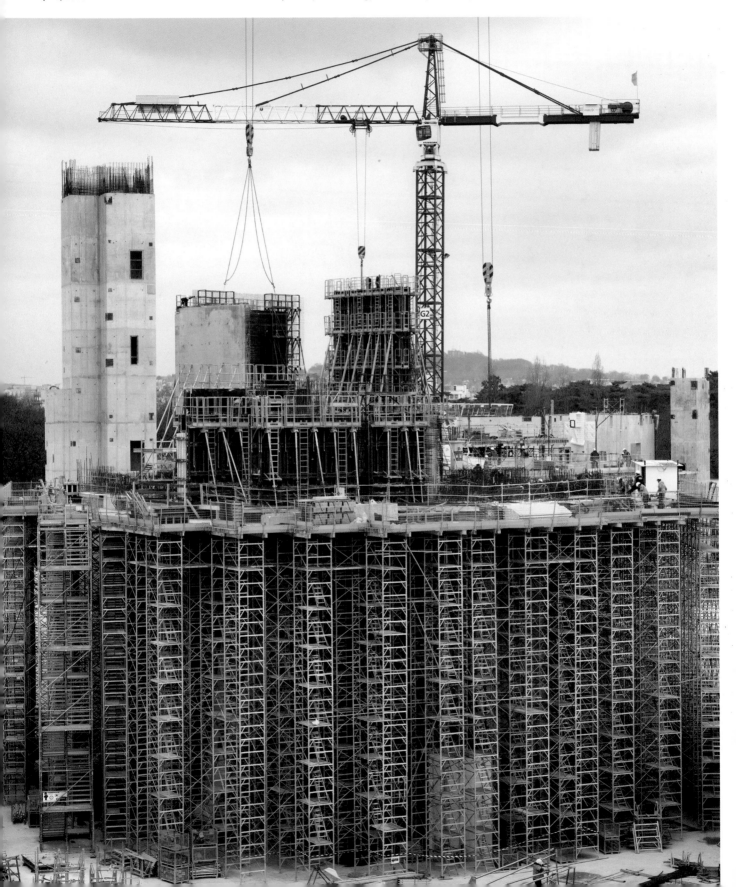

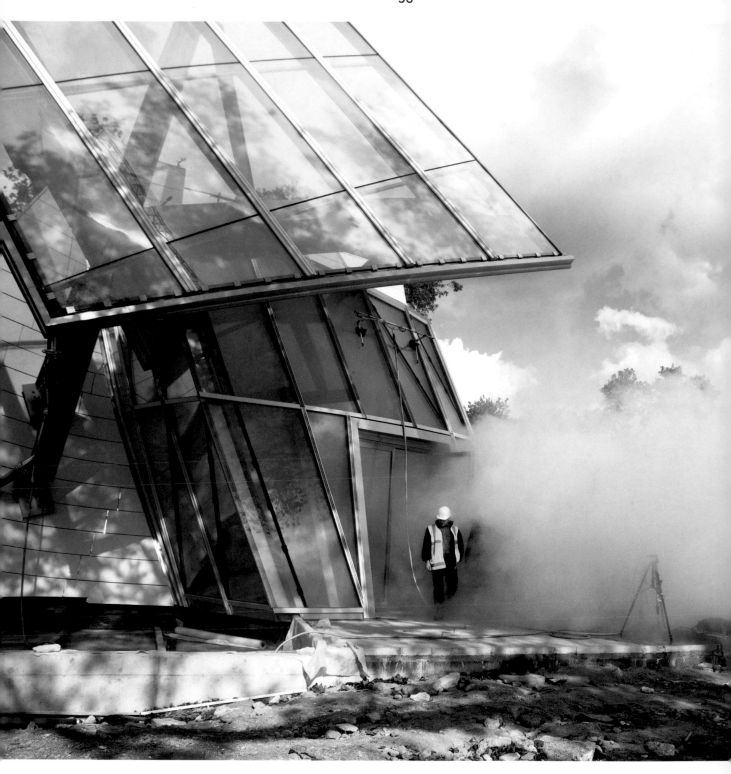

March 2012

the "*premier de série*" ephemeral prototype built on the edge of the construction site to validate
the choice of materials, building methods and, here, the tightness.

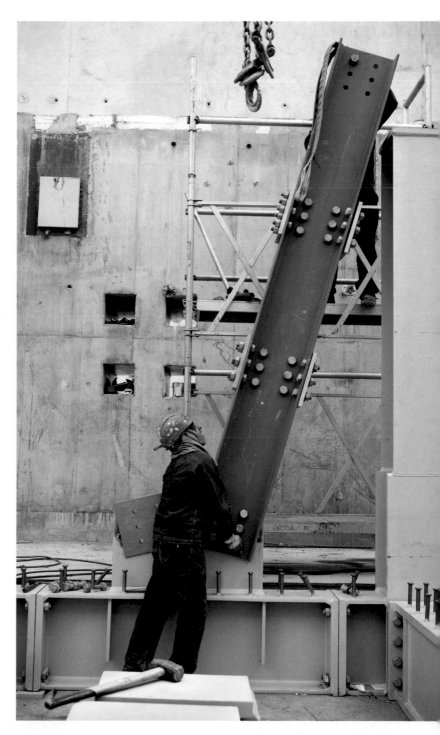

March 2011

two workmen adjust a metal beam.

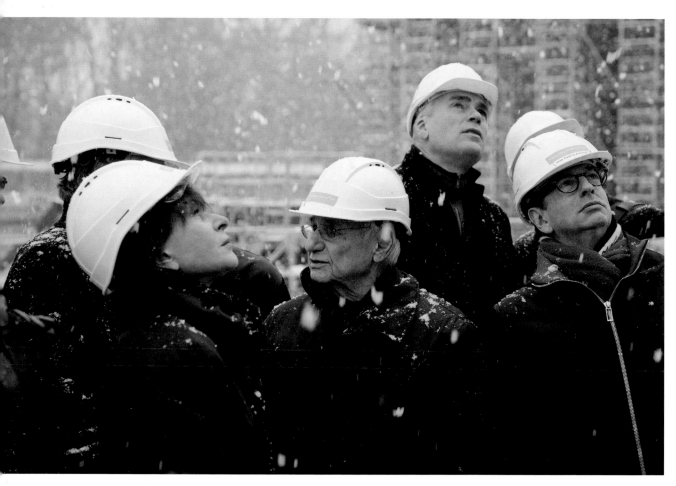

December 7, 2010

Suzanne Pagé, Frank Gehry, Bernard Vaudeville and Jean-Paul Claverie
visit the construction site.

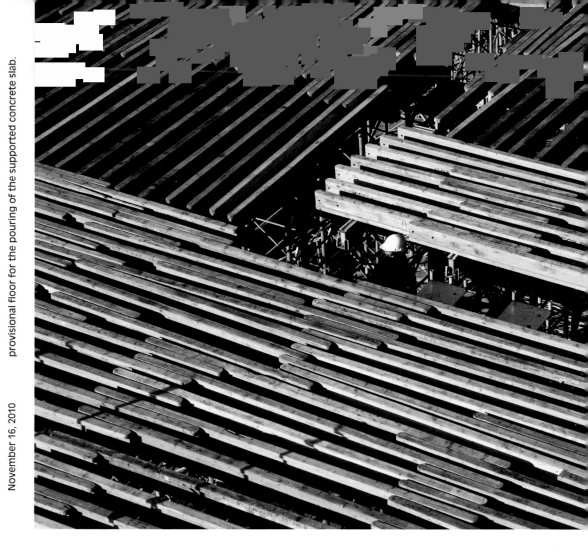

November 16, 2010 provisional floor for the pouring of the supported concrete slab.

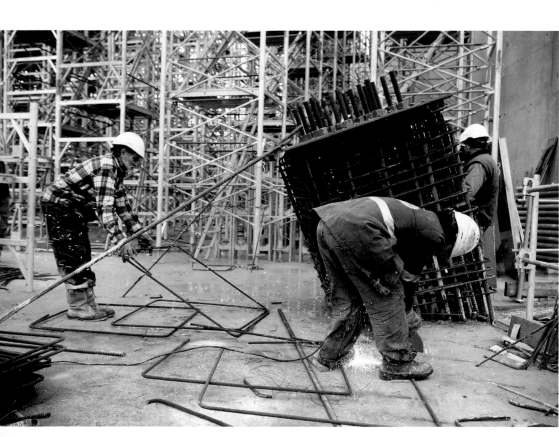

December 17, 2010 cutting out a part of the metal armature.

June 1, 2011

stainless steel insert forming the wood and steel assemblage in the glass roof,
made in the workshops of Eiffage Construction Métallique.

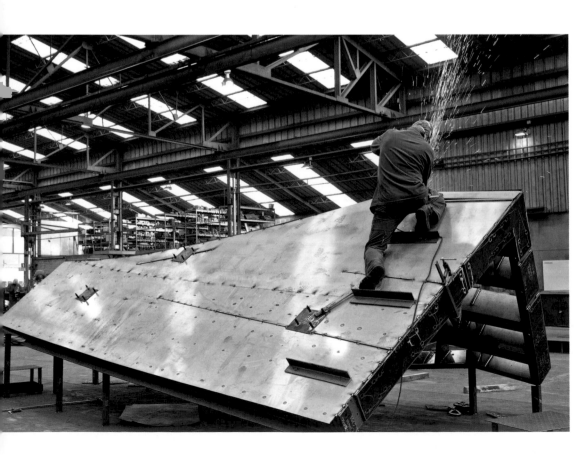

October 13, 2011

construction of an element of the facade
at Iemants, Belgium.

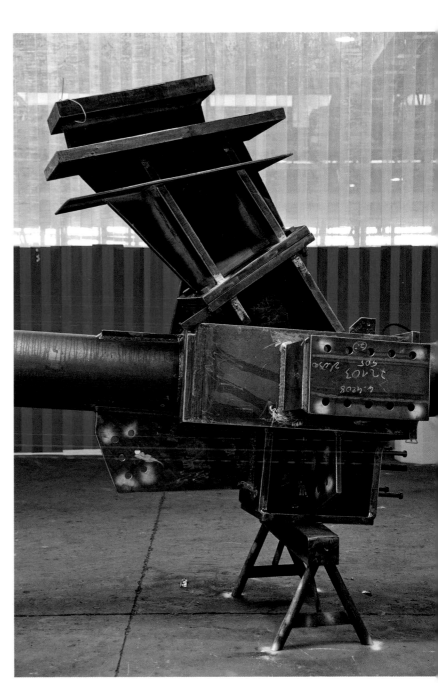

element for fixing the glass roof to the structures of the building.

October 13, 2011

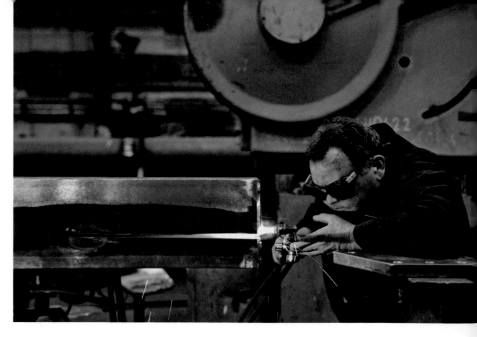

October 27, 2011

production of the secondary structure in steel for the glass facades in the Czech Republic.

May 21, 2012

Inspection of the 3,600 glass panels, one by one.

May 21, 2012

in the workshops of the Italian firm Sunglass, specialists in shaping glass: lamination in a sealed kiln.

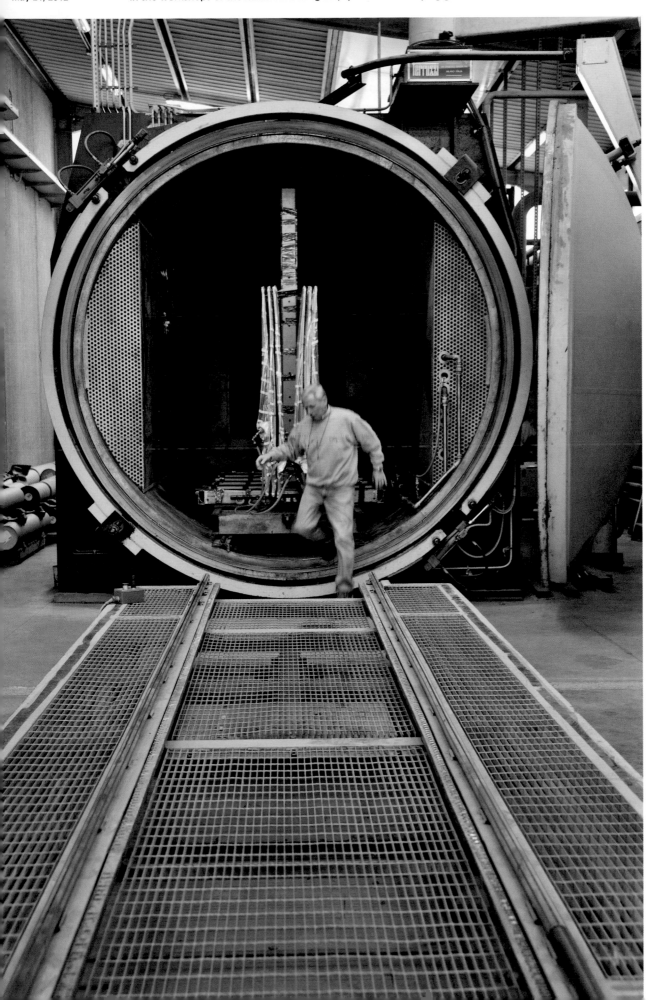

March 24, 2011

reinforced concrete sails of gallery 9, with inserts for installation of metal framework and ducts.

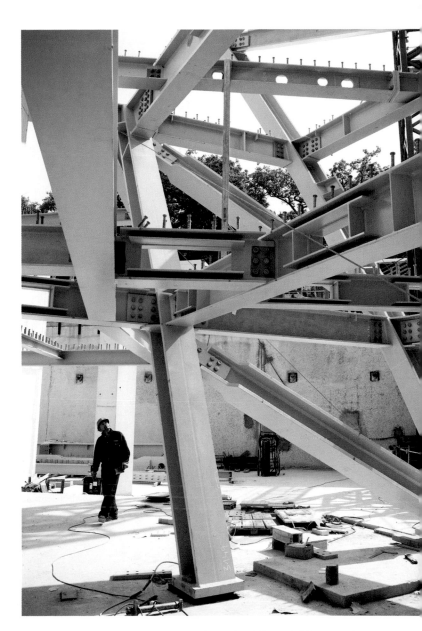

May 4, 2011 elements of the metal framework.

March 4, 2011

perspective through the building's future circulation areas.

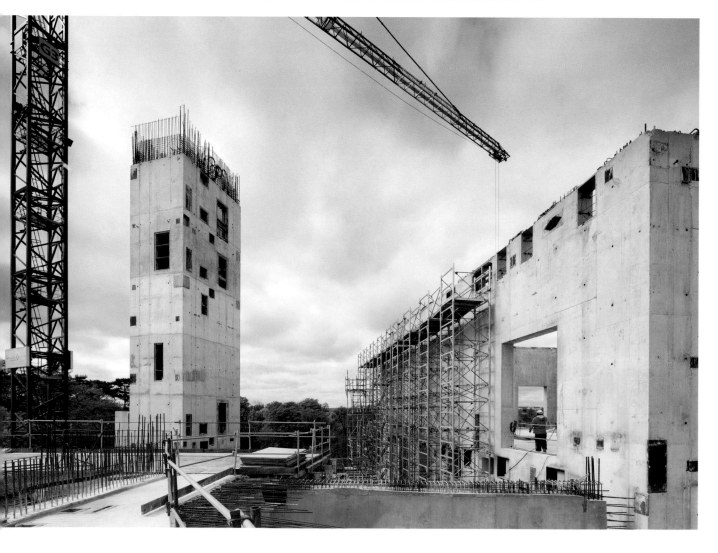

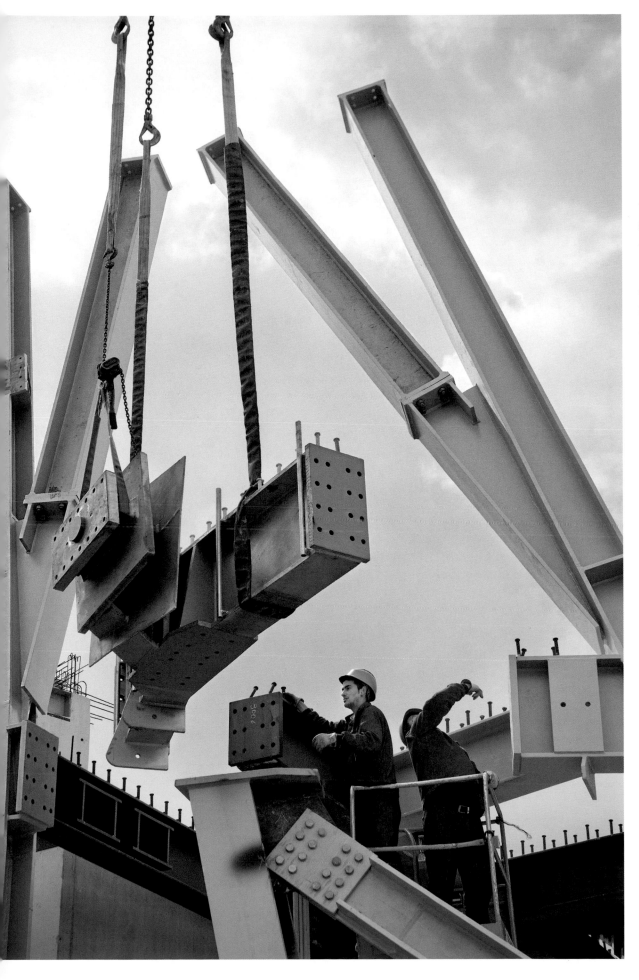

June 24, 2011

modeled using 3D software, made to measure, the pre-tripod must be fitted to the nearest millimeter. It is used to hang the glass canopy from the structural elements.

metal structures of the north facade.

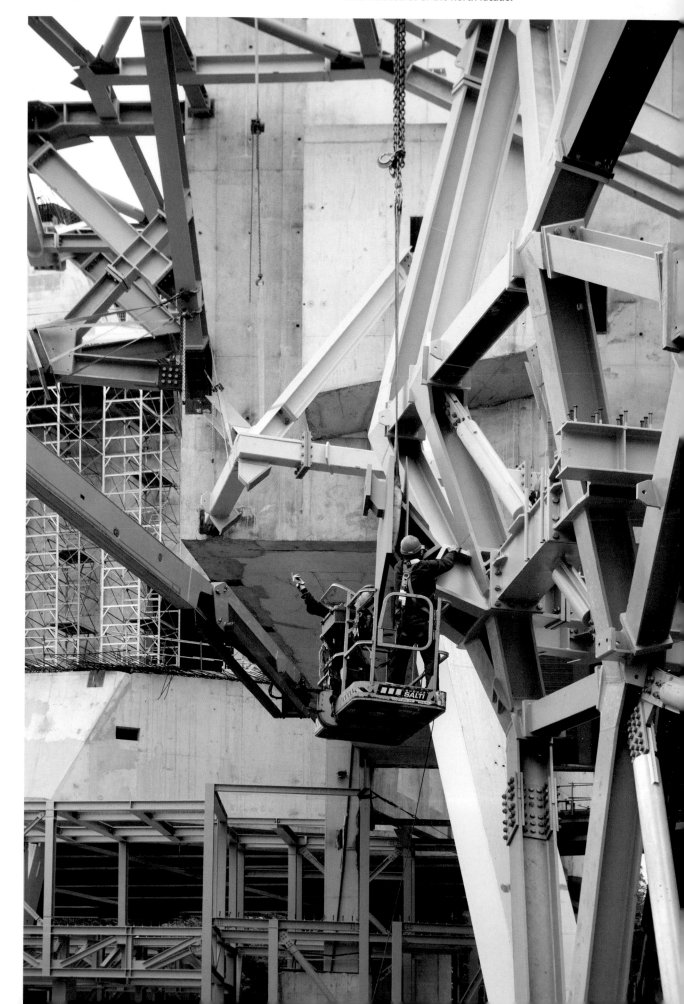

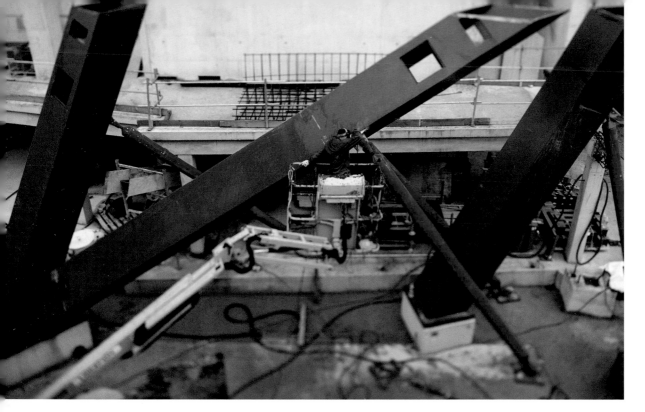

July 20, 2011 · installation of the angled posts, before construction of the floor that they will support. They are held in place by temporary bracing.

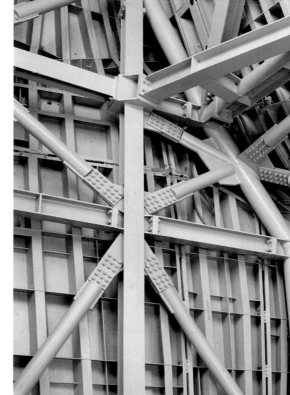

September 19, 2012 · the metal structures and steel shells on the inside.

June 24, 2011

view from gallery 5 with elements of
the metal framework.

the concrete structures define the Fondation's internal volumes.

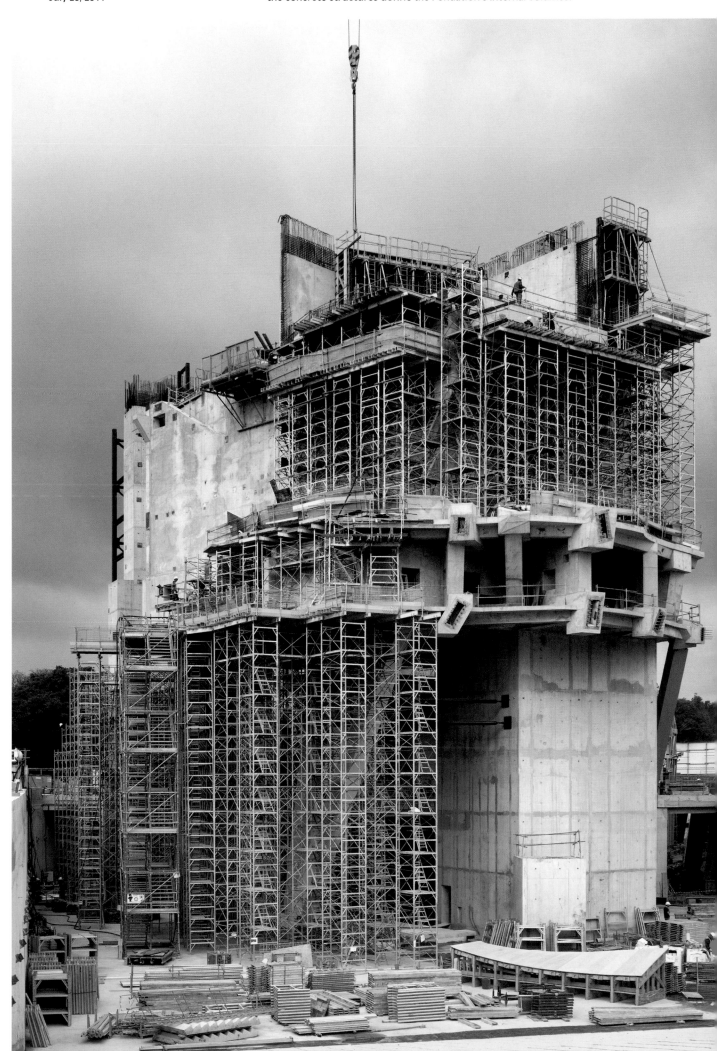

September 21, 2011

hanging of the facades in sloping planes, like putting together a gigantic jigsaw puzzle.

Charles Fréger, December 2012.

Charles Fréger, November 2012.

Charles Fréger, February 2013.

Charles Fréger, November 2012.

A UNIQUE ADVENTURE

Christian
Reyne
—Executive
director,
Fondation
Louis
Vuitton,
in
charge
of
project
management

Louis Vuitton has commissioned many prestigious buildings from the world's leading architects, but the creation of the Fondation Louis Vuitton still stands out as a unique experience, the collective product of an inventive and innovative work process.

We knew, when the models for the new building were officially presented in Paris in 2006, that it would really challenge all our methods. An architect on the other side of the world, Frank Gehry, had dreamed up a white glass cloud, floating on the edge of the Bois de Boulogne. Lightness and transparency were its substance, innovation and daring its doctrine. To faithfully create such a work meant jettisoning old ways and certitudes. Everything had to be reinvented, even our working methods.

Jean-Pierre Barillet-Deschamps. Erecting a contemporary construction in this favorite Parisian spot was quite a challenge.

Thanks to a precise study of the Jardin d'Acclimatation, we steeped ourselves in the special history of this wooded area west of Paris. From the outset, our thinking about this project took into account the building constraints and the need to enhance the landscape, including its paths, circulation routes, vistas, and planting arrangements.

In studying the intentions and realizations of the designers of the Bois de Boulogne, we inevitably took a fresh look at the existing buildings and questioned the utility, aesthetic quality, and legitimacy of each one. And because there was a statutory limit on the number of square feet that could be built, this study enabled us to determine which buildings were sufficiently lacking in interest to be demolished. In this way we were able to obtain the building permits needed for the new construction while respecting the original constraints limiting us to one storey (G+1), but without height limits.

Taking on board these regulatory imperatives, Frank Gehry created a unique building, a composition of forms. A building team of some twenty people got down to work at once. This score of men and women was soon a hundred, as Setec and RFR + T/E/S/S engineers and implementing architects from Studios Architecture with the participation of Quadrature Ingénierie got to grips with the construction of this unique building.

TAKING THE ENVIRONMENT INTO ACCOUNT

Constraints linked to the choice of site necessitated an extremely precise analysis of the historical, heritage, and administrative parameters. The Bois de Boulogne is a mythical site, conceived and realized in the nineteenth century in accordance with principles laid out by Jean-Charles Alphand and

INNOVATIVE ORGANIZATION

Before defining the project in greater detail, the team studied the technical development and the feasibility of the glass curves, while assessing the companies that might be able to construct them. In the process, the methods of conventional building were turned on their head.

This new approach engendered innovation, but also meant a longer conception period, gave rise to a new way of organizing the work called the "fundamentals phase." This intermediary phase involved deciding on the main

principle of the building's conception, notably the structural elements, the use of geothermal heating, and the distribution of fluids by means of radiant floors. It made it possible to fix certain parameters of the construction in order to move the project forward without having to wait for the finalization of the studies.

It was soon clear to us all that we needed to work together to direct these studies on a day-to-day basis. This onus on efficiency produced a novel form of organization: all those working in the building group came together and worked on a single digital 3D model which we shared in real time.

The realization of this project was an extraordinary technical feat, but also a magnificent human adventure in which each person carved out his or her own place. Thus the general contractor, bolstered by the strength of its knowhow, supported the architects and engineers with its experience, just as the architects and engineers enriched the expertise of the general contractor. This permanent interactive inventiveness is without doubt one of the key factors in the project's ultimate success.

BESPOKE MANAGEMENT

In this effervescent world, where even the tiniest change in a building program can trigger a cascade of new studies, bold new proposals still emerge, whether by chance or by necessity.

Sometimes, when the clock is ticking, you simply have to act. In late 2008, before all the studies had been completed, the decision was made, based on this collective method, to start work. A rash act or reasoned boldness? The endless back-and-forth of machines was set in motion, the work site came alive. The project was taking shape.

At each phase of construction, the intelligence, mental flexibility and adaptability of each participant was mobilized in order to ensure the success of this unique experiment. It is something that fills all the teams involved with great pride, not only because they contributed to this extraordinary undertaking which has given Paris a new and important contemporary building, but also because they have experienced one of those unique adventures that are a highlight of any career.

3D: AN AVATAR OF DRAWING

Alex Kunz, Thomas Maigne, and Andrew Witt —Gehry Technologies

Gehry Technologies was founded in 2002 to transform the construction industry by helping to develop creative, innovative approaches to organization, process, and technology.

The role of technology in Frank Gehry's work is at once central and peripheral. The use of 3D modeling software has become common practice since his creation of the "Fish" in Barcelona and the Guggenheim Museum in Bilbao. These technologies facilitate the manipulation of complex geometry and help control the cost of projects that are increasingly ambitious.

engineering and construction teams all work around this one digital model.

Not only did this new tool bring another dimension—the famous, traditional "Z" to "X" and "Y" of the plan—but it also demonstrated the effectiveness of new working methods, involving greater collaboration between architects and engineers.

The project and its demands thus opened up considerable fields of innovation by making the most of 3D modeling's potential for geometrical optimization, automation of engineering, and the generation of production data. It encouraged the young engineers and architects to move toward an engineer-builder role, using an instrument (3D software) to process an unusually high quantity of information.

During the conception and construction phases, the Fondation benefited from two kinds of collaborative platform, one physical, in the form of a hub of open-plan offices in central Paris, the other virtual, in the form of a database managed by Gehry Technologies, allowing the convergence of design data around the digital model.

THE SPIRIT

Computers don't play a role in Gehry's creative process, which is based essentially on sketches and physical models. Computer modeling technology and methods do, however, further the description and realization of ideas, as shared between the various participants in the construction of the building.

The architects at Gehry Partners have adapted CATIA, the 3D aeronautical software developed by the French company Dassault Systèmes, to the requirements of conceiving and constructing buildings, while at the same time developing a unique approach to the application of digital technology to architecture.

The Fondation Louis Vuitton and its architect provided an opportunity to radically innovate in the field of 3D modeling and collaborative design. They decided to put the 3D model at the center of the project, right from the first sketches, requiring that the design,

AN ATYPICAL WORK ORGANIZATION

The initial digital maquette was elaborated by scanning the physical maquette created by Frank Gehry in his studio in Los Angeles. This primary digital reference model, comprising nine files, formalized the architectural intention.

During the next phase, architects and engineers took on the conception of the project in Paris. It was now that a growing number of professionals in various fields started working around the digital model, and it became necessary to have a method for organizing the information. In digital logic, what is data output for some becomes data input for others.

The input for the design model comprised on one side the reference model from the Gehry Partners studio and on the other the know-how of the contributors to the construction process. The design model was made by a team of over sixty people and comprised some 1,500 digital files.

When the construction process began, the design model was elaborated into an execution model, enabling the builder to manage the project and its complex supply chain. The execution model resulted from enhancements made to the design model by the contributors from the Vinci company and its subcontractors. It comprised 190,000 digital files, representing the work of over 300 men and women. Numerous data were thus exchanged by the makers of the building. The design and execution models remained living entities, evolving in relation to each other and in keeping with the progress of the project.

The digital model contains 3D objects but also the various attributes, including status, activities of public works, geometrical mathematics, or the representation and management of the project. It is therefore necessary to be familiar not only with digital logic but also with the methods specific to each field.

Given the number of contributors, the quantity of data and information it contains and the many different developments of the project, the scope of the digital model is beyond any one person's grasp. This complex system based on a potentially infinite, constantly mutating model, immediately necessitated the creation of a simple information structure, at a stage when no one could have predicted the final level of information.

The information was structured so as to be able to accommodate each new contributor, essentially in keeping with a spatial division of the project and the timetable for future intervention by the different companies.

COMPLEXITY AND SIMPLICITY

There are two opposing, complementary logics here. The first is a logic of simplicity, which prevails when putting in place a tree structure with a stable framework, in which everything has its place and name in accordance with a precise naming convention. This is a hierarchical and rigid information structure for the project as a whole.

The second is a logic of complexity involving data that is generated, altered, and destroyed. Each element possesses its own relative position in the framework.

The engineer's working environment was thus profoundly changed. Whereas he was in the habit of concentrating all his energy on a problem arising within a fixed, finite environment, here he found himself working with infinite, continuous information. From now on, he would conceive and model on actual scale (1:1) in the software. The digital model obliged him to be closer to reality, whereas the 1:50 and 1:100 of classical plans allow only approximations.

He therefore had to invent new approaches to his profession. The first was granularity. His environment was no longer a sheet of paper with a pre-determined scale, but a landscape with multiple dimensions (geometry, construction methods, time, objects) through which he had to plot his own path.

The 3D software Digital Project used on the project and developed by Gehry Technologies offers a new way of describing a project through a logical sequence of geometrical constructions. Description focuses on the logics of the object, and not on a fixed representation of that object. At this stage the object is generic: it can adapt to any context that meets certain conditions. In this process of description, the frontier of the object emerges, its input data and properties become clear. A given item of knowledge, in the form of a function or rule, is integrated or externalized. Once the object is created, it must be named and related to the other objects, entering their life cycles, since all are going to be modified and transformed as the project proceeds.

Even before describing the digital objects, it was vital to have close collaboration between all the different participants: the architect at Studios, the engineer at Vinci, the industrial producers at Bonna Sabla and Sunglass. This multi-angle approach underpinned the drafting of each object's specifications.

It was now that we could start creating our components. Their nature could be diverse: physical objects, classes, relations, parameters, optimizations, rules, and

objects that clone other objects (knowledge patterns).

Once these generic components were created, they could be duplicated within the project model. Each component would then be adapted to its context.

Once "instantiated" in this way, cloned from a model, the computerized object is able to autonomously "receive, stock, process and emit" information, without human intervention. That is to say, it becomes a living object, in accordance with the definition put forward by Michel Serres.

From now on, each object evolves in keeping with a rhythm adapted to those contributing to the project, and the dialogue between all the different objects shapes and modifies the project. The model gains in precision and in turn provides new information.

FROM THE DIGITAL TO THE INDUSTRIAL

The Fondation project initiated a space for the mass-production of bespoke pieces. The conception of the project and all its objects had to integrate industrial processes and their requirements as early as possible. As for the industrial contributor, he had to adapt his own logic to the variability of the pieces to be produced and find repetitions even within all these differences. Each product to emerge from his production processes was unique.

Digital modeling became the bridge between the industrialist and the architect. Conception was broken down into as many phases as needed for the final digital product to translate directly into the industrial process. This is why the many constraints of industry impact and inform the design process.

This constant back-and-forth made it possible to create objects that were not at first exact and to allow the system—in the form of both automatic and human interventions— to progressively advance them into increasing levels of detail.

These various operations were made possible by putting in place the "virtual" platform of the pyramidal information structure and by recording each object at a single address.

Gehry Technologies concentrated on the industrialization of repetitive processes and the application of automated routines. By automatically controlling the characteristics of every object in the maquette, and by transferring the data to specialist professional softwares, the architectural and engineering teams both saved much time and also made considerable quantitative gains.

One of the benefits of the Digital Project software is that it allows the production of large quantities of bespoke generic objects. As soon as an object was stabilized, the architects and engineers applied considerable computing resources to its execution. Over a hundred routines were developed to automate geometrical optimization, statistical analyses, updated data distribution, and digital cleansing. It was a vast system, comprised of hundreds of thousands of objects, properties, and life cycles, all constantly interacting.

This set of living objects within an environment of diverse actors represents a new art of building, implemented specially for the Fondation Louis Vuitton.

THE MATERIAL

The "Iceberg" is the nickname given to the unusual white façade of Gehry's building. This non-standard project is made of steel shells covered with a succession of layers: insulation, water proofing, aluminum, and white outer panels in Ductal. Ductal is an "ultra-high—performance" concrete made from sand, cement, organic fiber, and water. It is factory cast in order to ensure proper quality control. Working in partnership with Lafarge and Bonna Sabla, the RFR + T/E/S/S/ design studios defined the characteristics of a ductal panel based on certain rules of geometry, structural performance, hanging, and adjustment, as well as a remit for its production process.

The construction site also generated its own share of constraints: short lead times and limited storage space necessitated a real-time approach to design, manufacture, and delivery.

While each ductal panel is unique, their industrial production necessitated repetitive processes. The designers were informed of these production criteria at an early stage so that the digital files could be directly conveyed to the machine tools. Each file contained the exact description of each panel.

GUIDELINES

Even if two of the 19,000 panels produced could be identical, the industrial producer decided to treat them all as unique, in order to deliver each one just in time, in the order of assembly. The panel was translated into a set of data taking into account the industrial production process and the ongoing evolution of the building itself.

The drawings were then industrialized and a computer bridge put in place between the project, the construction site and the factory, in order to precisely describe the 19,000 Ductal panels, with each description containing the set of information needed for production: in addition to the traditional "physical" description (height, width, curves), the file incorporated computerized metadata, ensuring the smooth implementation of operations—details such as the order of assembly of the panels.

Gehry Technologies then went about orchestrating the system for industrializing information. The Iceberg was broken down into "works," that is, nineteen specific parts, based on the general model, and corresponding to the volumes assembled by Frank Gehry.

These works were themselves broken down into 452 surfaces, deriving from a 3D scan of the physical model. The initial task was to convert the clouds of dots captured by the 3D scanner into mathematically defined developable surfaces (surfaces that can be created from a curved sheet of paper), then to define their borders, which often corresponded to the intersections between the different surfaces. These defined surfaces were used as a shared reference and vocabulary by the engineers and the industrial partner.

The architect defined the panel joints in an "earthquake" pattern, so called because of the visual effect evoking post-seismic cracks, as well as the overall specifications for each surface.

Working from these guidelines, Gehry Technologies drew the parallel lines and their perpendiculars, defining a preliminary breakdown into 19,000 portions of surface in space and serving as the basis for the unitary objects to be produced by the industrial partner.

These units were comprised of Ductal panels together with the aluminum or stainless steel fittings for their assembly on the facade and on whatever structural consolidations were necessary. These reinforcements were planned in such a way that the Ductal could bear the weight of rope teams who might intervene for maintenance purposes.

The panel, its fasteners, the rails, and the reinforcements became generic digital objects. To create a generic object is to define it in terms of its parameters but without drawing its form; it is, in a sense, to make it abstract. Each object was then named and defined by its perimeter, its geometry in space, and by a set of complementary parameters.

Our initial data were thus the architect's curved surfaces, the plane dimension of the standard panel, its thickness, the width of the hollow joins, the difference between one row and another, an angle of inclination, and a starting point.

Zones were created capable of supporting fasteners while maintaining the structural capacities of panel overhang, and integrated into the digital wireframe model.

The generic objects were then automatically instantiated 19,000 times on these wire frames and surfaces drawn in as many versions as there were contexts.

On the project as a whole there was a real financial onus on maximizing the ratio of flat panels, which are less costly to produce, to curved ones. Geometrical analysis of the 19,000 panels made it possible to accompany both the builder and client in defining the criteria for "flattening" the surfaces, corresponding to the thresholds on the basis of which a highly curved panel could be made flat without the eye being able to identify this geometrical approximation once the panel was integrated into the facade. The software was used to analyze this geometrical information across the project as a whole, but without being part of the 19,000 3D objects. The technological feat in this instance consisted in finding the

right level of geometrical information (forms, characteristics) for each object created: neither too little nor too much, so as to make the most of the capacities of the 3D software without encumbering the work of conception.

Once the criteria were defined, each panel could be analyzed and detailed (curved or flat) after its instantiation.

Fifteen percent of the objects (Ductal panels and fastenings) were nevertheless viewed as particular cases and were not automatically instantiated. The builder and the Vinci company designed these elements specially. Several people worked on these surfaces with both manual and automatic tools. Some objects were removed, others merged, yet others created. This kind of process makes it possible to refine the model step by step.

During the last phase of data production, families of objects (rails, fasteners, reinforcements) were brought together in order to provide the manufacturer with all the information needed to produce each of the 19,000 panels, making it possible to launch production of the geometrical fabrication data. The industrialized drawing production system made it possible to connect all the different specialists working on the project.

ON GLASS AND MATHEMATICS

Bending, deforming, and shaping glass in order to achieve the result sought by the artist constituted an unprecedented challenge. No one had ever attempted to make a curved glass facade on such a scale with a structure capable of resisting buffeting from the wind, rain, and snow. Each of the 3,600 pieces of glass was cut and bent to measure, the difference from the previous piece sometimes no more than a few millimeters. In fact, the whole building is an haute couture realization in which every element, down to the smallest detail, was exactingly tailored.

Gehry Technologies created a model that provided the geometrical logic and integrated all the requirements of the facade engineers (RFR + T/E/S/S) and glass fabricators (Sunglass). Close collaboration between all these players made it possible to simulate on a massive scale the geometric optimization of the glass facade.

The rules proposed by RFR + T/E/S/S took into account the slightest details of the construction and set margins of only a few millimeters for the construction of each panel. These rules also defined the details linked with adaptation to a series of structural supports for the glass roof, among them connections to the primary structure, high-precision yet flexible mullion details, and specifications for the compression rods holding up the entire glass assembly.

Sunglass, the glass fabricator, provided invaluable theoretical and empirical expertise on the behavior of glass. They also provided a unique CNC-controlled machine that could bend large sheets of glass to any cylindrical radius. This remarkable machine made possible the creation of 3,600 unique panels in an efficient, industrial way. Each panel was constituted by two curving sheets of glass. The machine consisted of a computer-driven mold, able to create glass cylinders of any radius and orientation. The transformation of the unitized panels into cylinders—or, later, bi-cylinders—was a significant challenge in the mathematical simulation of the project. A method had to be developed for producing cylinders as close as possible to the underlying form.

Gehry Technologies therefore translated the ambitious design into a series of specific construction methods compatible with the machine tools used for the project. This mathematical shape optimization process was quite intricate, involving as it did simulation around multiple objectives capable of computationally testing millions of alternate shapes in order to achieve a perfect balance of design intent and constructability. Over forty simultaneous variables were embedded in intelligent digital models of the glass facade. The design team employed never-before-used statistical methods to simulate glass construction, to balance the requirements of external constraints, and to calculate the perfect solution.

A key to the success of this complex optimization process was the collating of the design rules of the architects, engineers, and fabricators into a common database of mutually interdependent constraints. This database constituted a form of artificial intelligence,

128 able to immediately alter the geometry of the glass design in response to global design changes. The database also facilitated the automatic creation of downstream documents to accelerate and automate fabrication. It encapsulated the intelligence of the entire project team, in digital form.

The result of this happy marriage of art and science is a building unlike any other. Its glass facade is a superb showcase for the most sophisticated methods of design simulation and fabrication. The process for creating these glass sails was the outcome of the successful melding of design, science, and fabrication.

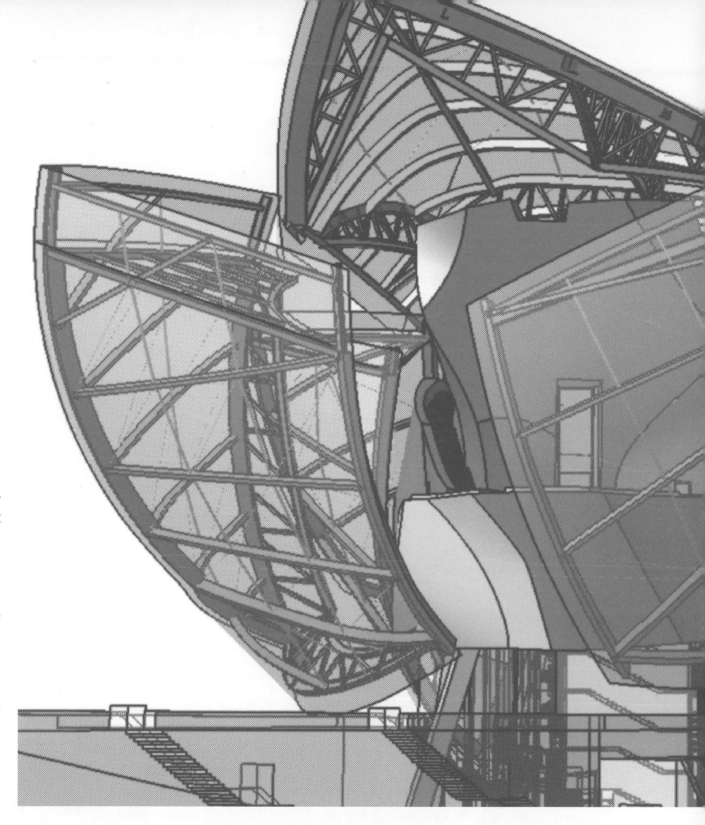

Conception model built by a team of over sixty people.

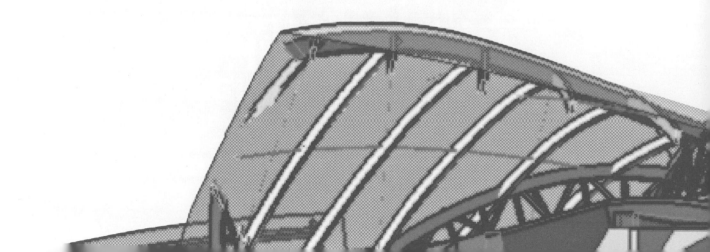

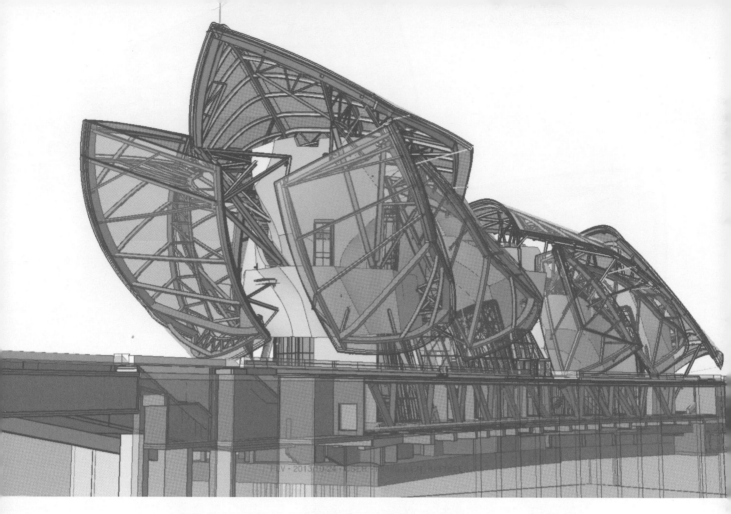

Execution model made by the company. More than 300 people worked on this model.

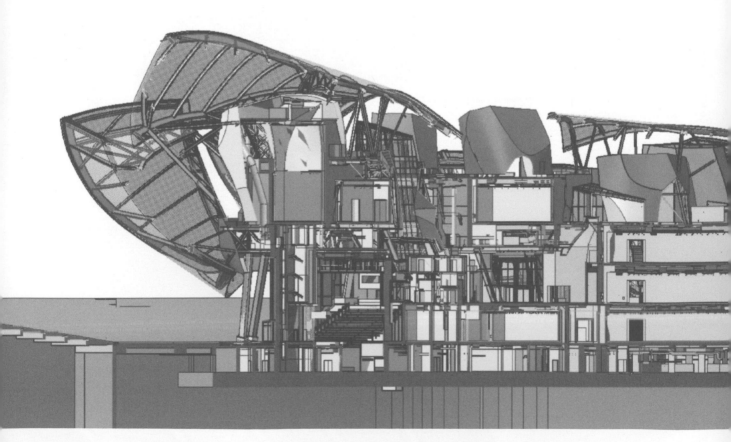

The model describes the facades of the building, the inner spaces, and all the technical lots.

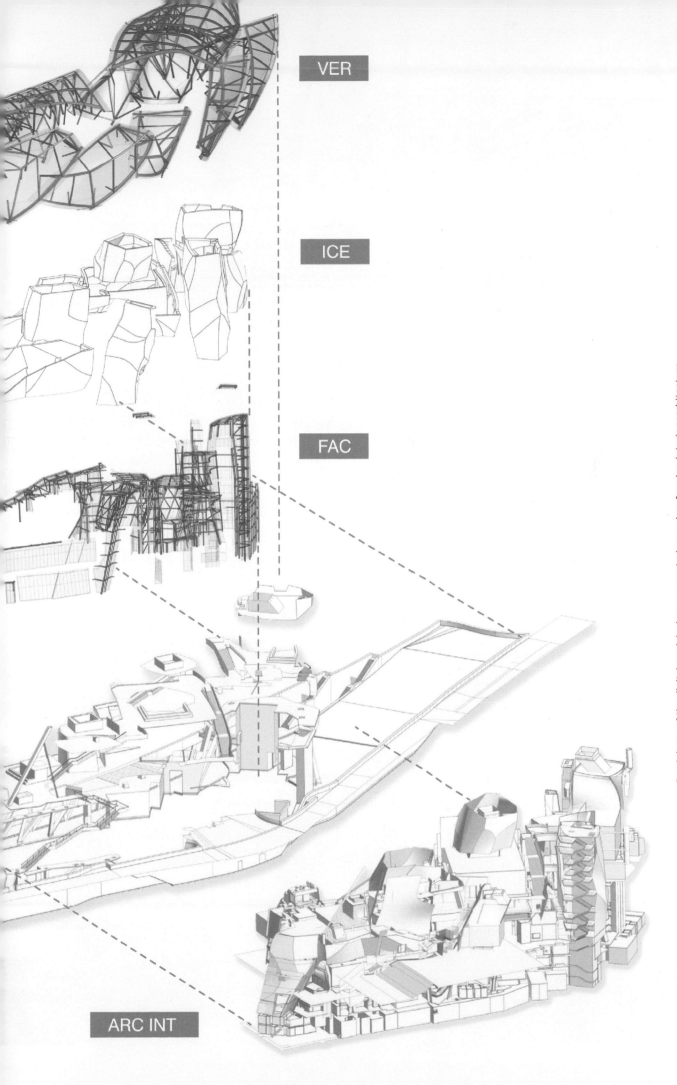

VER

ICE

FAC

ARC INT

Breakdown of the digital model: glass canopy, Iceberg, glass facades, interior architecture.

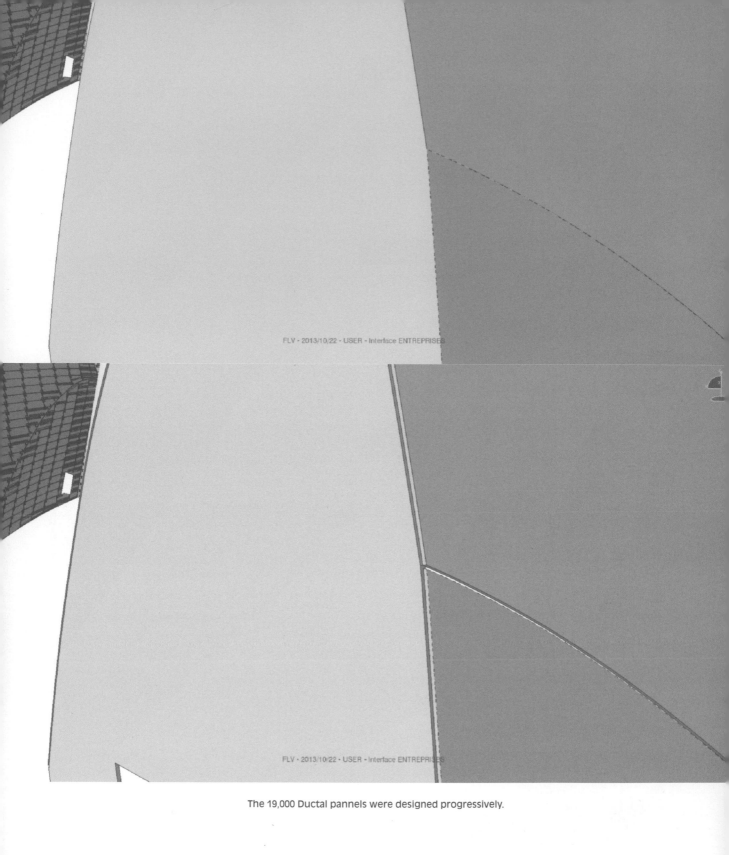

FLV · 2013/10/22 · USER · Interface ENTREPRISES

FLV · 2013/10/22 · USER · Interface ENTREPRISES

The 19,000 Ductal pannels were designed progressively.

The digital environment is infinite and continuous.

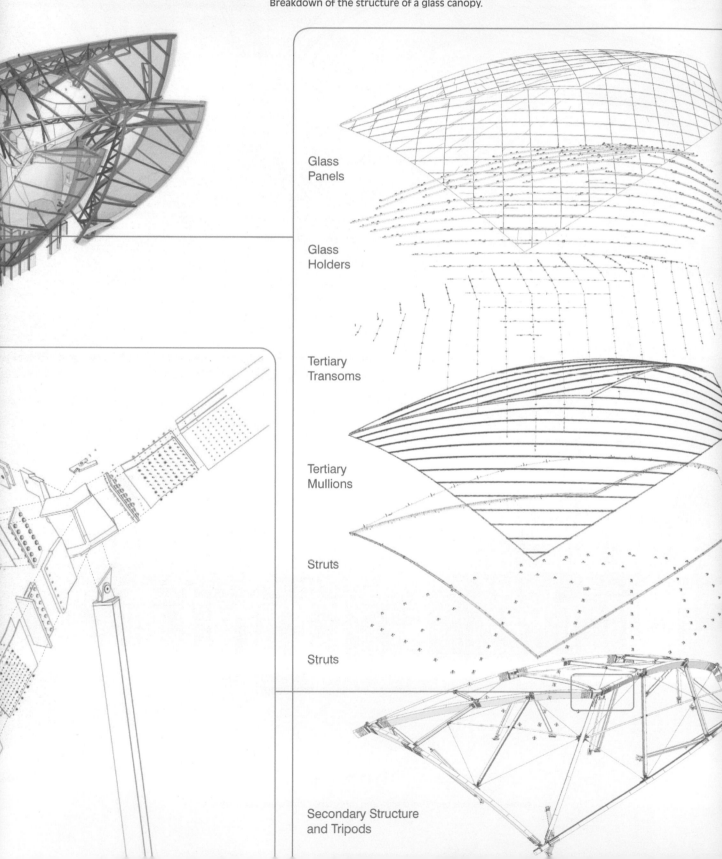

Breakdown of the structure of a glass canopy.

Glass
Panels

Glass
Holders

Tertiary
Transoms

Tertiary
Mullions

Struts

Struts

Secondary Structure
and Tripods

The single points can be hand-drawn and integrated into the overall model.

The 3D model makes it possible to synthesize all the details and organize the work of each trade: cladding, glass, rails, stone surfaces.

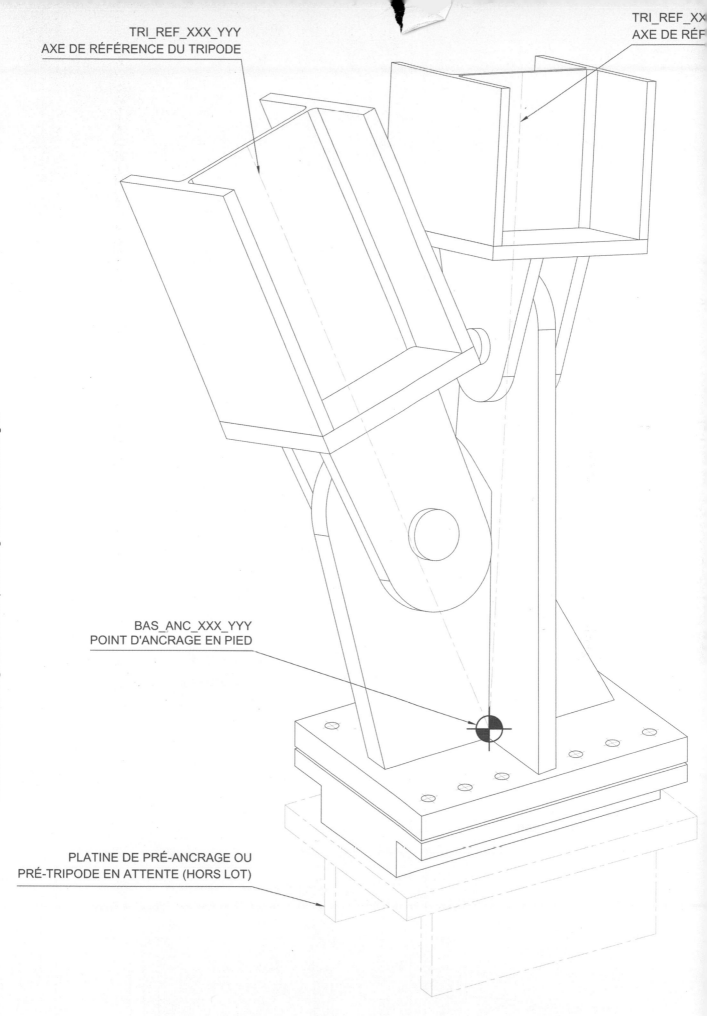

TRI_REF_XXX_YYY
AXE DE RÉFÉRENCE DU TRIPODE

TRI_REF_XX
AXE DE RÉF

Detail of a double anchorage with two interpenetrating brackets at variable angles.

BAS_ANC_XXX_YYY
POINT D'ANCRAGE EN PIED

PLATINE DE PRÉ-ANCRAGE OU
PRÉ-TRIPODE EN ATTENTE (HORS LOT)

Détail 1: bi-ancrage Géométrie type G2
1
ECHELLE NA

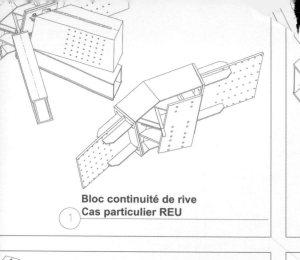
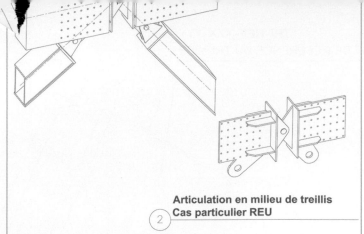

Bloc continuité de rive
Cas particulier REU
1

Articulation en milieu de treillis
Cas particulier REU
2

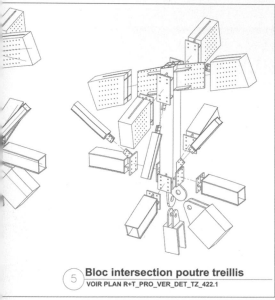

Bloc intersection poutre treillis
VOIR PLAN R+T_PRO_VER_DET_TZ_422.1
5

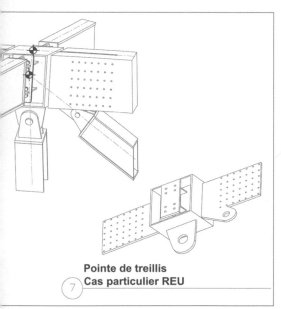

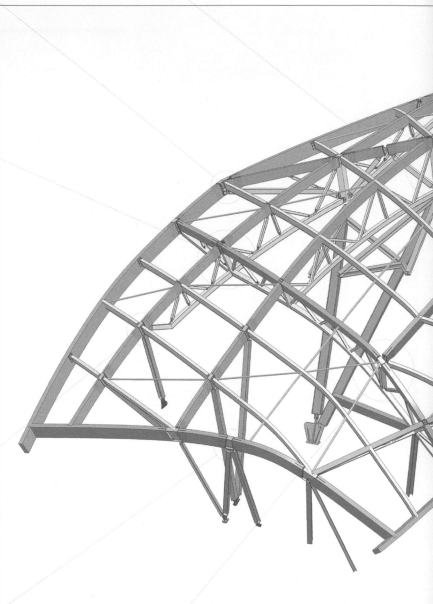

Pointe de treillis
Cas particulier REU
7

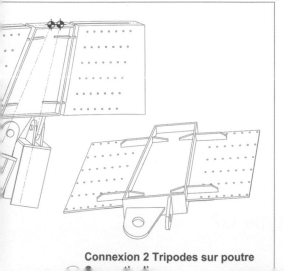

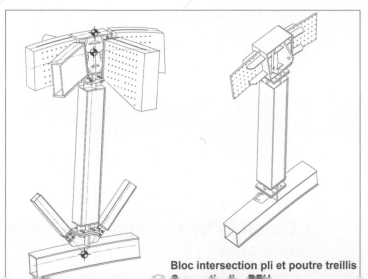

Connexion 2 Tripodes sur poutre

Bloc intersection pli et poutre treillis

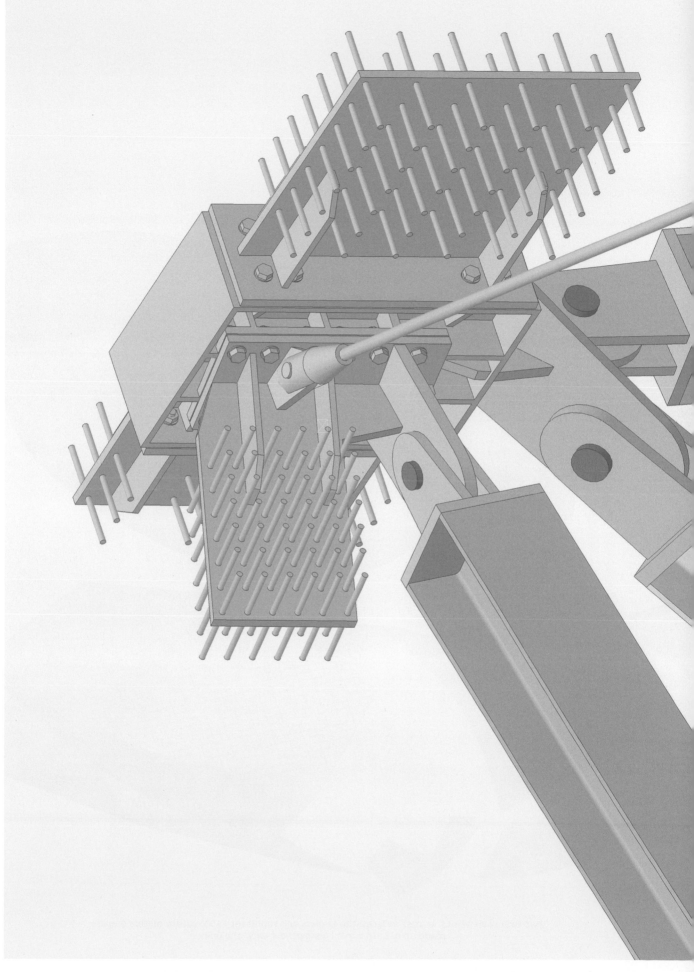

Plan identifying the typologies of secondary connections between the lattice beams of the REU glass.

Steel-wood panel joint. Here, a 3D image of the steel part of the assemblage.

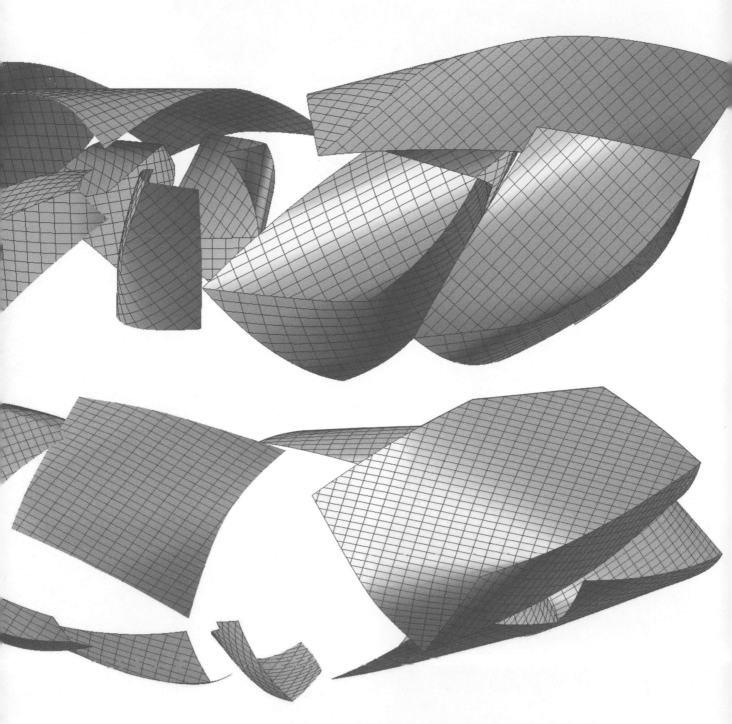

Two overall views of the glass surfaces: the 12 glass sails represent 13,500 square meters of glass
made up of 3,530 curved glass panels, each one unique.

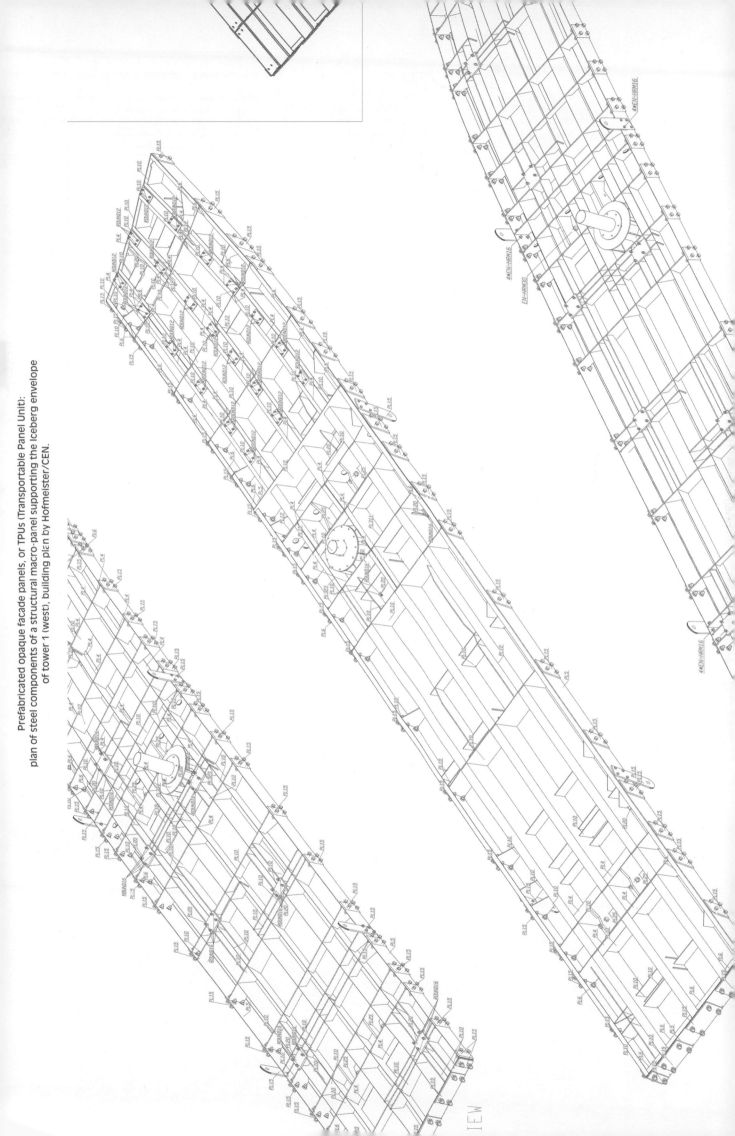

Prefabricated opaque facade panels, or TPUs (Transportable Panel Unit):
plan of steel components of a structural macro-panel supporting the iceberg envelope
of tower 1 (west), building plan by Hofmeister/CEN.

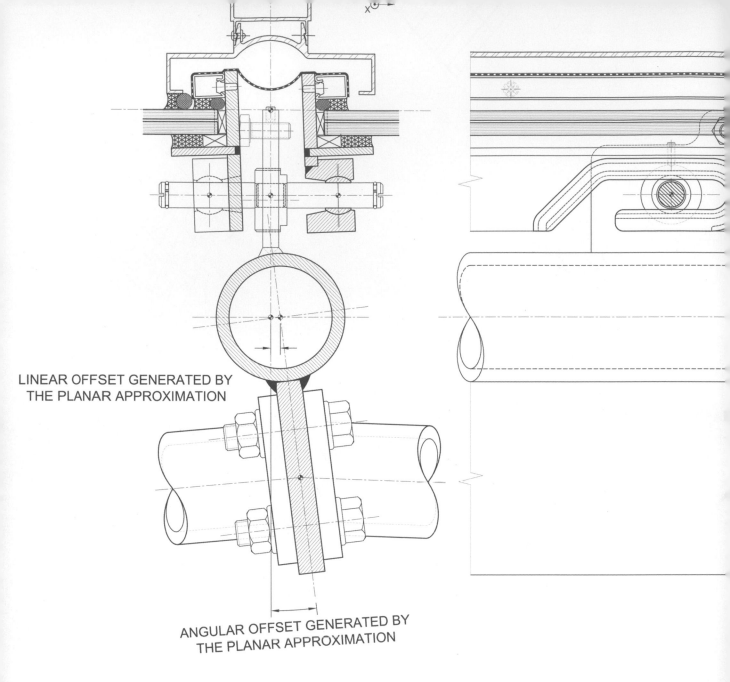

LINEAR OFFSET GENERATED BY
THE PLANAR APPROXIMATION

ANGULAR OFFSET GENERATED BY
THE PLANAR APPROXIMATION

Detail of fastening of a glass panel: sliding, articulated assemblage allowing the panel to float in its plane,
without interacting with the neighboring panels, whatever its curve and orientation in space.
Left: cross section; right: longitudinal section.

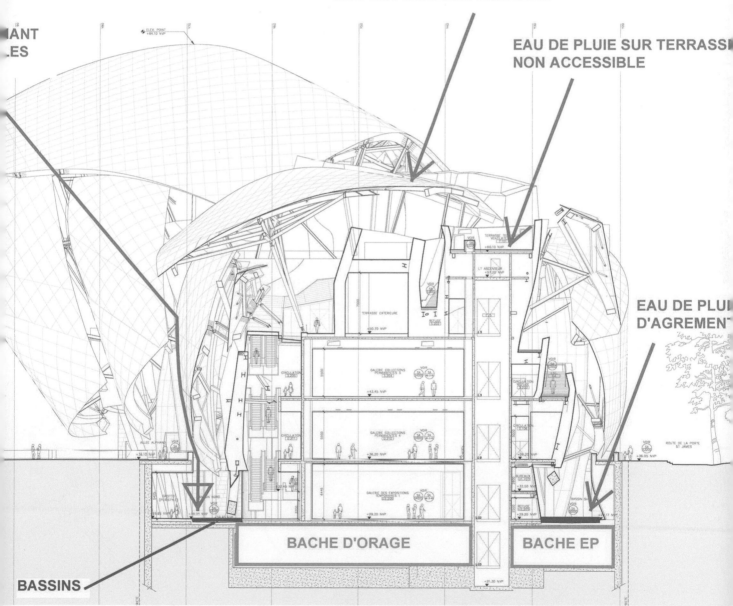

EAU DE PLUIE SUR VERRIERE

EAU DE PLUIE SUR TERRASSE NON ACCESSIBLE

EAU DE PLUIE D'AGREMENT

BASSINS

BACHE D'ORAGE

BACHE EP

Rainwater drains from all the surfaces towards tanks, where it is treated and filtered for reuse.

Floor plan of the Fondation

THE
INVENTORS

Bernard
Vaudeville
—Deputy
director,
T/E/S/S

Philippe
Bompas
—Architect,
RFR

Matt
King
—Deputy
director,
T/E/S/S

Africa
Garcia
—Director,
RFR

One of the most striking impressions one has on first visiting Gehry Partners is of the multitude of models at every scale filling the studio. As a working tool, a vehicle for conception and reflection, each model represents a different step in the evolution of the project. This exploratory process by successive models is characteristic of Gehry's approach: the project takes shape gradually, alternating between periods of refinement and revolution, the exact opposite of the common (if illusory) image of architecture emerging fully formed from the mind of the designer. As engineers, we participated in this process from the beginning of 2006, at a stage in the development of the project when it first really began to need engineering input in terms of the choice of materials, structural systems, and construction methods.

At this point, the project was a long way from its final configuration, but key features were already in place: an outer skin of glass floating around the main body of the building, itself highly complex in form. This layering, the freedom of the geometry and use of materials, called for a radical departure from the classical approach to building construction. The energy and originality of the architecture required technical invention in practically every aspect of the project, from conception to construction, shaping the choice of materials, fireproofing, constructive systems, structural calculations, weathering systems, industrial processes, structural assemblies, etc. This has led to many innovations that will doubtless be exploited in future projects, and generated a number of industrial patents.

Our intervention was not a delegation, but a dialogue, an interaction. It involved a continual stream of communication with the architects and numerous flights between Los Angeles and Paris. We would respond to an architectural idea—often expressed in exploratory sketch models that were intentionally unresolved—with propositions for structural schemes, geometrical principles, constructive systems, and material options, combined with testing and multiple prototypes. The architects would then start to integrate these into the project, developing and enriching them, sometimes twisting their logic and introducing dissonance. Gehry's architecture is not founded on the celebration of constructive or industrial techniques. In the end these are very much present, but sufficiently muted so as not to compete with the more fundamental aspects of the architecture: the perception and experience of the space. This process is not always comfortable for an engineer because it calls into question the classical approach to design, which is to search for rationality and order, based on analysis and optimization. It creates moments of doubt and uncertainty, but the challenge always drove us on. Far from being abstract or conceptual, Gehry's architecture ultimately impelled us to explore solutions rooted in the physical and the practical.

The project was thus an adventure, for us and for the many other companies involved in its realization—a collective journey that mobilized and motivated us, and helped forge lasting relationships. We will try to give a flavor of it here through four subjects that are representative of the challenges we faced.

THE
TWELVE
GLASS
SAILS

The glass sails floating around the building started out as surface models formed from folded and curved Plexiglas sheets. Each one unique in geometry and scale, they

overlap, forming a complex, constantly changing, porous space in relation to the main body of the building. Eventually, after many iterations, their number was set at twelve. Their form was inspired by images of America's Cup J-class racing yachts from the early 1900s, with billowing sails traced with delicate seams.

Their glazed surfaces are convex, with curves that are variable throughout. Ten of them have a pronounced fold running through them. The first and most obvious option for constructing the glass skin would have been to break the surfaces down into multiple triangular facets, each one different. The result would have been an image very remote from the gentle, flowing, tension forms of a sail. The alternative, using curved glass, offered the advantage of being able to cover the surfaces with rectangular panels, reducing their number by half and eliminating a third of their joints. This not only resulted in a visually lighter system, but also offered a significant simplification in their construction.

The advantages of the curved glass were undeniable. Classically, the panel shape is produced by forming heated, softened glass on a mold. Fabricating a mold, usually in steel, is costly, which is why bending glass is typically only viable for geometries with a high degree of repetition. In this case, because of the geometrical irregularity of the sails, there was practically no repetition. We therefore had to find a different mode of production. As we started to confront this problem we became interested in the potential of a fairly recent machine we knew about, owned by only a small number of glaziers, which produced tempered cylindrical panels without the use of molds. The machine is programmable, and so the radius of each panel can be individually set. We had the additional idea of customizing it by feeding the panel into the machine at an angle so that its curvature was no longer parallel to its sides. With this innovation it became economically feasible to fabricate the 3,600 panels, with each one bent to a unique radius and specific geometry. However, like any industrial process, the machine has its limits: it can only produce cylindrical forms, and the surfaces of the sails are clearly not cylindrical. This apparent incompatibility was resolved by a compromise: we didn't try to perfectly match the original surfaces, but contented ourselves

with getting as close to them as possible, by choosing the cylinder best suited to each glass panel. This approximation necessarily leads to a small step in the joints between panels, but this is no more than a few millimeters, and, as such, is barely perceptible.

The idea is based on a compromise. This invention occurs at the point where classical techniques cannot fully respond to the question that is being asked. In buildings it is rarely the case that a solution will come from an entirely new production technique. More commonly it is generated by transposition or recycling, drawing on existing technical systems used for other applications, and customizing them to suit the new conditions.

The nature and composition of the glass itself was established in steps, working through numerous samples of curved panels, at actual size, presented in different light conditions and orientations on the project site at the Jardin d'Acclimatation. In the end, a fritted, extra-white laminated glass was adopted. Extra-white glass is the result of a special production process, in which the quantity of iron oxide, which causes the greenish tint of normal glass, is strictly limited. One of the two glass panes constituting the laminated panel is fritted, or silkscreened, with a regular grid of 2-millimeter diameter white dots at an overall coverage of 50 percent, then covered with a very fine layer of metal applied by cathodic coating, which has the effect of subtly increasing the degree of reflectivity. This composition, combined with the variable curves of the sails, transforms the simple transparency of glass into a material that catches light and colors in a way that is constantly changing.

THE STRUCTURE OF THE SAILS

There are twelve sails, each structurally independent, of varying size, configuration, and orientation. Each is suspended off the building, often cantilevered out a significant distance from its supports. These eccentricities meant that supporting their self-weight

without excessive deformation was a significant structural challenge, as illustrated by the two examples below:

—REU (each sail is known by a reference code name) is the biggest sail, located at the eastern prow of the Fondation. With a total glazed area of 3,000 square meters (32,290 square feet), it is the size of half a football pitch, and is made up of 500 tons of wood, steel, and glass, supported over 25 meters (82 feet) above the highest terrace.

—SHU is located under REU, with a glazed area of 1,700 square meters and weighing around 385 tons. It is suspended more than 20 meters (65 feet) from the building's prow, creating a striking overhang over the pool.

In addition, the sails bear 90 percent of the wind force acting on the building, and, because of their form, they generate complex and unpredictable wind flows and vortices. A series of tests were carried out in a wind tunnel on a 1:125th scale model of the building to measure the pressure of the wind from thirty-six different azimuths. The hundreds of thousands of measurements gathered were then fed into a calculation program specially developed by the contractor to model the dynamic response of the structure to ensure it was not susceptible to excessive movements due to resonance.

The glass panels themselves can only withstand local loading from the wind, and must be isolated from global movements of the structure to prevent them being damaged. To this end, we developed, in collaboration with the contractor, a sliding, articulated fixing system to ensure that the glass is free to float in its plane, without being tied to its neighbors, whatever its curve and orientation.

Given the scale of the forces in play, it was evident that the structure would become a central element of the architecture of the sails. A clear hierarchy and choice of materials was established to differentiate the identity and role of its two principal component systems: a stainless steel grid supporting the glass panels, conceived to be as light and fluid as possible, and a structural frame in timber and steel, less regular and more massive, to transfer loads to the supports located on the Iceberg and on the terraces.

The stainless steel grid, placed close to the glass surface in line with the joints of the panels, is formed principally by 80-millimeter (3-inch) diameter tubes, reinforced by fin plates, in one direction and 70-millimeter (2 3/4-inch) diameter tubes in the other. It is as uniform and constant as possible with its detailing repeated for each of the sails. Stainless steel was chosen for its resistance to corrosion, as the durability of the construction was always a primary consideration. But, with its brushed, reflective finish, it also catches the light, glinting and sparkling to make the sails shimmer.

Conversely, the steel and timber structural frame plays an integral role in the composition of each sail, heightening the perception of movement and reinforcing the sense of tension. With such a marked impact on the architecture, each element had to be perfectly configured, requiring a constant dialogue between architect and engineer. As engineers, we were faced with a dilemma. Out of necessity, every stable structure must follow a rationale, an order: this is a condition of its predictability. But the architectural imperative was that this order must not dominate and compromise the dynamic sculptural qualities we were trying to create. We had to negotiate between these two opposing demands. In the end, behind each sail lies a clear structural logic, but its legibility is deliberately blurred, subordinated to the freely expressive geometries of the system.

This quality is particularly seen in the 179 columns supporting the sails. Not one is superfluous, and the dimensions of each are calculated exactly for its structural role. They are subjected to tension and compression, exceeding 440 tons in some cases. Nevertheless, each one is different in its orientation (from 0 to 250°, never vertical or horizontal) and length (from 3 to 25 meters [10 to 82 feet]). One knows, intuitively, that these columns are vital to support the weight of the sails, but it is unclear just how they do it. In this way they help create a space that is dynamic, surprising, destabilizing, and disorienting.

The architect chose to introduce timber alongside steel in order to give the structure a unique character and warmth. It was established from the outset that the timber was not to be merely added as a decorative cladding to the steel profiles, but was to play a real role in the principal structural system. Larch was chosen due to its high durability and its sustainable sourcing. Structural elements were fabricated using glulam techniques, where thin planks are glued together to form sections up to 1.2 meters (4 feet) deep. Curved beams can easily be fabricated

by bending the planks on a form as they are glued together. Once a curved beam is finished it can be bent on its other axis by cutting it into thin strips and bending these on a jig and gluing them together. Such techniques were perfectly suited to the sculptural forms we were trying to create. For the folds of the sails we were thus able to make twisting, doubly curved beams, which are masterpieces of fabrication in their own right.

Getting timber and steel to work together with such geometries posed challenges. Indeed, the two materials differ significantly in the way they react to and withstand stress. Steel is a homogenous and predictable industrial product, which reacts in the same way to tension, compression, bending, and torsion, making it an ideal mechanical material. Timber, in contrast, is a living material, fibrous, knotty, and imperfect, whose properties vary over time and with changing weather conditions. If this imperfection and non-uniformity add to its character and attraction, they also make it less predictable. In order to assess the forces acting in these mixed timber and steel structures, we had to make a comprehensive computer model for each sail, integrating the different materials and their mechanical properties, and subjecting it to multiple loading conditions. The values resulting from these calculations ranged from tens to hundreds of tons, due to the variability of each sail's geometrical characteristics. We were also extremely attentive to the 400 connections between the timber elements. Each one is unique. The principal connections, transferring the highest loads, were conceived as solid pieces of steel, fixed to the timber beams by means of stainless steel plates, slotted into the timber and tied together with multiple transversal pins. After a long collaborative process between the contractor and ourselves we were able to determine the precise number, position, and size of the pins, necessary for each condition, to prevent rupture of the timber due to excessive force in any one of them. Large-scale tests were carried out on three representative assemblies, perfectly validating the conception and calculation of all the connections.

Apart from four shared masts at the eastern prow of the building, each sail is structurally independent. What is striking about the project is that these twelve huge structures are incredibly close and yet not linked. The methods and sequencing of their erection was very tightly constrained, since the sails had to be built one by one, independently. The construction of the final and largest sail, REU, was particularly spectacular, for it had to be erected directly above four other sails, which were already complete.

THE ICEBERG

The choice of the principal material for the cladding is a key aspect of each project by Frank Gehry. The Guggenheim Museum in Bilbao is associated with titanium sheet, the Disney Hall in Los Angeles with stainless steel. In the very early stages of the Fondation, colored titanium was envisaged, but relatively quickly the design settled on white, chiseled forms evoking an iceberg, and inspiring the name of this element of the building. However, the actual material to be used for the cladding remained open for quite some time. The architect was searching for a mineral-like material, rather than an applied or painted finish. Initially, bare plaster was considered, but this was abandoned because of its vulnerability to water damage. Following this, three technologies were studied in detail: curved panels in enameled or painted aluminum, panels cast in cement, and sprayed concrete. For each one we sought out specialist companies, worked through the construction process, and produced a large number of samples. This research process, carried out in close collaboration with the architects, led, on a bright morning in January 2009, to the presentation of five prototypes of curving surfaces in the snow-covered Jardin d'Acclimatation. In the end, we chose white cement panels for the cladding. The cement in question was of a new variety, BFUHP (fiber-reinforced, ultra-high performance), best known under its brand name Ductal, and made up of a finely tuned blend of particles including silica fume. Mixed with fibers of steel or, in this case, polyester, it offers a remarkable resistance in both compression and tension, without requiring the steel reinforcement bars used in traditional concrete. The fineness of the particle mix gives this concrete a remarkable fluidity, opening up a range of potential textures and finishes for its cast surface. It was this property that particularly caught the interest

of the architect, as it was possible to produce a very smooth, slightly matte surface with an appearance and feel reminiscent of porcelain. The color, which is very white for cement, was obtained by using white cement and sand, with an admixture of titanium oxides.

The Iceberg is clad with 19,072 curved panels, practically all of them unique. As with the glazed panels on the glass sails, it was not logistically or economically possible to make a separate mold for each one. An industrial process therefore had to be invented, centered on the more regular geometrical characteristics found in the project, rather than concentrating on the variability of each individual panel. The point being that the curved surfaces are globally very regular, being based on a geometry that can be made simply by rolling a plane, like a sheet of paper. On these surfaces, the panels are laid out along what are known as geodesic lines, which means that if they were unrolled and laid flat they would form perfect, identical rectangles (apart from at the edges of each surface, where they are truncated). The principle that was developed for fabricating the panels stems directly from this geometrical property: liquid Ductal is poured into a flexible silicone mold, itself sealed in a vacuum and then placed on a polystyrene jig shaped to match a particular surface. In this way, the precisely made mold, designed for repeated use, provides all of the common details and features of the panels (the rectangle, the texture of the surface, the quality of the edges), while the jig, specific to each individual surface, but much less expensive to produce, was used to manage the variable aspect of each panel, that is, its curvature.

Developing this highly innovative technique called for numerous tests, prototypes, and adjustments, which is not typical for building works. The conditions of production were themselves radically different from those usually found in this field, with the creation of a "white" workshop in which panels were handled wearing white gloves, and geometrically verified using a five-axis robot of the kind typically employed for checking components of airplane engines.

Putting the Ductal cladding in place on site was the second big technical challenge of the Iceberg: covering 9,000 square meters of complex surfaces without visible variations in the width of the joins or steps in level between panels. Given that the open joints create dark shadow lines, any inaccuracy in the alignment would be obvious against the white ground of the cladding, even from a distance. Discrepancies, therefore, could not be allowed to exceed a few millimeters. This was particularly challenging, given the curved forms of the surfaces. Successive prototypes persuaded us that the only practical solution was to fabricate extremely precise supports for the panels; otherwise, accumulated tolerances would have made it impossible to complete the layout and positioning of the final panels of each surface. We therefore developed a system of 1,700 aluminum shells fixed on the insulating layer of the wall, on which the Ductal panels were hung. These shells match the variable curved surfaces of the Iceberg to an accuracy of a few millimeters. Each is unique not only in terms of its geometry but also by virtue of the many features it incorporates (rails, electrical ducts, bracing, etc.). To fabricate them, we borrowed from naval construction techniques: each shell is constituted by an egg-crate grid of laser-cut aluminum plates which defines the geometry, and on which is welded a continuous metal sheet. These shells are not exposed to view and their function is purely technical. However, their shapes and the extreme precision of their fabrication, combined with the rough finish of the aluminum, makes them remarkably beautiful pieces. For several months, before the cladding was put in place, they made the Iceberg look like a reflective gray battleship with random joints.

The Iceberg is also the surface that, with the glass facades, ensures the building's weather tightness and thermal insulation. Behind the aluminum shells, a black neoprene membrane provides the principal waterproofing barrier. It covers a 180-millimeter (7-inch) thick layer of rock wool insulation, which is itself fixed to the Iceberg's primary structural shell, a robust ribbed steel construction that is typically hidden behind the plaster internal finish of the wall, but that the architect chose to reveal at one point: the northern stairwell—a hollow tower 40 meters (131-feet) high, made in a single piece. This inner wall, including the insulation and waterproofing membrane, was also entirely prefabricated, and delivered to site in large, transportable pieces, allowing extensive testing of its construction to be completed in the workshop, ensuring the highest level of quality control. Three meters wide

and as much as 12 meters (40 feet) high, they were like parts of a ship, lifted by a crane then bolted and sealed together, reconstituting the global form of the Iceberg.

THE GLASS FACADES

The gaps between the opaque masses of the Iceberg are enclosed by glazed walls whose function is principally to let in daylight and open up views from the heart of the building. However, unlike the glass sails, these facades form part of the weather-tight envelope of the building, which means they must perform a large number of functions that are both demanding and sometimes contradictory: they must be water- and air-tight, act as thermal barriers, sound mufflers, sun screens, enhance user safety and building security, evacuate smoke, resist fire, and be easy to maintain. Such a range of performance calls for technologies that are sophisticated but are already well developed: they are indeed required of the glass facades on many other buildings. However, achieving them with the twisted, fragmented forms of the Fondation was a real challenge both for the designers and the contractor.

There are in fact a total of forty-six individual facades distributed around the building, which vary greatly in size, configuration, and geometry. The architect wanted them not to stand out, and to remain homogeneous in spite of their diversity. They were, in a sense, to be made as neutral as possible. To this end the goal was to build them using a single, unifying constructive system. This required a significant effort to rationalize their geometries without compromising their architectural qualities, and thus to make them compatible with the system. The glass tower housing the panoramic lift, 40 meters (131 feet) high, is representative of this work. With the architect we were able to adapt its twisted, initially awkward form into a series of so-called "translational" surfaces, which can be faceted in quadrangles, enabling us to foregot he need for triangular glass panels in all but a few exceptional cases.

The constructive system of these facades was inspired by Gehry's earlier projects.

Its principles are: a clear separation between the glass skin and the steel structure supporting it; a structure that has itself a marked hierarchy, comprising primary load-bearing columns and secondary horizontal transoms, placed at regular intervals over the whole of the building; glass panels, either parallelograms or triangles, of constant width and height; an aluminum frame enclosing the panels and incorporating all the components required for weather tightness. In places, the steel structure seems somewhat massive or redundant; in others—on the "fly-bys" for example—the complexities of the aluminum grid are overtly exposed to view. This is the natural consequence of applying a single system, without exceptions, to a multitude of varied configurations.

There is only one system but the geometries to which it is applied are all different. To build them, a high-precision industrial process had to be devised, one that pushed the classical boundaries of the construction industry. Spiral, the Czech company in charge of these elements, made 3D computer models of each bar, each panel connection, each silicon joint. This modeling was then fed into digitally controlled machines to cut each piece and machine-tool components to a tolerance of around 0.1 millimeters, which were then test-assembled in the workshop and, after that, erected on site without any tolerance or adjustment. This huge jigsaw puzzle involved over 1,800 panel connections, and 2,850 glass panels—in all, over 200,000 pieces, large and small, typically unique, representing a huge logistical challenge in terms of their supply, transport, and assembly. This complexity is not readily perceptible, but requires extreme care and attention to detail, for, once assembled, the continuity and weather tightness of the system has to be perfect. As a result, these facades, like the glass sails and the Iceberg, will no doubt constitute ground-breaking works of "mass customization," that is to say, large-scale prefabrication of non-repetitive components, made possible today by the interconnection of computer modeling and production tools for fabrication.

There can be no denying that the project is technically very complex. As engineers, we do not see this as a drawback; on the contrary, it is what drives our profession. Technically speaking, the Millau viaduct, the Eiffel Tower, and Sydney Opera House were all complex,

meaning that their construction called for new technical solutions.

The Fondation is nevertheless distinguished by the fact that multiple complex issues are concentrated on a single element. To give an example, the glass sails combine sculptural geometries, tortuous load paths to supports, the structural hybridization of timber and steel, the requirement of structural stability in the case of fire, the continuous curvature of the glazed surfaces, their fragility, the need for access for maintenance operations, etc. Such concomitance of complexity exponentially increases the challenge of finding a solution that will resolve them all. However, we always attempted to untangle these sets of problems, not by forcing together a combination of individual responses, but through the development of a unified, global approach that was as simple as possible. The examples we have given here show that these solutions are not self-evident. They are arrived at by experimentation, constant questioning, failure, abandoning one direction and starting again in another, and multiple calculations, samples, and prototypes. But once the path was cleared, the solutions suddenly became evident. To confront this complexity one must constantly seek to simplify at every level: looking for constants to draw on, rationalizing the project without compromising it, establishing industrial processes, creating systems. Our objective was always to ensure that, in spite of its complexity, the technical work behind the project remained imperceptible so that materials and systems combined and assembled naturally, almost effortlessly, leaving the qualities of its architecture to speak clearly for themselves.

HE

PRS393-25-40*399-40-399
PRS375-20-30*394-30-394
PRS393-25-40*399-40-399
PRS375-20-30*394-30-394

PRS393-25-40*399-40-399
HE360A
PRS375-20-30*394-30-394

HE450
HE360

PRS407-30-50*404-50-404

HE450A
PRS407-30-50*404-50-404

HE360A
PRS407-30-50*404-50-404

HE450A
PRS407-30-50*404-50-404
HE450A
PRS407-30-50*404-50-404
HE140A
HE140A
HE450A
PRS407-30-50*404-50-404

-30-55*315-55-315

-30-55*315-55-315

CHS219.1*8

30*395-30-395

0*395-30-395

HE700B

HE650B

CHS219.1*8

CHS219.1*8

CHS219.1*8

PRS380-20-30*395-30-395

PRS380-20-30*395-30-395

PRS380-20-30*395-30-395

PRS393-25-40*399-40-399

HE500A

HE500A

HE700A

PRS380-20-30*395-30-395

HE140A

HE140A

HE240A

HE140A

HE240A

HE140A

HE700A

HE140A

HE500A

HE500A

HE500A

PRS393-25-40*399-40-399

HEA240

HE500A

HEA240

HE500A

HE700A

HEA240

HE700A

HEA240

HE360A

PRS375-20-30*394-30-394

HE500A

HE500A

HE360A

HE500A

HE500A

HE240A

HE450A

HE140A

HE240A

HE140A

HE360A

HE450A

HE140A

HE360A

PRS393-25-40*399-40-399

HE360A

PRS744-30-55*313-55-313

HE360A

PRS744-30-55*313-55-313

HE500A

PRS744-30-55*313-55-313

HE360A

HE700A

HE450A

HE140A

HE360A

HE240A

HEA300

HE140A

HE500A

HE500A

HE240A

HE140A

HE140A

HEB450

HE450B

HE140A

HE450B

HE360A

HE140A

PRS407-30-50*404-50-404

PRS407-30-50*404-50-404

HE450A

HE450A

HE450A

HE140A

HE360A

HE360A

HE140A

HE450A

HE200B

HE450A

HE240A

HE450A

HE500A

HE140A

HE500A

HE240A

HE140A

HE500A

HE140A

HE140A

HE450A

HE360A

HE140A

HE140A

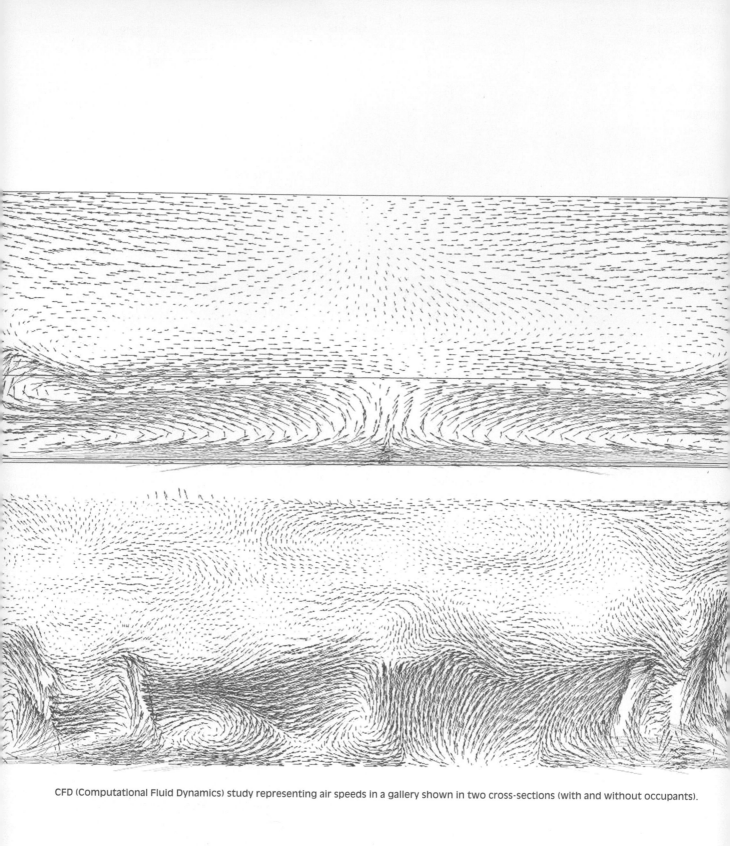

CFD (Computational Fluid Dynamics) study representing air speeds in a gallery shown in two cross-sections (with and without occupants).

THE GREAT SKELETON

Armel
Ract-Madoux,
Bénédicte
Danis
—Project
directors,
Setec

The work of Frank Gehry is prodigious in its formal richness and also in the sophistication of the innovative technical conceptions put in place by the engineers.

The SETEC group was entrusted, one by one, with several project missions central to the conception and construction of the building.

At the outset we were asked to design the building's primary structure, combining the pedestal of the envelopes and the framing of the inhabited spaces, but our field of intervention broadened considerably when the Fondation Louis Vuitton asked us to take up the mandate of the project management group, as a result of which we directed the technical and transdisciplinary aspects of the project globally. Later, our engineering mission acquired a third strand with responsibility for the technical equipments. The engineers explored the singularities of this building in order to define what sustains, determines, and animates the structure.

FRAMING: CONCEPTION OF THE PRIMARY STRUCTURE

Exchanges between the teams at Gehry Partners and the project leadership in Paris began in 2006, ten months before the first public presentation of the project. The project went through several successive iterations, and architects and engineers discussed their propositions and counter-propositions in almost daily video conferences, thereby laying the foundations for an understanding of the building's structural principles. Workshops were held regularly in Los Angeles and Paris with the models, which back in 2006 constituted one of the only possible supports for technical discussions—as yet, there were very few plans.

Frank Gehry placed his building on a small lake, surrounding it as if it were a boat on the sea. A slurry wall 25 meters (82 feet) deep, anchored in the underground clay, rises up around the pool to a height of 7 meters (23 feet). It is stabilized by the pool's intermediary slab and plays the double role of holding back the earth and protecting the structure from the Lutetian-Cuisian water table.

The idea of founding the building on a bottom slab came up at a very early stage. This choice of a very thick concrete plaque (2.6 meters [8,5 feet]), rather than piles, a technical solution currently used for tall, slender buildings, met two crucial requirements: firstly, by continuously and lastingly proofing the buried base of the building in order to prevent water infiltration should the water table rise; secondly, by spreading evenly across the ground the load from the glass, which is itself very unevenly distributed. This option gave the general contractor Vinci the chance to anticipate the start of the work by beginning construction of this thick and metal-strengthened (2,094 tons of steel for 11,000 cubic meters [388,500 cubic feet] of concrete) foundation without waiting for completion of the construction tests for the envelopes.

In the exhibition galleries, for which the program imposes a totally free plan, we envisioned mixed floors (combining the structural properties of steel beams and concrete slabs with a span of 20 meters [65 feet]). These spaces of 500 square meters were conceived to take concentrated loads of 11 tons that generate vibratory constraints that were previously subjected to detailed analysis.

The galleries located above the hall and auditorium are supported by monumental rods—vertiginous, inclined pieces of steel over 20 meters (65 feet) long. These leaning

posts, one of Gehry's strong stylistic signatures, free the space and allow for views over the trees of the Bois de Boulogne.

The structure of the building was conceived so as not to change Gehry's project. The corridors and vertical circulations (stairways, elevators) around the galleries follow the forms of the Iceberg. The chord members of the framework consequently follow the curves drawn by the architect by approaching them as closely as possible in an approximation using canted edges. This unprecedented technical feat assembles 4,800 connection points, all different both in their design and in the stress they are subjected to.

In order to maintain the project, to respect Gehry's design, new connections were created between the calculation softwares used by the engineers and Digital Project, the software used by the architects.

Ensuring the representativeness of the geometries fed into the calculators is a key question in this development, since the representation, from the models to the finished elements, had to correspond exactly to the architectural project.

A GLOBAL MODEL

The sloping poles supporting the glass canopies, the tripods, are secured in the structural base of concrete and steel. It became evident very early on in the process of the technical conception tests that the structural justifications had to be managed by joining the building's primary structure and the secondary framing of the glass.

For one thing because the glass sails, which are hyperstatic in order to preserve their stability, even if one of their supports were to disappear, are particularly sensitive to the movement of their supports, the tripods: this sensitivity is expressed in a redistribution of the stress into the tripods. For another, because the primary structure is proportioned so as to be able to support the trust from the glass.

In these conditions, the structural interactions between the borne and bearing elements can only be described and quantified by creating a global calculation model. During the conception phases, this global model was realized jointly by the engineers of SETEC and RFR + T/E/S/S.

At the request of the project leadership, a global model was also assembled by Vinci Construction Grands Projets in liaison with the general contractor's subcontracting engineers in order to combine the primary structures in reinforced concrete and complex frameworks with the secondary structures supported by the icebergs, the glass envelopes, and the glass canopy.

In our role as project leaders, we supervised the realization of this model in order to ensure that it was properly representative.

The general contractor's subcontractors later proportioned their own elements on the basis of so-called local models, that is to say, specific and detailed models for each element. Our mission, for which we drew on the experience acquired during the conception phases, was to ensure that the development of the tests in these local models remained compatible with the reference of the global model.

FACTORING IN WIND EFFECTS

The complex form of the structure with its twelve sails places it outside the regulatory framework and standard practices. The Centre Scientifique et Technique du Bâtiment (CSTB) was mandated to determine the wind pressure to be factored into our tests and into those of the general contractor and its subcontractors. This it did using physical and digital models.

Initially, we pre-proportioned the elements on the basis of a digital simulation made by the CSTB. These wind pressure readings were then honed in wind tunnels on a 1:125 physical model (in tests carried out in Nantes by the CSTB). During these wind tunnel tests, an impressive quantity of data was collected at a rate of 200 measurements per second on 512 synchronous sensors on each half of the model over 235 hours with thirty-six different wind directions. The reference speed taken by the CSTB was determined

on the basis of a return period of fifty years in Paris. Before that, in order to characterize the actual turbulence of the site, anenometers positioned on a mast at heights of 15, 30, and 45 meters took wind speed measurements on the construction site over a period of several months.

A national expert committee that was formed to pronounce on the methodological approach later formulated recommendations for the implementation of the execution tests.

Monitored by the general contractor, these led to a spectral modal analysis, taking into account the way the dynamic effects of the wind set the structures in resonance. The data provided by the CSTB was then enriched using a method known as reconstituting power spectral density, which constituted an extension of this curve. This innovative method was devised in collaboration with experts.

The Fondation was thus subject to extremely advanced scientific testing that had never before been applied in the world of building.

COMPLEXITY AND TRANSVERSALITIES

The concentration of technically innovative aspects, which are by nature complicated, raised the project to a higher dimension, that of *complexity*, in the systemic sense of the term. Here, the transversal approach becomes the rule. Behavior of the structural elements, fire-resistance, quality of use, rules of access, and acoustic quality—if these parameters are not contained within a global approach they can easily overlap and contradict each other, and sometimes even be mutually detrimental. This offers an unmatched field for the expression of complex thought, as theorized by Alain Farel in his seminal book *Architecture et complexité*. Indeed, the Fondation would have made an excellent case study.

On another, equally decisive level, the multiplicity of people involved, from diverse backgrounds, each with their own specialization, was, from the outset, a real complicating factor in the process of exchange and information sharing. The system had to be made to work: left to its own arbitrary autonomy, it could easily have ground to a halt.

The turning point came in summer 2007 when the client decided to bring all the design teams together on the same floor and to give the scheme direction by entrusting management of the project team to SETEC. As the architectural forms continued to evolve at Gehry Partners in Los Angeles, the Parisian teams were making progress and stabilizing the technical options defining the work. Later, on the construction site, the system took on yet another dimension, when the conception teams, general contractor, and subcontractors were all brought together in the same premises.

By developing methodological tools dedicated to prospecting and then following up critical points, by directing collaborative studies to resolve them, by coordinating the different participants and planning their actions, and by administering the documentary base and the exchanges, the management team at SETEC took up position in a system that, while it was not contained within a unity of time (far from it), was founded on unity of place and action. The collaborative platform, a matrix woven by direct and immediate relations between the partners, focused on a shared objective and organized around 3D models, was the heart of the set-up.

But let us come back to the notion of complexity and its illustration through the conceptual and constructive principles developed by our teams. Transversals, horizontals, vectors of complexity: we discussed matters relating to the performance of the building. Below are a few examples.

More than ever before, this structure is a shape shifter: a cloud, chrysalis, or insect with rustling wing case—the exterior suggests endless formal analogies. So does the interior.

The interlocking of free forms that constitutes the Fondation implies the assemblage of thousands of pieces, all singular, in a great range of materials (aluminum, carbon or stainless steel, concrete, plaster, stone, etc.), which, like a giant construction set, each has its own special place in the whole.

In fact, the result is not so much a construction or an inert object as a sophisticated, polymorphous, and living organism.

And yet—and that is the beauty of the paradox—this building that looks ready

to move but that is immobile, is alive with movements that the eye cannot see, and that the constructional systems must allow to take place freely.

The conception factors in all the movements induced by thermal expansion, the effects of the wind, snow, and ground movement, and, more generally, all the parameters relating to the later conditions of the building's use (transportation of heavy loads when setting up a monumental artwork, for example). Naturally, this means applying the rules for correct construction, but often it also means going beyond them and looking at the environment of the object in question, and by taking a critical, safety-conscious approach in a comprehensive discussion of hypotheses and reasonings adapted to exceptional circumstances.

Movements of structural blocks in relation to one another, the displacement of facade elements with regard to their support, the deformation of metalwork parts held by or holding different materials—there are countless examples. The elements are ordered in keeping with the laws of an organic body or a horological mechanism whose subtle clicking recalls the perfection of the fashioning of pieces and the finesse of the adjustment of the apparatus.

THE INTERSECTION OF DISCIPLINES AND PERFORMANCES

If the main role of the Fondation Louis Vuitton is to exhibit works of art, this museum function goes hand in hand with institutional activities and events. The versatility of the spaces—the cornerstone of the remit behind its conception—is a notion that guided the teams throughout the development of the project. Exhibitions both permanent and temporary, receptions, events of all kinds, their requirements sometimes contradictory, will structure the life of this building.

However, by its nature and by its function, the Fondation is contained within a regulatory *corpus* that cannot authorize everything. As a public access building of the first category, the Fondation must abide by safety standards set by the general provisions of French fire safety regulations and, for some of the spaces, of national labor laws.

For obvious geometrical and construction reasons, these regulatory protections cannot be applied to the innovative structures that are the glass canopies, the icebergs, some of the glass facades, and the building's complex framework. For the same reason, the —natural—smoke evacuation of the hall, the monumental staircase, and the escalator space stretching across the full extent of the building required highly specialist tests.

It was therefore necessary, on the advice and under the authority of the Commission de Sécurité's technical services, to define the safety objectives for each element, starting with definition of the real fire risks that the site may be exposed to. From this risk analysis stemmed use scenarios, and the models quantifying the thermal stress exerted on the elements. After a sustained dialogue between Efectis France, the certified laboratory in charge of the study, the project management teams, and the users, technical solutions meeting the requirements of the building's actual were applied to each specific area, always adopting a technical approach in which questions of safety (often going beyond regulatory norms) and flexibility of use were paramount.

PREPARING FOR THE BUILDING'S USE

After completion of the conception tests, and with the execution tests already under way, the process of functional analysis took the project beyond the conceptual abstraction of its initial stages.

This rereading of the project, not from the viewpoint of the designer or prescriber, but from the perspective of those who make the machine work—the users—concerns

159 all the technical services running through the building: heating, ventilation, air conditioning, electrical installations (power, emergency, lighting, computer network, safety, etc.) and plumbing (water management, fire fighting, toilets, etc.).

This key stage was managed by the engineers at SETEC backed up by the contractors in charge of the technical trades. This made it possible to acquire the necessary detachment at a moment when, with the work in full swing, it was vital to take a very practical approach to the processes controlling the functioning of the building.

These analyses were expressed in documents giving a detailed description of the operation of the installations sustaining and irrigating the Fondation.

The Fondation Louis Vuitton defined a program governing the thermal and hygrometric conditions in the galleries: 20°C ± 1°C in winter and 24°C ± 1°C maximum in summer, with a relative humidity of 50% ± 5% in all seasons. This subject is particularly sensitive because the insurance companies of external institutions lending a work often request as many as six months of recordings proving the stability of these climatic conditions.

Two thermofrigorific units working by thermal exchange with the ground water distribute through the museum's hydraulic networks water whose temperature controls the specific installations for each gallery (air processing units and radiant floor loops).

The choice of geothermal energy, made early on in the conception stage, makes it possible to exploit the site's hydrological assets, which are the two so-called Lutetian-Cuisian (depth: 25 meters [82 feet]) and chalk (90 meters [295 feet]) water tables. The Fondation is thus heated and cooled using natural, renewable resources in the ground, as demonstrated by the results of the impact study we carried out projecting over a hundred years.

Climate control in the museum spaces is effected by a mixed system combining air distribution through slits at the bottom of the picture walls (picked up by other slits around the edge of the ceilings) and a reversible radiant floor, which can heat or cool. The processed air diffused at floor level at a low speed thus spreads naturally to the middle of the room, creating a mattress of air at a homogenous temperature, which slowly rises in strata following a very low gradient (the temperature increases by about 0.5°C per meter).

In order to fine-tune the regulation of the galleries, functional analyses were consolidated by dynamic thermal modeling that served to validate the general proportioning of the installations and, above all, to better apprehend the climatic behavior of the spaces and their sensitivity to external thermal input (thermal charges induced by the lighting and display equipment, or by the sun).

The results from the modeling could be used, for example, to highlight the time zones in which the radiant floors worked, by distinguishing between galleries with opaque walls only and others with glass walls, and to determine the amount of water that needed to be maintained in the diffused air in order to abide by the programmatic requirements.

These studies ultimately led to a "user's manual" for the galleries guiding the opening of the first exhibitions. The museum's first year of operation will allow us to tweak the regulation of the systems before they are definitively stabilized.

These kinds of studies were also carried out in the hall, in the auditorium and in the large escalator space.

Apart from the use of geothermal technology, the environmental policy presiding over the defining technical choices for the Fondation led us to make major efforts in terms of water management. The concern to make the most of natural resources dictated the conception of systems for collecting, conserving, and using rain and water-table water in order to keep use of the urban water supply to a minimum. To this was added the concern to send only what was strictly necessary—used water—into the sewer system.

The types of rainwater gathered by the collection systems on the terraces and the glass canopy are different, as are their uses:
—The rainwater collected by the glass canopies (their folds and lower edges are fitted with gutters) and by the terraces off bounds to the public is kept in a tank, then processed and reinjected into the sanitary installations (cisterns), and used for watering the terrace gardens as well as for cleaning the facades.
—The runoff water from the terraces open to the public and on the forecourt is directed

towards a second tank, then injected into the pools surrounding the museum in order to offset water loss due to evaporation.

Calculations based on statistical data gathered over a period of ten years enables us to calculate the volume of these two tanks, which contain, respectively, 150 and 350 cubic meters (5,297 and 12,360 cubic feet).

A third, much bigger tank (1,000 cubic meters [35,310 cubic feet]) serves as a storm basin. It is designed to collect all the water inundating the site in the case of torrential storms and thus avert the risk of flooding in the inhabited areas.

This system for managing rainwater, using complex, automatic instrumentation, is made secure by the possibility, in the event of the tanks being empty, of drawing on the ground water to top up the pools, supply the plumbing, clean the facades, and water the terrace gardens. Urban water supplies would be used only as a last resort.

Ongoing innovation in terms of both construction and methodology has contributed considerably in recent years to the liberation of forms. Today, the creativity of architects and engineers can make real, habitable structures from what, yesterday, would never have got beyond fantasy and utopia. At the same time, the constraints weighing on projects and determining the designers' framework of intervention have been constantly evolving, gaining in precision and, very often, becoming stricter. Those of us involved in the conception process are therefore helping to forge a new project culture. The history of the Fondation has been a perfect experimental terrain for this.

The panel joints bring together 5, 6, sometimes 8 bars of the framework, all out of plane.
4,800 panel joints, all different, punctuate the weave of this complex frame.

odele Global 1 - ELU

NODAL SOLUTION ANSYS 11.0

STEP=2
SUB =1
USUM (AVG)
RSYS=0
DMX =.217381
SMX =.217381

odele Global 1 - ELU

NODAL SOLUTION ANSYS 11.0

STEP=2
SUB =1
USUM (AVG)
RSYS=0
DMX =.217381
SMX =.217381

Interaction between structural elements is crucial, which is why the engineers of Setec and RFR + T/E/S/S decided to construct a global model combining the primary structure of the building and the 12 glass sails.

Following spread: CFD (Computational Fluid Dynamics) studies of the air in the hall indicating the climatic effects of the air-circulation devices were repeated to find the optimum positioning. Here, two photographs of the airflow. These theoretical results show that the occupied areas enjoy good, homogenous thermal comfort.

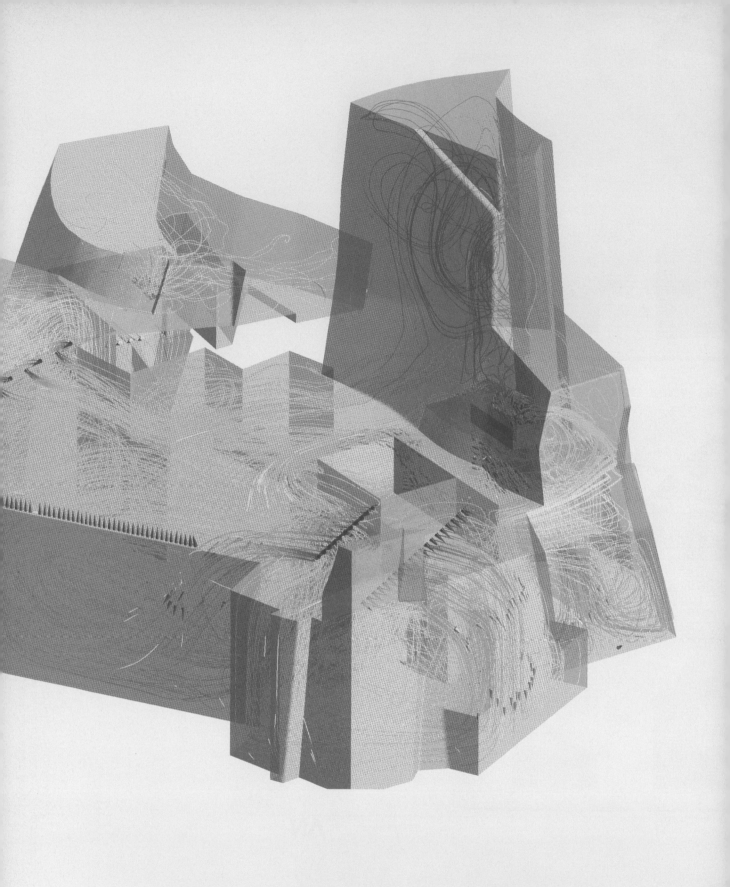

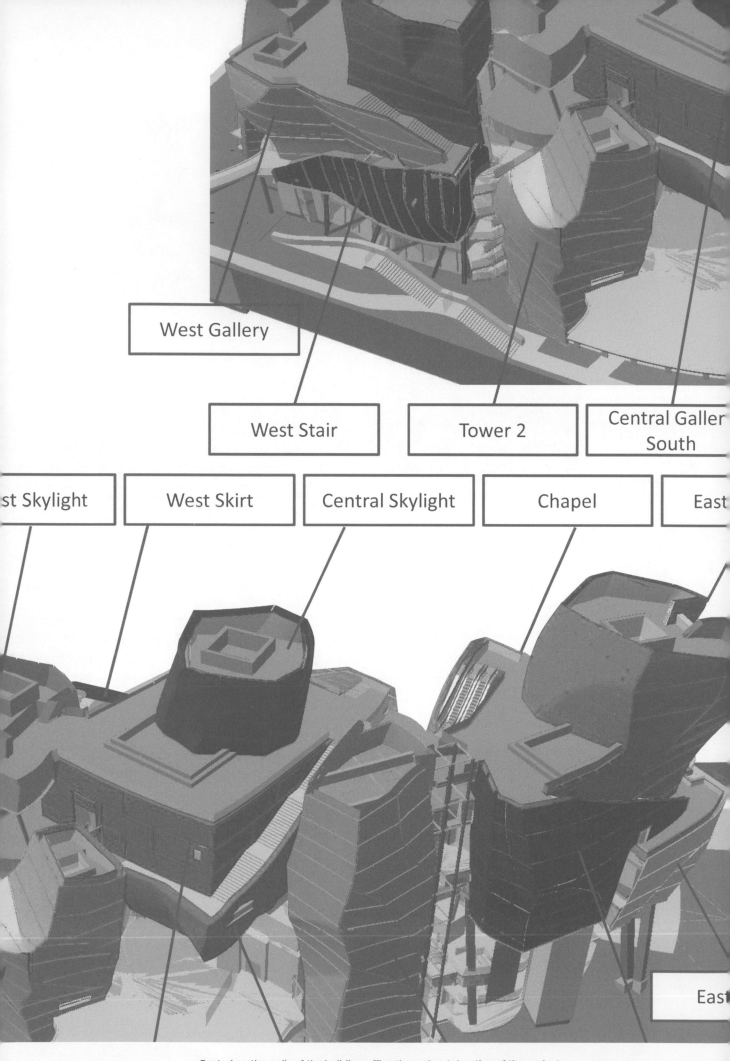

West Gallery

West Stair

Tower 2

Central Galler
South

st Skylight

West Skirt

Central Skylight

Chapel

East

East

Posted on the walls of the building office throughout duration of the project,
these work plans were part of the teams' shared vocabulary.

"APPRENTICE TO GENIUS"[1]

Rahim
Danto Barry
—Studios
Architecture,
local
architect

A COLLABORATION WITH GEHRY PARTNERS

Wednesday December 18, 2013 marked one of the high points in the construction of the Fondation Louis Vuitton with the "setting of the last stone." The previous day, a memorable photo session brought together all the craftsmen and workers on the southern terrace.

Cleaned and cleared of the clutter and building protections, the site afforded a glimpse of the nearly completed building before the formal handover scheduled for the following spring.

The main protagonists, whether client, worker, engineer, or designer, could finally measure the sheer scale of the construction they had been toiling over for months or years. It was a moment of rediscovery, offering a new vision of a project that had been marked by unexpected events, setbacks, and breakthroughs, but was now declared by all to be a spectacular success.

The celebration that particular day was the climax of five years of construction and a day to honor a remarkable adventure spanning ten years that had begun with Frank Gehry's first sketches and culminated in an unprecedented sculptural edifice, a chrysalis of glass, a ship unfurling its sails.

DRAW ME A FOUNDATION

The tale of this adventure brings us back to Gehry's now famous sketches. Executed with the virtuosity made possible only by long practice and a great freedom of expression, these line drawings suggest a myriad of possibilities. Simple scribbles for the uninformed, they constitute above all a formidable matrix of the project designed to speak to and seduce the client, a microchip acting as a set of guidelines for the architects and engineers and containing the essence of his vision: glass clouds floating above icebergs, all seemingly placed on a reflecting pool into which pours a waterfall.

But however prolific and free it may be, the architect's imagination cannot ignore technical and functional constraints, any more than it can escape financial considerations or deadlines when the task is to construct a building with a precise program and use—in this instance, a space dedicated to contemporary art.

The sketched image of the Fondation is therefore not a simple stylistic exercise. The shell is not empty: the organically formed volumes of the icebergs must house museum spaces; the building perfectly clad and sealed must respect the latest norms and regulations. Then there was the challenge of the clouds, so emblematic of the project. They needed to be materialized, to be solidly moored, without losing their suggested evanescence and ephemeral quality.

Clearly, the postulate stated at the genesis of the project consisted in dealing with a myriad of constraints and resolving their implications, down to the slightest ramifications.

What seemed an insurmountable challenge became the reason and role of the local architect.

1 —
These words come from the title of Edgar Tafel's memoir, *Years with Frank Lloyd Wright: Apprentice to Genius,* Dover Publications.

The first was to closely follow a project designed by a North American agency, from sketch to construction, and to ensure the application of French norms and regulations, to obtain the necessary permits, all the while preserving the integrity of the design intent. Equally key was the collaboration with the other design team members to meet the technical and constructability challenges inherent in the geometrical complexity of the project, moreover, in a landmark site. The role required both the finesse and expertise to understand and to provide for an effective response to often contradictory or even opposing aspirations and to find the right compromise between the concept architect's precepts and the client's program. It had to satisfy the latter's requirements in terms of finish without distorting the former's language, as well as ensure the control of both budgets and deadlines.

SCALING EVEREST IN FLIP-FLOPS

Contacted in June 2005 by the Fondation Louis Vuitton to act as local architect alongside Gehry Partners, Studios Architecture found itself facing a number of thorny questions—as indeed did most of the other participants: How to go about constructing such a complex building? How to transpose into rational, optimized parameters such bold, organic forms, bristling with tripods pushing out in every direction, hemmed with a maze of circulations flowing across and between the glass envelopes?

The answers are not found in any architect's manual, not when the project is as unusual as this one. And however instructive in their own right, visits to Gehry buildings such as the Guggenheim Museum in Bilbao, the Disney Concert Hall in Los Angeles, and the Marta Herford Museum—all among the key references when the project for the Fondation was being developed—only served to confirm the idea that every project by Gehry is sui generis, and that none offers a complete tool kit for dealing with the problems raised by the next one.

Furthermore, in addition to an internationally renowned architect, Studios Architecture was working for a world leader in the luxury industry, and an expert team of engineers. Clearly in such a set-up, the balance of power does not necessarily lie with the local architect. It was therefore vital to assemble all the resources necessary to avoid being in the position of a mountaineer setting out to scale Everest in flip-flops.

PARIS– LOS ANGELES

All this notwithstanding, we were able to draw on the experience of Gehry Partners. This was invaluable as the team there had already pulled off the feat of translating projects with particularly bold forms into actual constructions. Ensuring a monthly presence at the start of the project, their visits gradually grew further apart, becoming bi-monthly and then tri-monthly with videoconferencing, providing a permanent and necessary link.

Our Californian partners followed the development of the project from their Los Angeles base, spotting the slightest surface mismatch on the 3D master model, questioning us on a given curve or line, or alerting us over any adaptations that they considered detrimental to the design intent. Being confronted with the realities of the construction process, with its regulatory and budgetary constraints, and directly affected by tensions arising from schedule pressures, we had to anticipate certain key issues to minimize going back and forth. Studios kept Gehry's team informed of events even if at times—with the risk of upsetting them— this occurred after the fact.

THE CONSTRUCTION SITE AS LABORATORY OF EXPERIMENTATION

In 2007 the client brought together all the project's key players—architects, engineers, and consultants—and, with them, Studios Architecture's core team moved to the Rue Bailleul project office before setting up permanently on site in 2009.

A specific organizational structure was set up for the construction phase, each member of the Studios Architecture team managing one or several parts of the project from the execution studies through to construction: concrete, steel framing, icebergs, glass canopies, glass envelopes, technical and finishing trades, etc. While indispensable, this division also implied one major challenge: coordinating these different activities to ensure an overall coherence guided by a transversal vision.

Over time, adjustments proved necessary, and the teams fluctuated in keeping with the varying needs of each phase. Initially, the work was focused on the interactions between the different members of the design team. Subsequently, exchanges extended to the general contractor and then to the subcontractors.

Putting in place the tools for managing the project, such as the 3D modeling software Digital Project and the Batiwork digital database tool, was a gradual process, adapting to exchanges between the different participants: between architects and engineers, with Gehry Partners during the design phase, and with the contractor during the finalization of the project phase, before the execution phase, gradually integrating the contributions from the contractors in charge of the main packages: principal structure, primary framework, icebergs, glass canopies, and glass envelopes.

3D MODELING: A DECISIVE TOOL

Overall spatial coordination was ensured by the design and engineering teams based on pre-dimensioning of the technical elements.

It is important to note that the graphic documents provided to the builders during the construction drawing phase acted essentially as guidelines, and required extensive technical development to achieve optimal sizing during the execution phase. This iterative work served to verify the spatial compatibility of the different elements. The work of architectural and technical synthesis and coordination—making it possible to identify and resolve geometrical conflicts and other interface problems—took into account the dimensioning of the elements by the different trades in the execution phase. The 2D plans were extracted from the 3D model and ensured coherence between the 2D and 3D representations at each stage.

Many found this method disconcerting, contrary as it is to the conventional approach. Each and every artisan, whether the mason, the plasterer, the carpenter, the locksmith or the *façadier*, was required to become familiar with 3D modeling. Most were unconvinced of its necessity, but the tool proved vital not only to the development process but also to the production and installation of the different components. Indeed, one of the difficulties of the operation was to persuade the various contractors, and their degree of engagement did effectively vary, depending on whether the trades were engineering-based for which modeling played a central role in defining everything down to the bolts and screws before production could begin, or were simply involved with more traditional trades such as the finishes.

The project necessitated an extraordinary number of samples, prototypes, and first-of-series, with the process of validating many of the elements requiring specific tests, new construction technique site certifications, or experimental technical assessments (ATEX).

Despite the recurrent use of innovative hi-tech tools, some created specially for the project, the human hand remained a vital counterpart to the machine. While some of the complex elements were prefabricated using cutting-edge software, other elements were made in a more artisanal fashion.

GRAPHIC SEMIOLOGY

All of the teams also had to adopt the project's specific vocabulary: pool, cascade, icebergs, iceberg skirts, chapels, canyon, sails/umbrellas, grotto, etc. Beyond this lexicon

which identifies and names the different families of elements in order to improve legibility, comprehension, and memorization, a more detailed map was drawn up, reducing the complex components of the project to simple, coherent, and controllable entities. Each element was thus listed and individualized, and assigned a label ensuring its traceability. From design to installation, via production, each and every item was clearly identified: nature of the works, technical characteristics, origin, location, etc., creating a database that was accessible in real time.

EVOLUTION OF THE PROJECT

The presentation and validation of the finishes served as a revealing process, highlighting opposing approaches: on one side, the architect, privileging the essence of the material, even if this meant recommending a rough finish on certain elements, and on the other, the client, keen to have finishes that were consonant with the expression of the luxury brand. Working with the owner's technical advisor, who was our close and continuous collaborator, the client was personally invested in the decision process, to such an extent that at times there was a risk of it encroaching on what we considered our exclusive prerogatives.

Adaptations, whether architectural or technical, are inherent to such exceptional projects—not least on the part of the architect himself. One day, the grotto wall and the pool were thoroughly restyled; the next, the adjustable sloped seating in the auditorium was reconsidered, new balconies and removable hanging surfaces were added. In spring 2011 we were surprised to find significant changes to the project: two new glass structures rising up from the pool, one at the prow of the building and the other at the poop, were proposed as an alternative to the facades then being built. On either side, lattices climbed up the structure, a planted wall adorned the basin walls, and a promontory surmounted by planter boxes enlivened what remained of the original cascade.

This variant was set aside, its impact on the already established structural schemas deemed too important—not to mention other possible consequences. And these are merely the proposals that actually reached us: determined to ensure that the work proceeded normally, the client often shielded us from untimely and destabilizing demands.

Because a construction project is often a place of intense and potentially conflictual exchange, the quality of the relationships between its chief protagonists—client, project leadership, and contractor—is decisive. All things considered, the project proceeded in an exemplary atmosphere, with no major conflicts despite the difficulties inherent in such a complex operation requiring constant adaptation to new tools and the extraordinary flow of information, with the inevitable delays and hesitations resulting from the many changes that affected the project.

REFLECTIONS

As participants and privileged witnesses in the development of the project, to see the building metamorphose before our eyes day after day like a kaleidoscope was pure delight. Initially a simple excavation on the edge of the Jardin d'Acclimatation, then transformed into a giant concrete and steel Meccano emerging from the tree line of the Bois de Boulogne, the construction gradually morphed into an incredibly rich mass of forms to reach its stunning finale, revealing the reflections of the building in the water subtly suggestive of Frank Gehry's visionary first sketches.

As the project progressed, we sometimes found ourselves regretting that the process and finishes would inevitably make this constructive intelligence nearly invisible. The steel panels, for example, ended up being clad with Ductal panels, such that the luxuriant "primitive forest" of the framework, with its prodigiously beautiful tangle of beams, connections, and bracing was masked under the plaster of the interior icebergs.

The building does not outrageously favor form to the detriment of function, even if it did call for a few sacrifices: here and there, the curves of the icebergs resulted in constructional voids that might seem excessive; likewise, the glass canopy covers an area equal to that of the floors, even though it does not contribute to the enclosure of

the building. But what might appear an aberration on another project is the reflection of an imperious logic on this one: form and function are one. The Fondation Louis Vuitton will house works of art. Its architecture, too, is undeniably a work of art. Visitors will come not only for the collection but also for the building itself. Container and contents dialogue in a metonymic relationship.

The articulation of the spaces in this extremely complex volume is itself fluid and filled with subtleties. Traversing the building between the woods and the garden, the lobby irrigates the other functions. It prefigures what will be discovered inside.

Walking on the terraces, under the glass canopies and between the icebergs, there are views out onto significant features of the Paris landscape, seemingly indicating that the emphasis here is on the exterior. But a few steps further, this assumption is refuted by a rich assortment of pleasant surprises. The galleries with their monumental skylights—one of which is particularly twisted, another neither outside nor inside but both at the same time—the lyrical sweep of the monumental staircase, the rough steel shells of the staircase in tower 3 revealing part of the construction process behind the icebergs, and the ingenuity that went into making the auditorium so modular—all these offer a rich and varied spectacle.

revealing the pure forms of the framework as a negative, like the skeleton of a mysterious beast or a gigantic Japanese lamp. In this sequence of volumes with their modulated lighting, nothing is left to chance, even if the unexpected can never be ruled out: the shimmering of the water reflected in the facades or glinting under the external ceilings, the shadows of the metal framework forming arabesques on the inner walls of the icebergs. To move within this singular architecture is a unique sensorial experience. Its multiple facets make the Fondation an incomparable instrument for artists, the resonance between their works and the building providing a fertile ground with a myriad of possibilities.

The operation has only just come to an end, but some are already looking ahead to the next challenge. What will we do now? What challenge can inspire us after such an exploit? Looking back over the project, humility prevails.

We should recall how helpless we felt when confronted with the challenge.

Without a doubt, the experience has enriched us. But the next project may very well further push the limits of the possible, and make our current achievements obsolete.

We would then find ourselves back as we were during those first days of the project we have just delivered.

SHADOWS AND LIGHT

The museum's lighting is mathematical in its precision to meet the curators' requirements. It not only strictly complies with current technical standards, but contributes its own theatricality by highlighting a circulation or the singularity of a space. Painstaking research went into its integration in the stairwells' volumes.

Like true living membranes, the glass surfaces are by turns opaque, translucent, or transparent. They reflect the sun or, on the contrary, absorb it, sometimes merging with the mist and the clouds. Depending on the season and time of day, they can look diaphanous or incandescent. At night, the light is suffused and glows from within,

At the heart of the construction

Scan this QR code
to find out more about the contents
of the building.

Charles Fréger,
Pedro Fernands, plasterer,
2012

Charles Fréger,
Christophe Larger, metalworker,
2013

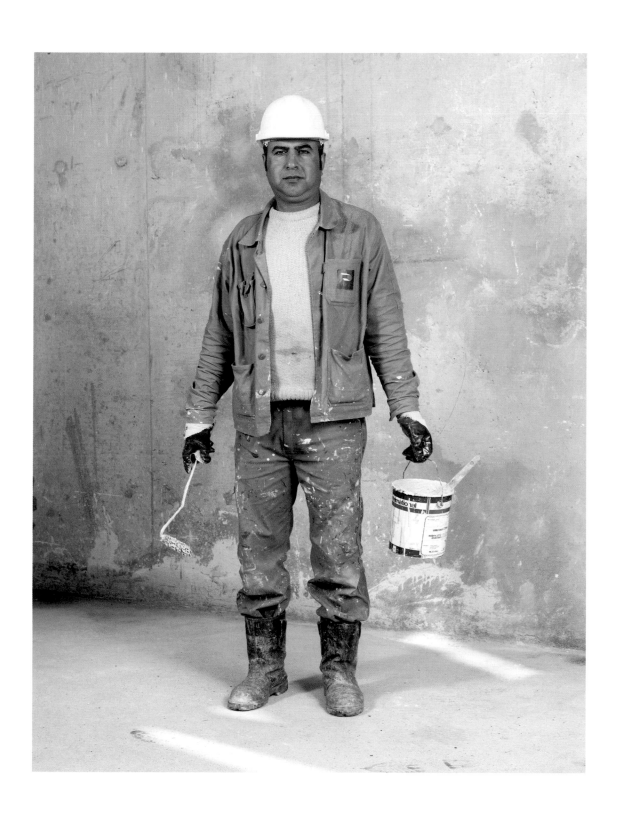

Charles Fréger,
Mehmet Yalavaq, painter,
2012

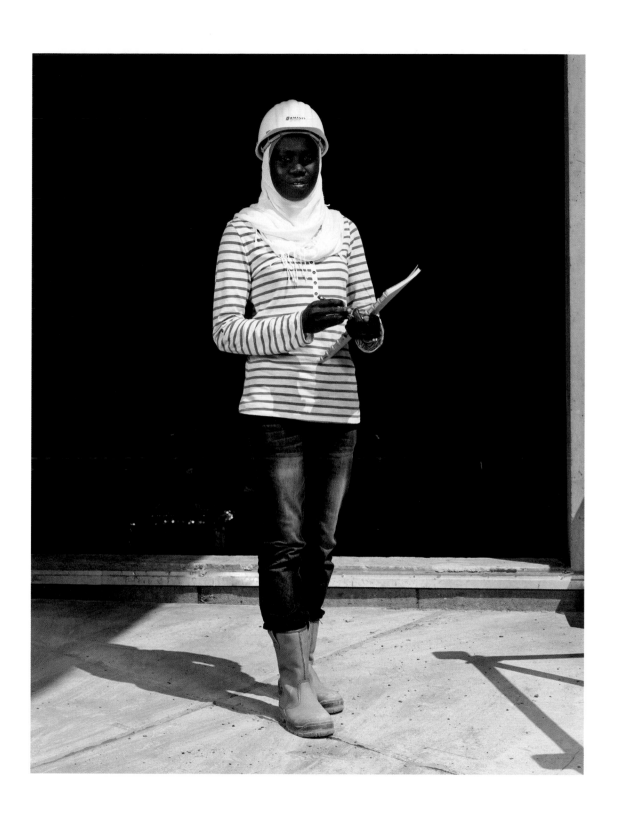

Charles Fréger,
Rokhaya Sagna, site manager,
2012

Charles Fréger,
Bakar Dianaka, mason,
2012

Charles Fréger,
Armind Monteiro, artisan, carcassing,
2012

Charles Fréger,
Stephen Kodom, scaffolder,
2012

Charles Fréger,
Jean-Paul Plas, metalworker,
2013

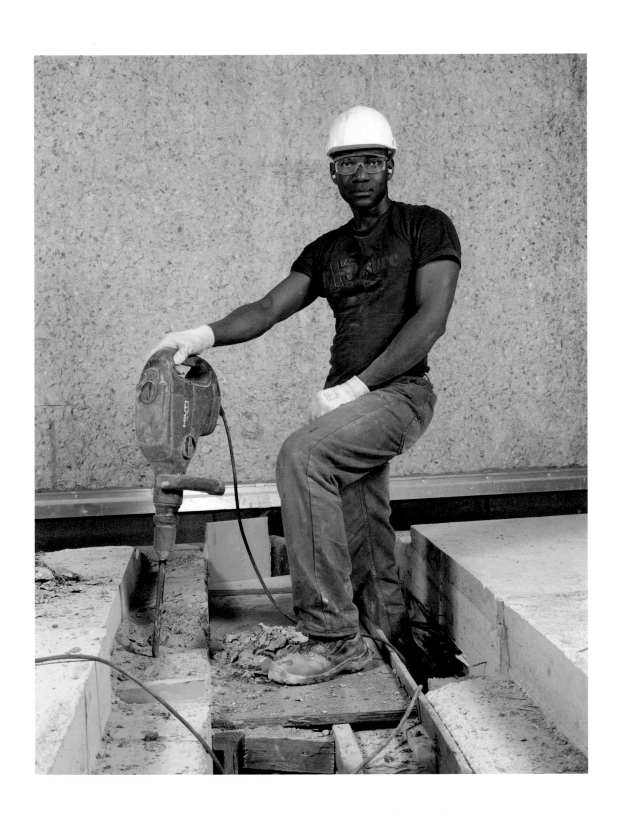

Charles Fréger,
Jaquiré Modibo, workman,
2012

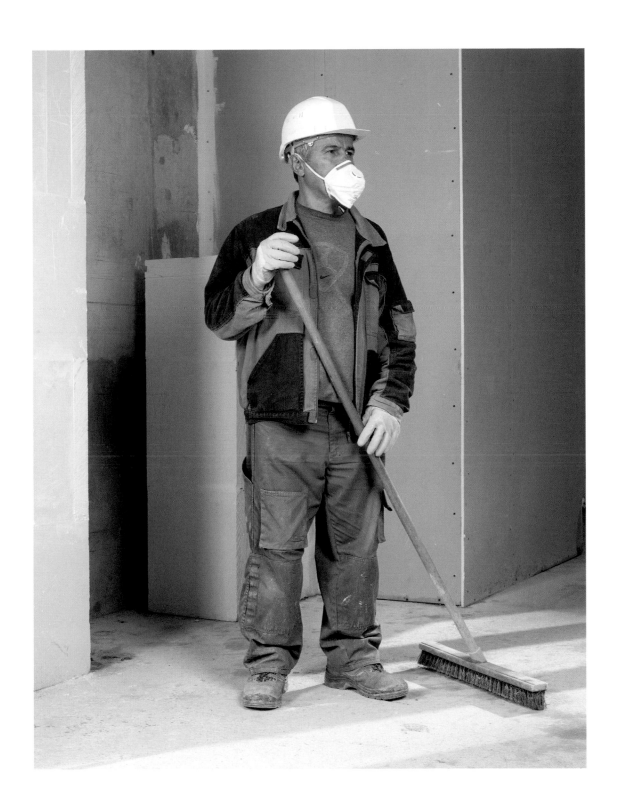

Charles Fréger,
Soy Selahattim, cleaner,
2012

Charles Fréger,
Izabela Wojciak, translator,
2013

Charles Fréger,
Gilles Müller, painter,
2013

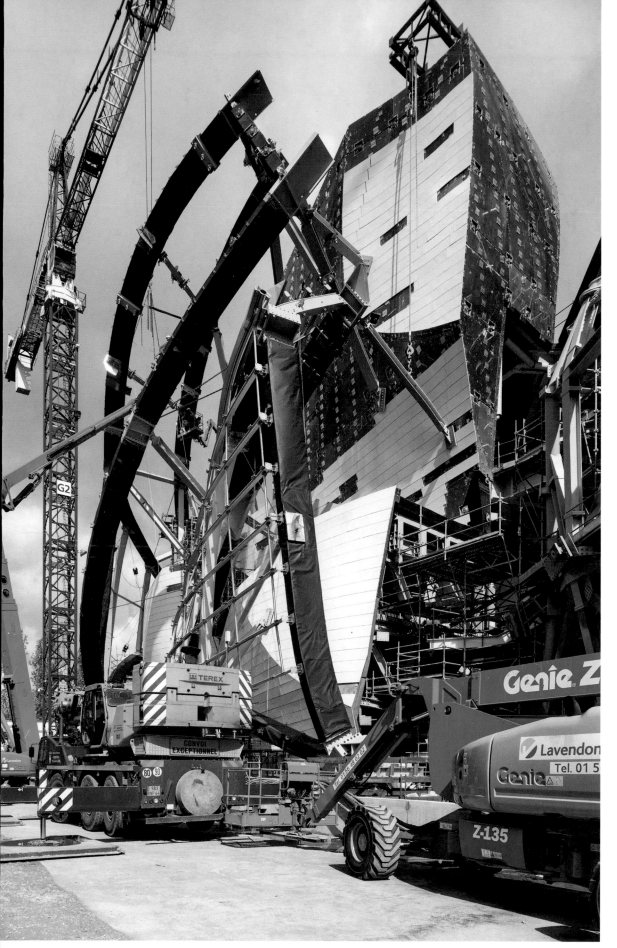

April 19, 2012

assembly of the wooden structure of the SWU1 sail located to the southwest of the building. The beams are protected by black sheeting.

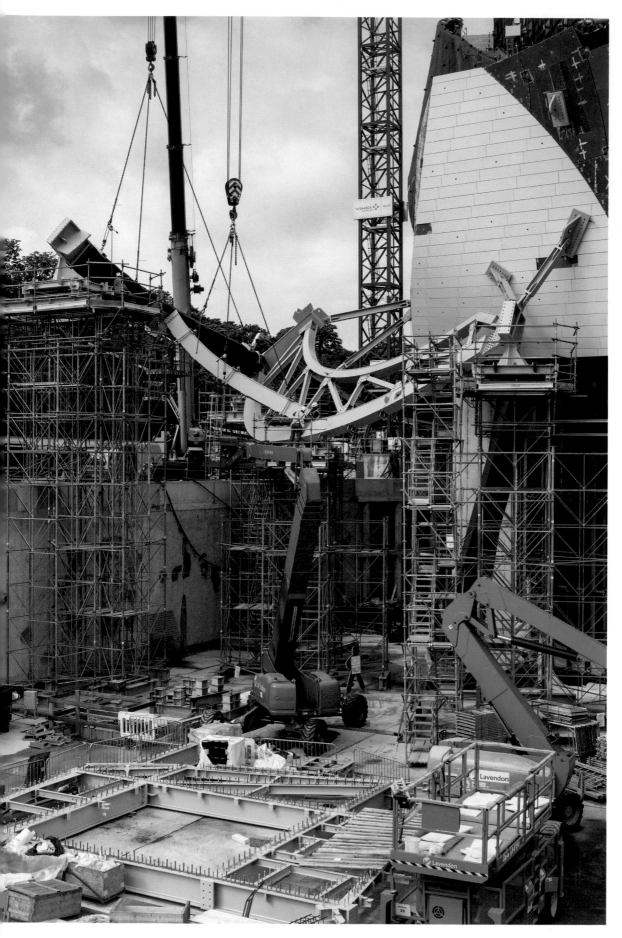

assembly of the beam/lattice supporting the SHU sail. In yellow, the elements for the provisional positioning on the support towers hold the structure in place while it is being assembled.

July 9, 2012

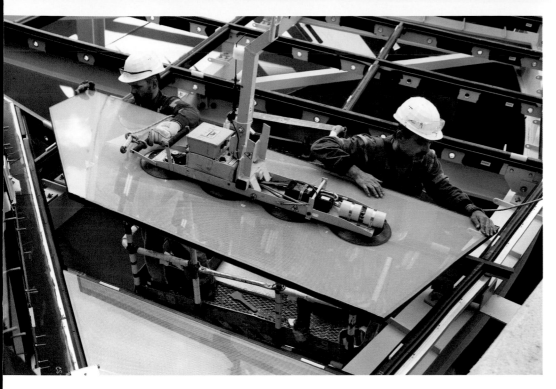

September 19, 2012

positioning a glass panel.

footbridge between the Fondation and the Allée Alphand.

January 8, 2013

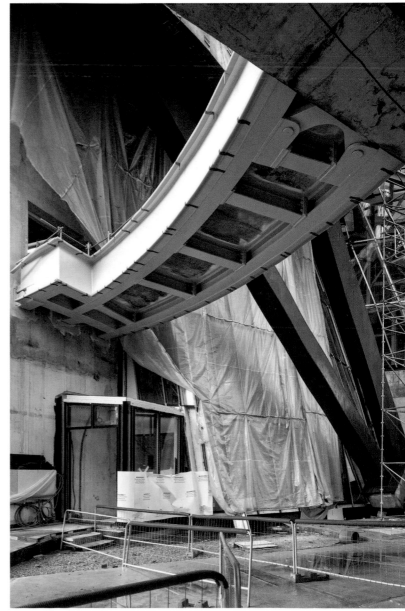

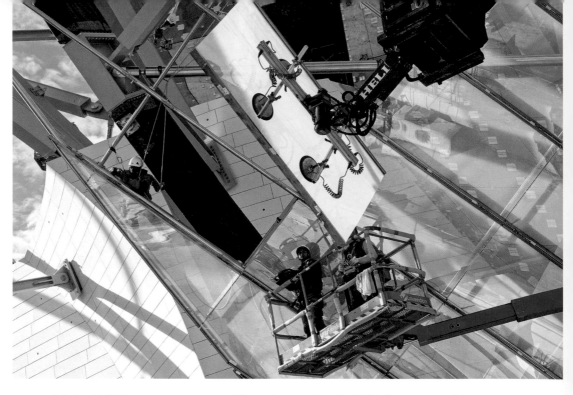

October 15, 2012

putting a glass panel on the NEU1 glass canopy using
a remote-controlled vacuum machine.

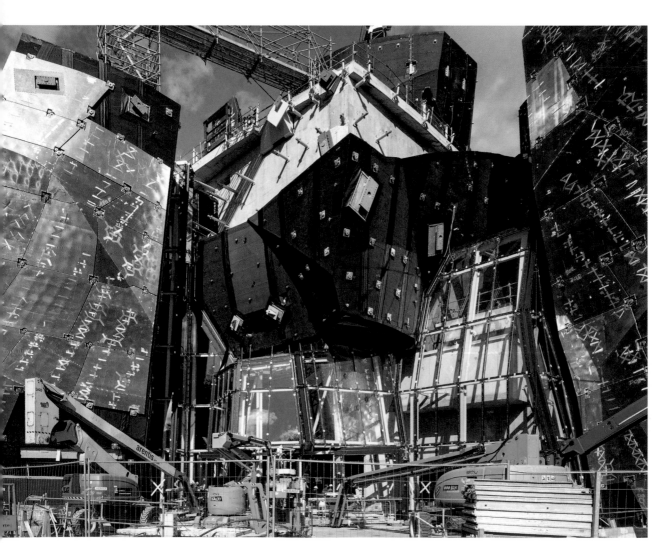

October 12, 2012

the iceberg shells forming the facades of the building
are covered with aluminum sheets, making it possible to adjust
each panel of white Ductal to the nearest millimeter.

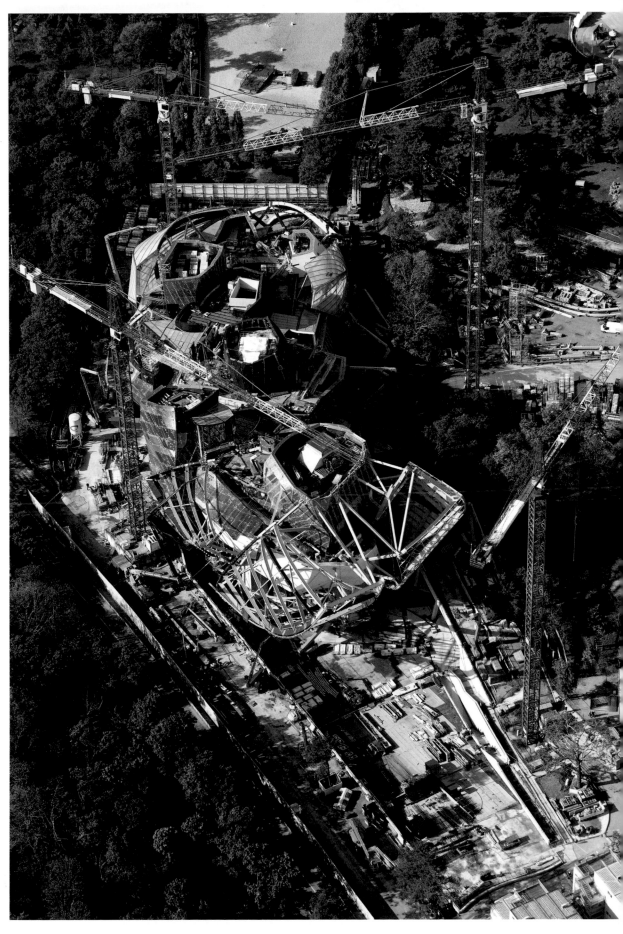

October 22, 2012

the construction work seen from above.

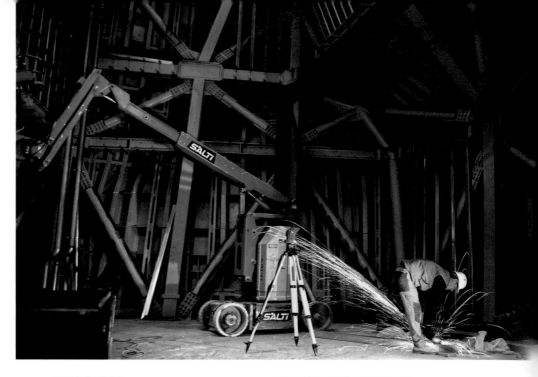

March 19, 2013 gallery 7 under construction.

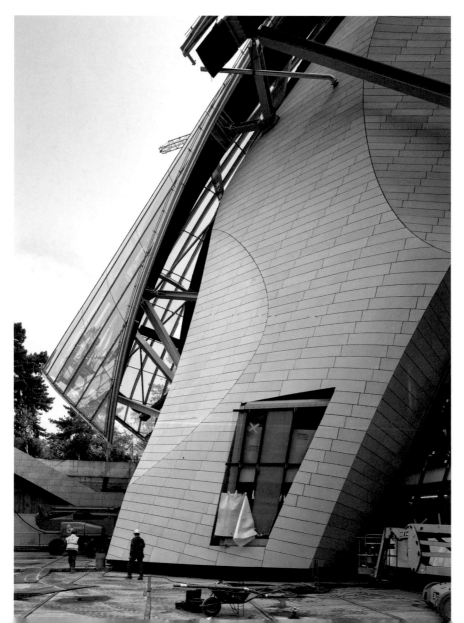

the iceberg of tower 1 is partially covered with white Ductal.

May 17, 2013

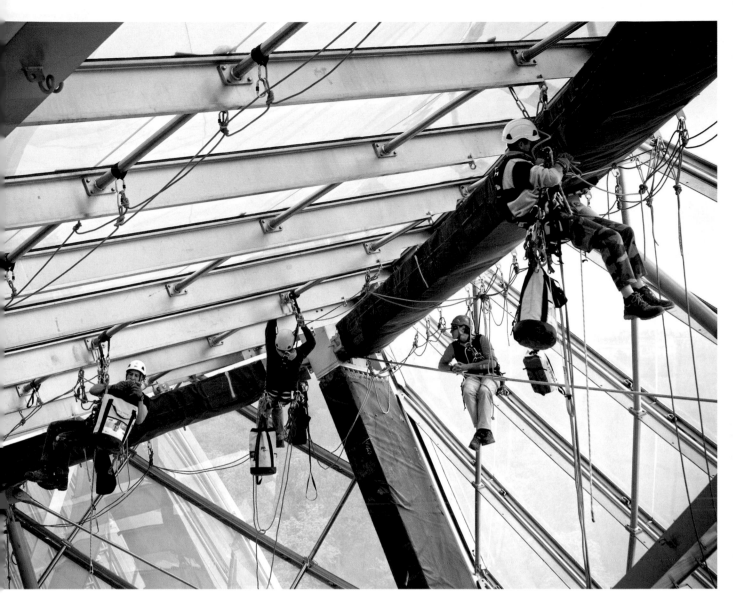

April 6, 2013

a rope team working on the construction of a glass sail.

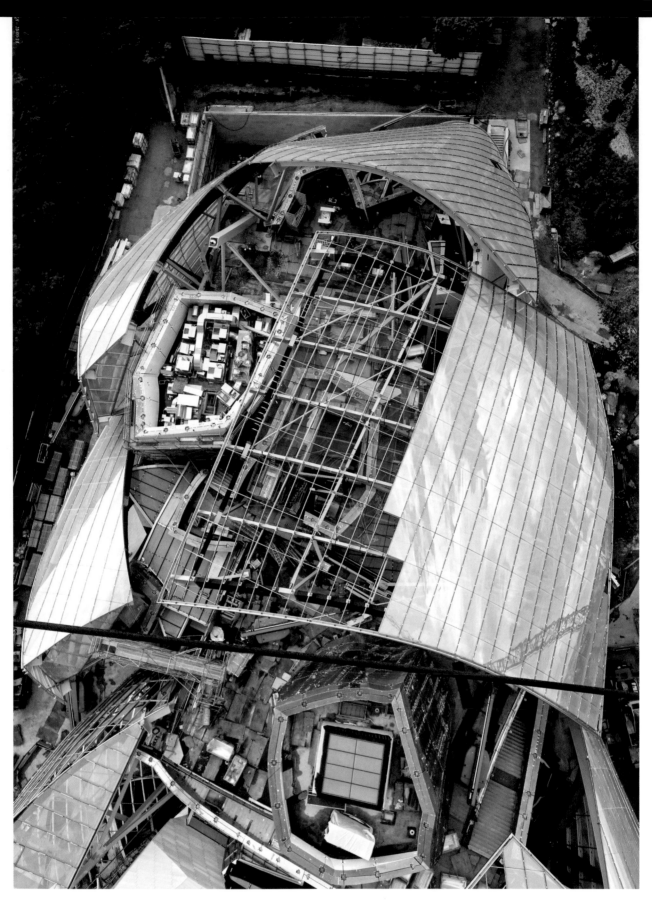

May 25, 2013

first reflections of the surroundings on the glass sails.

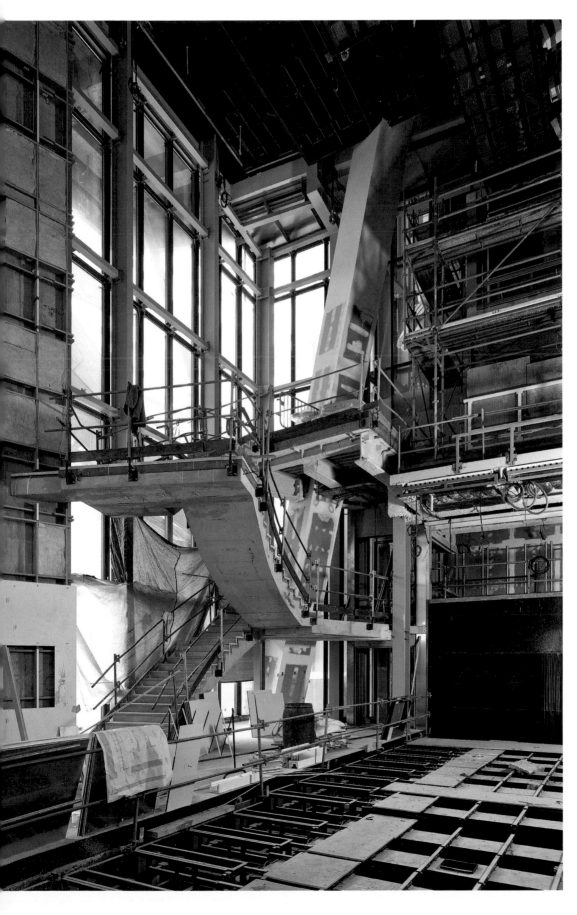

the auditorium of the Fondation under construction.

May 25, 2013

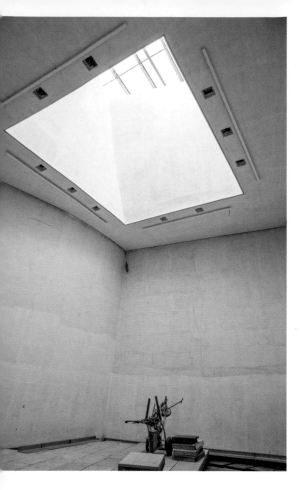

January 21, 2014

gallery 8 is an unusual space, at once interior
and exterior, like a patio at the heart of the building.

June 26, 2013

only a few more glass panels remain to be put in place.

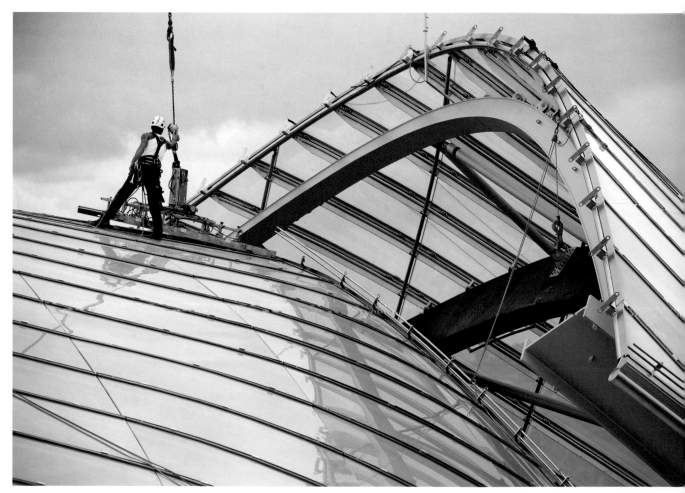

between gallery 10 and gallery 11.

June 3, 2013

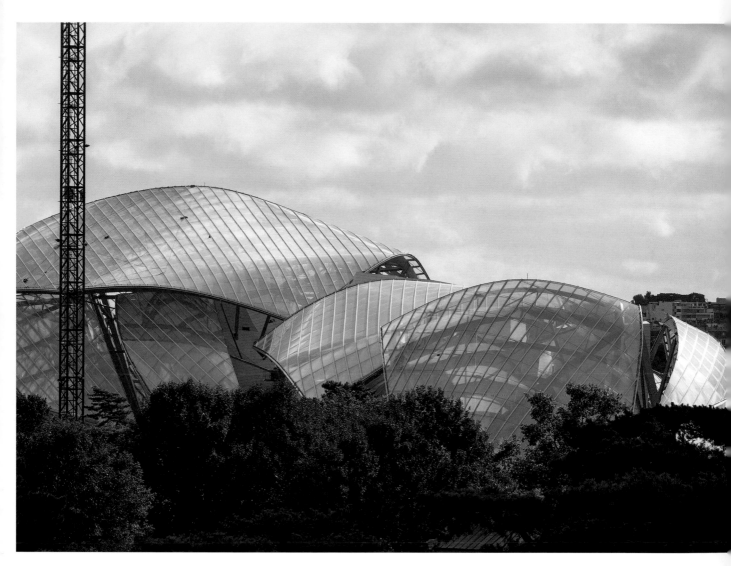

October 17, 2013

only one crane is left on the construction site.

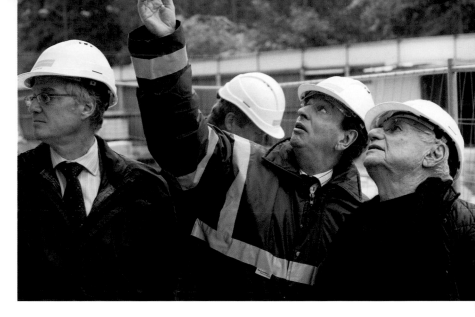

November 12, 2013

Christian Reyne, Jean-Paul Claverie and Frank Gehry
visiting the construction site.

view of the panoramic staircase.

March 6, 2014

December 4, 2013

detail of the north facade. Only a few Ductal panels remain to be positioned.

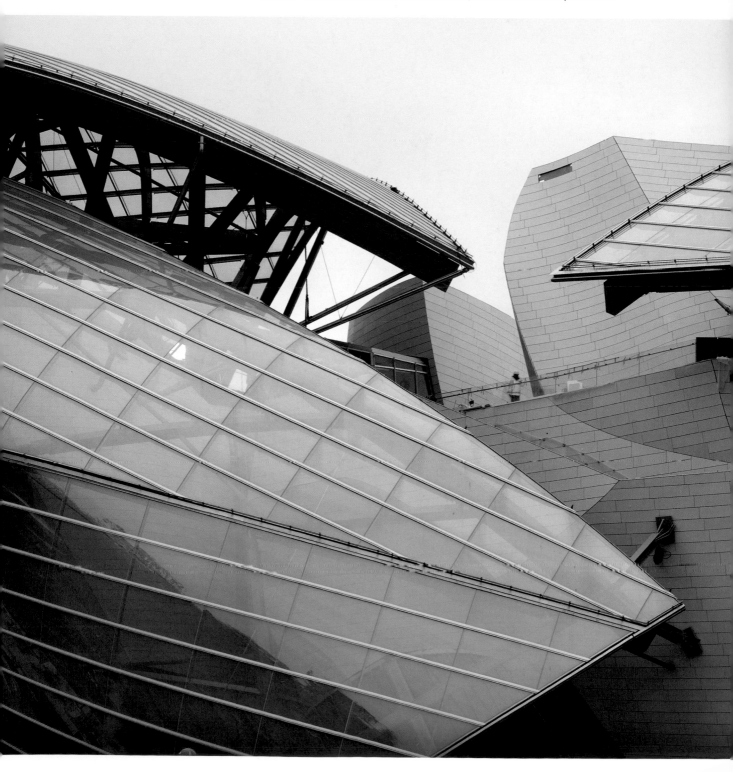

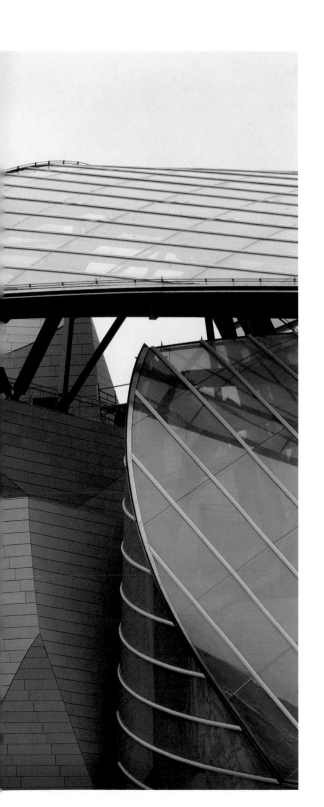

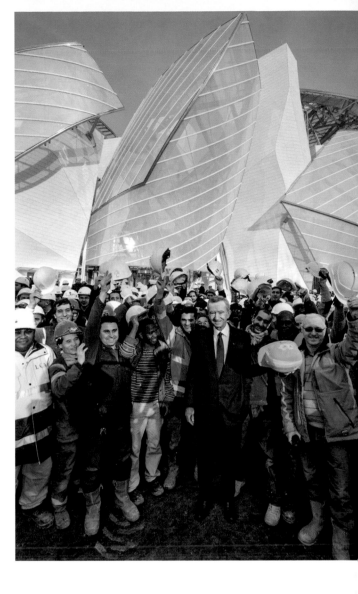

December 17, 2013

Bernard Arnault with some of the teams who worked
on the Fondation Louis Vuitton.

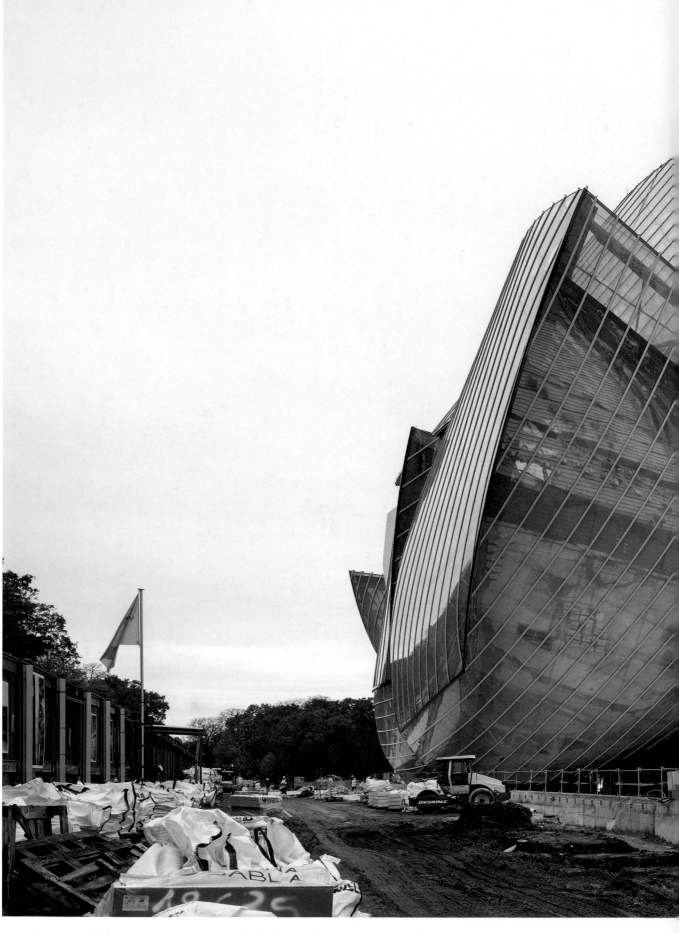

November 22, 2013 the building is almost finished. Now the surroundings must be laid out.

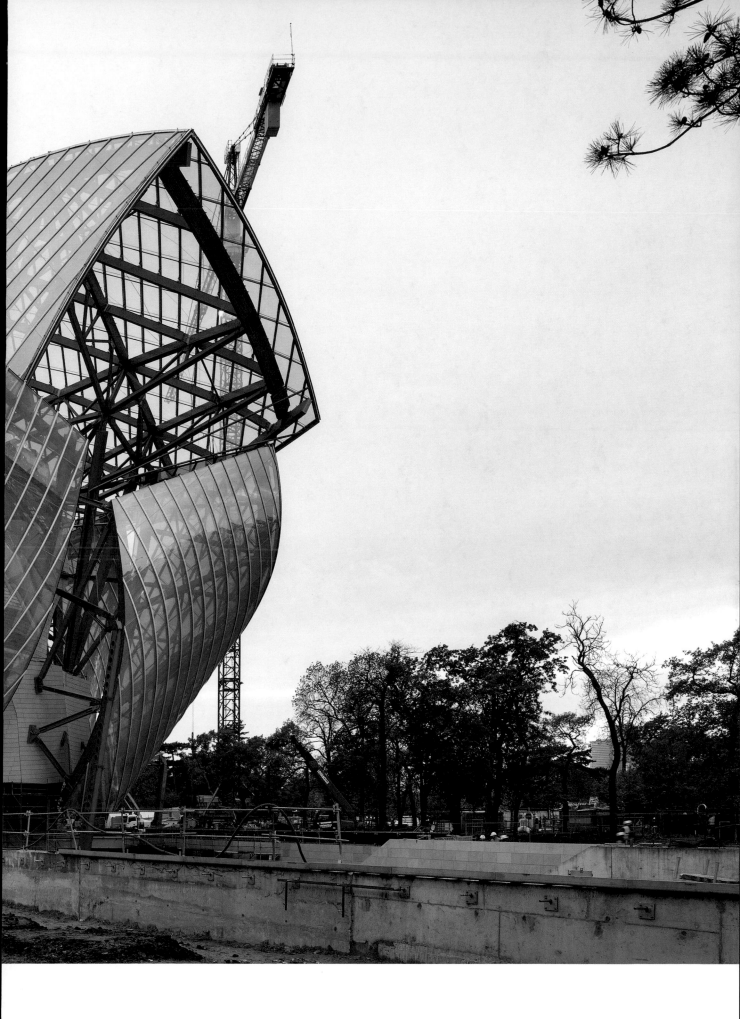

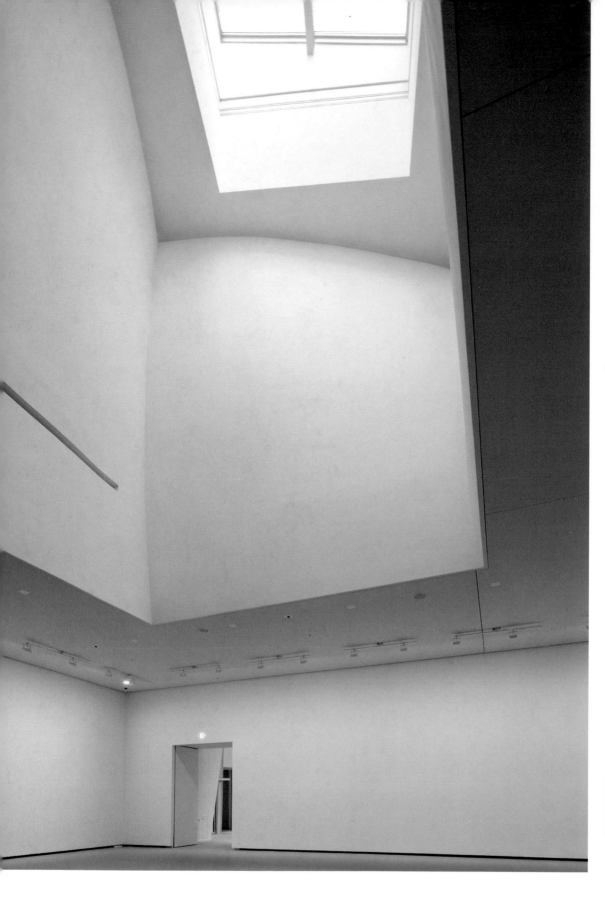

view of gallery 9.

May 23, 2014

June 7, 2011 Bernard Arnault and Frank Gehry working
 on the upcoming inside spaces of the Fondation.

May 23, 2014 between galleries 8 and 9.

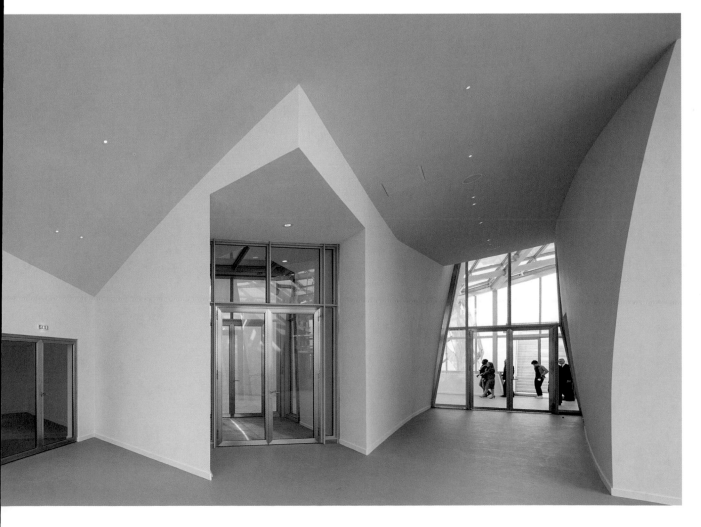

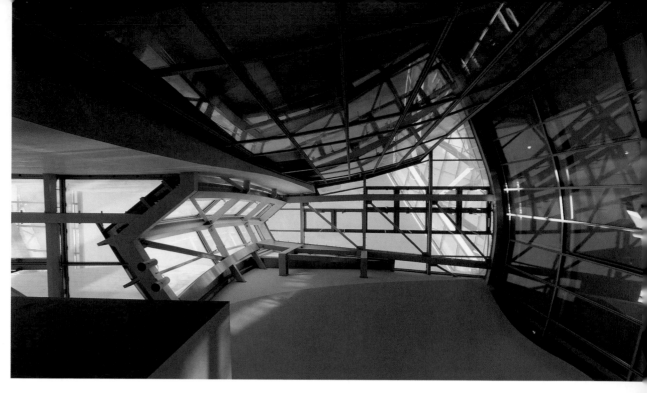

December 15, 2013

low-angle view of the Fondation "canyon."

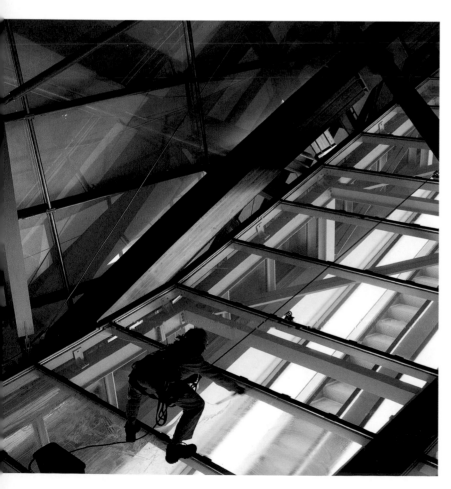

December 26, 2013

an abseiler works on a glass envelope.

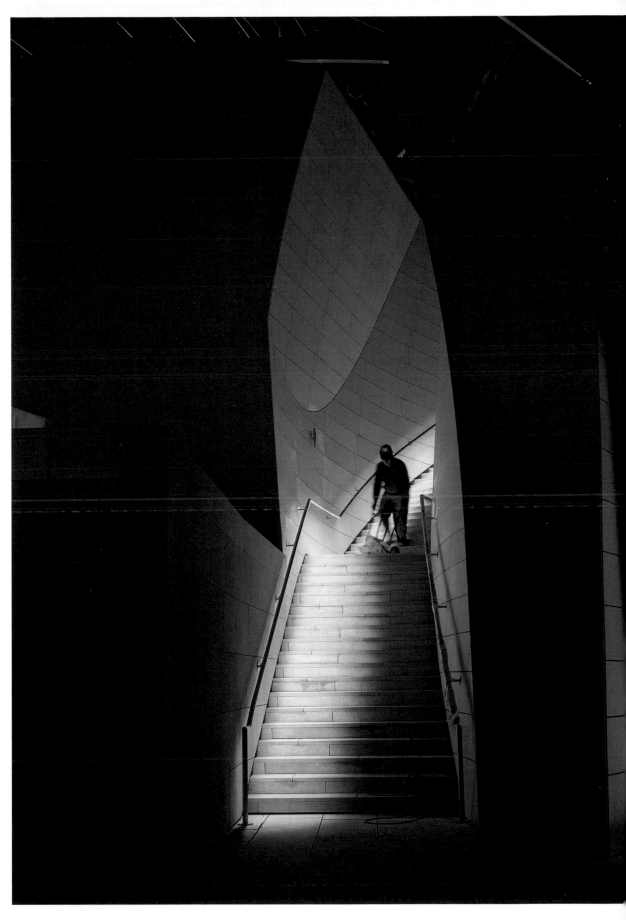

December 26, 2013 the staircase leading from the west terrace to the central terrace.

May 23, 2014

detail of tower 3, the only part of the building where the iceberg shells are left visible, giving visitors a sense of the technical complexity of the facades.

May 23, 2014 view over La Défense from the Fondation's upper terrace.

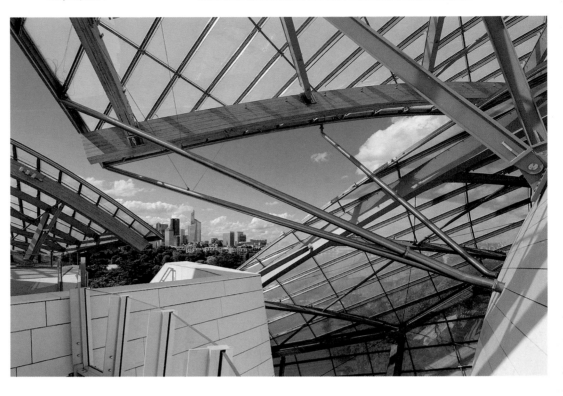

May 23, 2014 view of gallery 2, with the auditorium in the background.

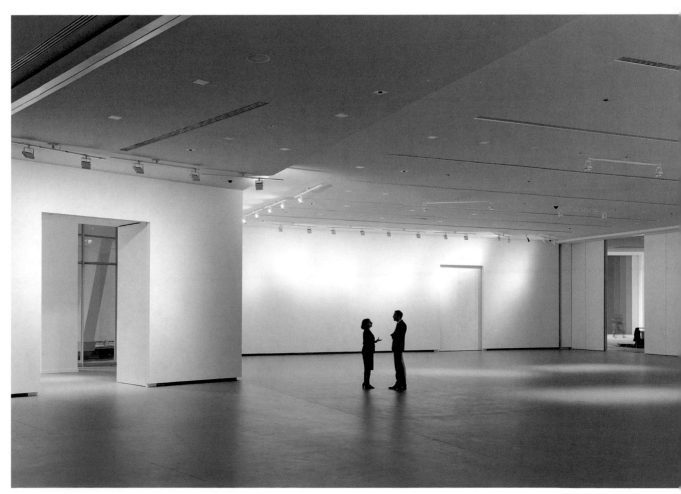

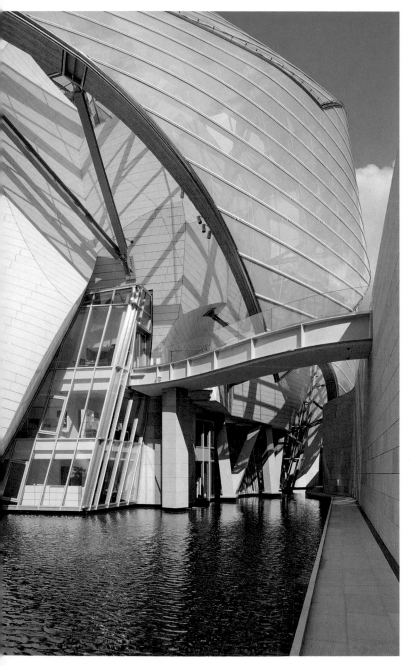

the pool creates a play of light and reflections on the building.

May 23, 2014

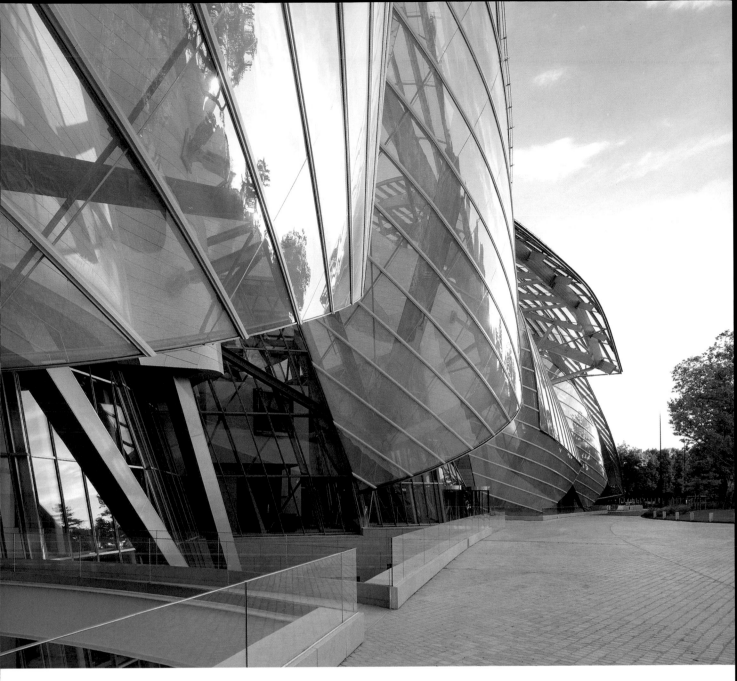

May 23, 2014 northern concourse outside the Fondation. The building is ready to welcome the public.

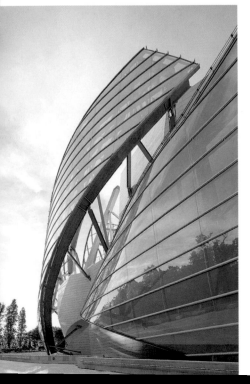

the south facade of the Fondation at sunset.

May 23, 2014

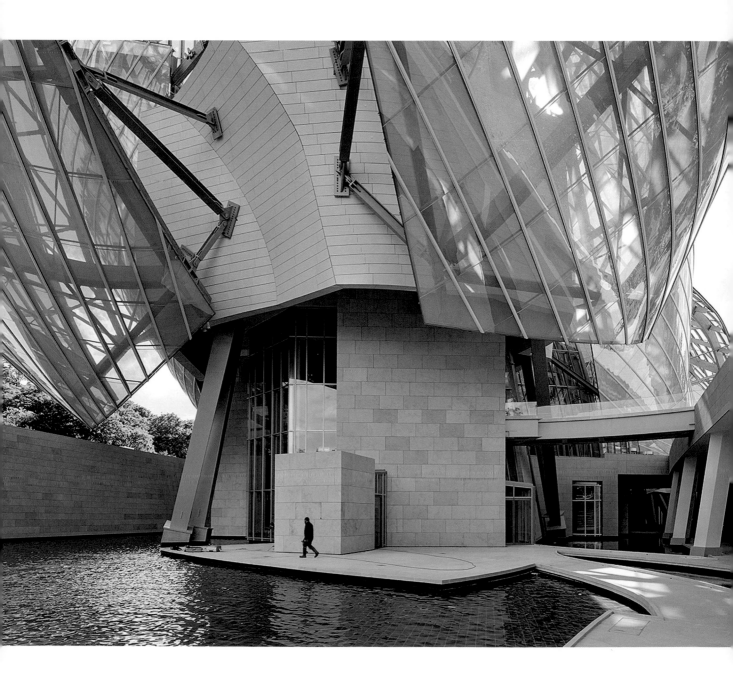

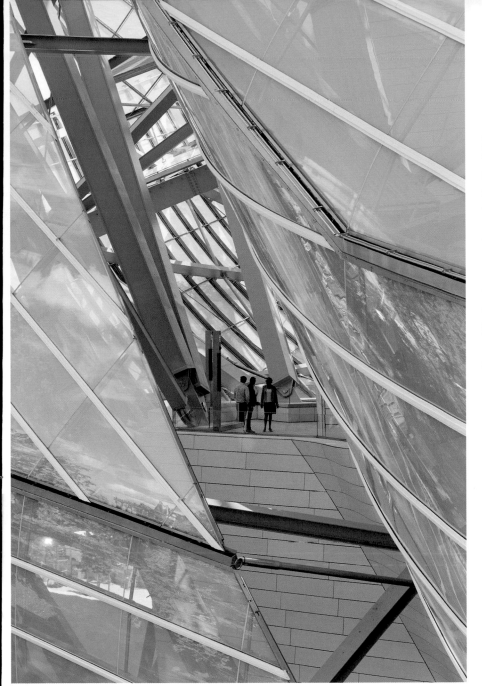

on the terraces, the architectural promenade created by Frank Gehry combines internal and external spaces.

May 23, 2014

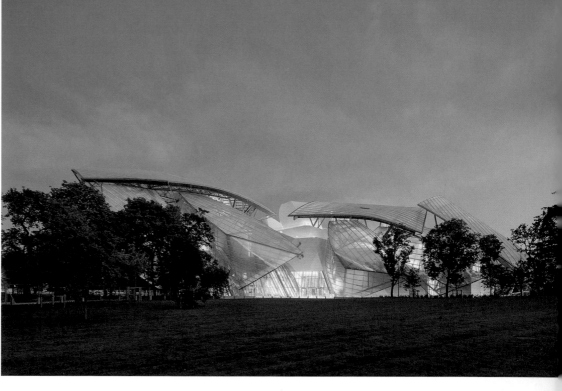

May 23, 2014

the north facade at night.

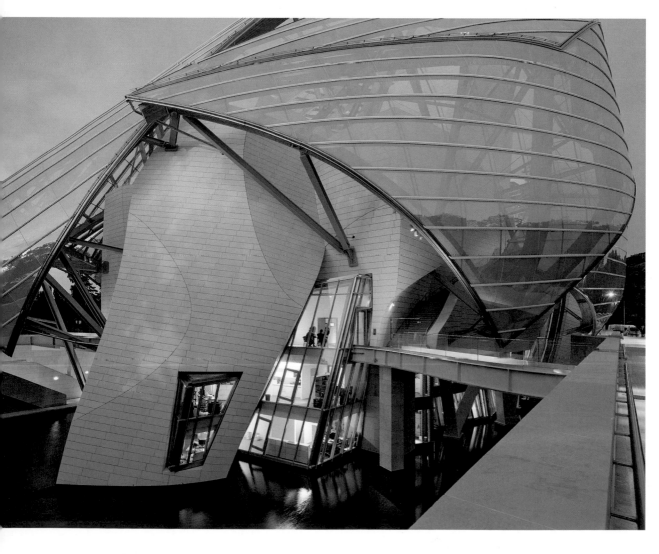

the west facade at night.

May 23, 2014

the east facade at night.

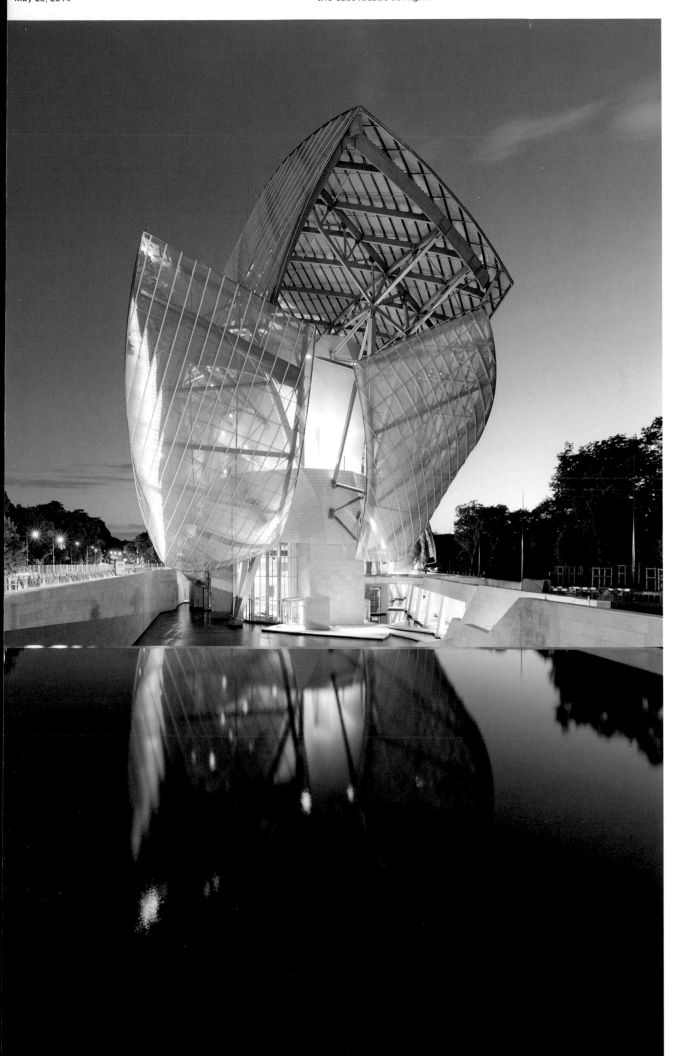

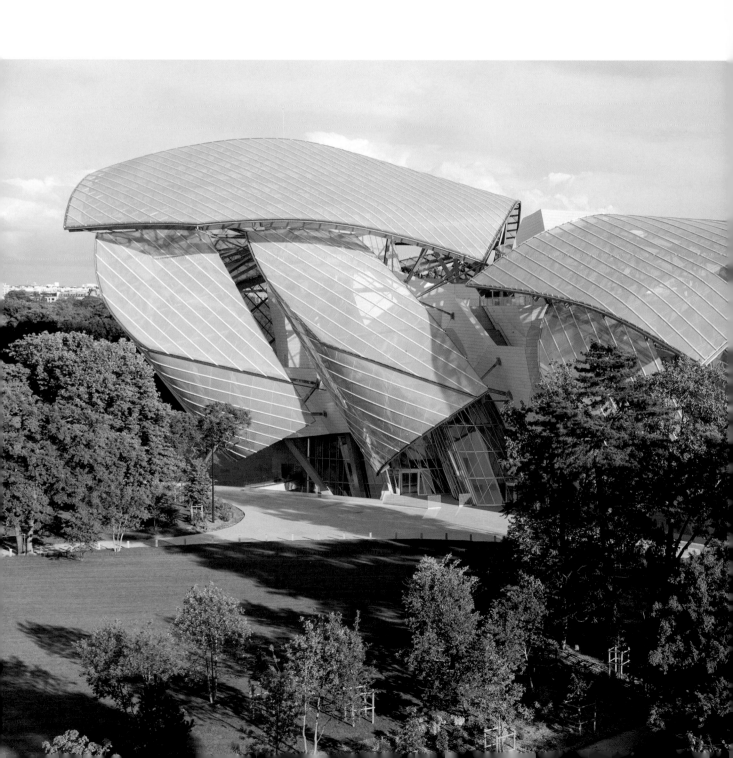

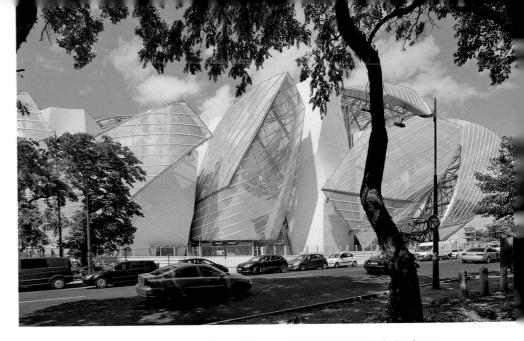

May 23, 2014 the south facade seen from the Bois de Boulogne.

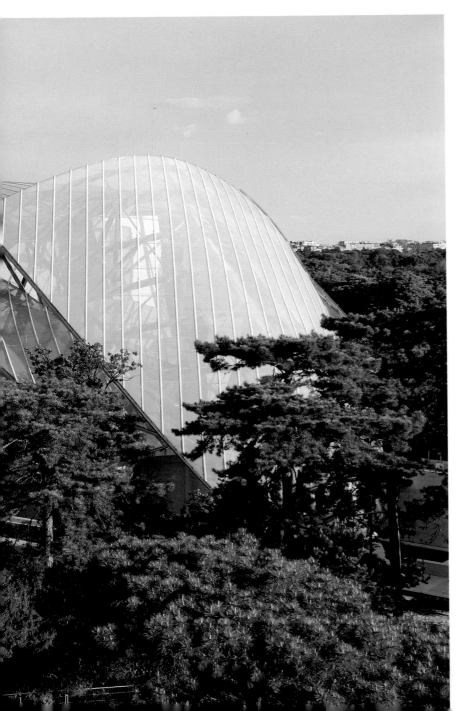

The Fondation Louis Vuitton is completed, after more than five years of work.
It is the product and symbol of an extraordinary architectural adventure.

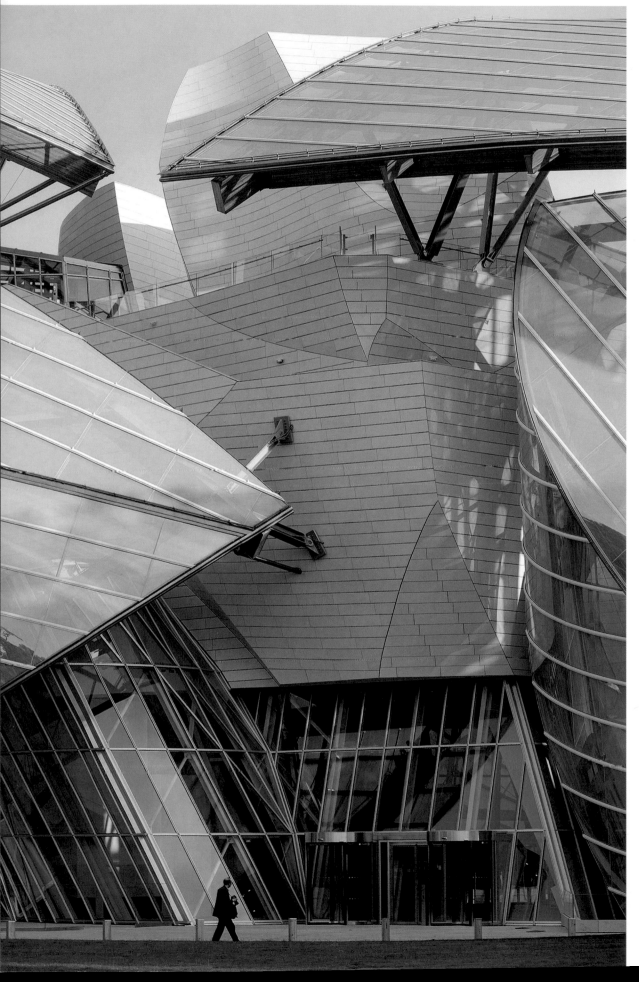

May 23, 2014

In the foreground, engineer Louis-Marie Dauzat, who worked with the project management from the initial plans to the final finishing touches.

THE TEMPTATION OF OXYMORON

Also resonant was his alert, permanent concern to respond to Bernard Arnault's wishes and his desire to cater to those of the artists. Gehry loves art and artists and he wants them to love him. His visionary legitimacy commands their respect. He himself is constantly describing himself as "respectful"** on a number of different levels: with regard to the features of the setting, first of all, the garden, its history, and its primary users—that is, children—and in insisting on his determination to place the building in relation to French culture and emphatically evoking the ghosts of Proust and other artists, musicians, and writers who, as he sees it, might have frequented this site when they were children. Even if he also speaks of the very personal "metaphor" of the sailing ship.*

An interview with Suzanne Pagé —Artistic director, Fondation Louis Vuitton

Conceiving a museum is an adventure. How did you work with Frank Gehry, a visionary architect with a strong personality?

From the start, working with Frank Gehry struck me as a tremendous challenge: along with Bilbao ("The" Guggenheim) and Los Angeles ("The" Walt Disney) as horizons, Paris would also, in its own distinctive way, be a reference, all the more so in that Gehry showed a strong attraction to some very Parisian and French cultural givens, both literary and architectural. From the outset, his engagement was very particular. In the assumptions, too, there was a slight fear amidst curators, art world professionals, and artists. Gehry is a strong personality: his architecture expresses a strong formal, even sculptural approach. Would there be room for other artists?

Gehry was chosen—by Benard Arnault—before I came in. No program was specified. Nor, at this point, was there any talk of drawing on a collection. The idea was to "make a museum." From now on, dialogue with the architect was central. The surprise was his remarkable ability to listen, combined with an unusual generosity in our continuously open discussion.

Borne along by an undertow of humor, our discussions were determined and fast-moving, soon full of fellow feeling, imposing the principle stated in the informal discussions I organized with a few artists—Christian Boltanski, Peter Fischli, Pierre Huyghe and, more rarely, Olafur Eliasson—: extravagant on the outside, on the inside the building would be somehow introverted and pacified, an instrument in the service of art and artists. Such is the lyrical explosion now put before us with the charms of oxymoron: powerful, never overwhelming architecture that is vibrant and full of élan, whose empathy with the sky, the trees, and its surroundings in general is complemented on the inside by well-ordered spaces that in terms of lighting, height, and linearity of walls offers optimal museum conditions while preserving the Gehry touch.

Discussions with the artists initially concerned the need to preserve the level of concentration conducive to approaching the works: hence the initial reflection on circulation and the proposal of a dedicated staircase between the exhibition rooms

next to the more "promenade-like" access offered by the moving stairways. With Gehry's teams, the in-house architects, and the advice of Jean-François Bodin, everything was rigorously planned, beginning with the lighting of the rooms which, almost everywhere, preserves, even though enhanced, the feeling of natural light. Also strictly determined were the configuration and the dimension of the walls, the quality and texture of the flooring, and the consistency of the facing, all helping to create regular volumes. The ceilings were conceived both to "calm" the structures and mask the technical solutions required for a major institution and heighten the qualities of the ensemble.

Also noteworthy is the autonomy of the rooms and, between them, the broad interstitial zones with openings affording interior and exterior views, conducive to pauses but not disrupting the calm of the spaces.

For Gehry, a good museum must not be a neutral place: the variety of scales, volumes, and openings deliberately sought by this architect who is loath to produce "museums that exhaust us with their enfilade of rooms,"* constitutes a fantastic and very welcome spur to artistic creativity. It also stimulates the imaginations and dreams of visitors with its interstitial spaces and, above all, terraces, which, by dilating the architectural data, open unprecedented perspectives onto the internal economy of the volumes and on the urban and sylvan surroundings while offering extra zones for intervention.

According to the architect's repeatedly expressed wish, the spaces under the glass canopies should gradually be hung with artworks in a combination that he likes—not unprovocatively—to compare to Autun. Here there is an alternation of "fast" and "slow" spaces (Rem Koolhaas), "surprise" spaces and "concentration" spaces, the near and the far, like an ideal condensate of spatial solutions meeting the expectations of artists and visitors, a visionary museum of the twenty-first century authorizing and stimulating the expression of all the different registers of art: painting, sculpture, photography, sound, video installation, performance,

as well as today's hybrid proposals. This can be seen in the polyphonic example of the three successive hangings of the inaugural period, and in the various events programmed for it, which, apart from the terraces with their various levels, the staircases, and multiple "promenades"—like the Grotto—provide users with marvelously inspirational spaces. This is a building where artists and visitors "feel good and happy to be there."*

What is the difference between a private foundation and a museum?

In fact, this is a museum, within the framework of a private foundation, intended to perform its various functions and, first of all, in relation to a specific collection to be developped, conserved and used for the benefit of the broadest possible public. This collection, which is of course still being put in place, is resolutely contemporary and conceived around clear positions. In the context of Paris, which has well-established public collections of which one, the Centre Pompidou, has an almost encyclopedic, universal mission, the private character of our establishment not only allows but actively demands a particular kind of engagement. This is articulated around targeted approaches resting on the kind of passionate engagement expected, or even required, of a private institution.

Indeed, this museum will perform the various functions of such an establishment in terms of temporary shows both monographic and panoramic, electively devoted to contemporary artists and events, but also, as intended by Bernard Arnault, looking back over the twentieth century, and even beyond.

Also planned is a calendar of regular multidisciplinary events allowed, notably, by the remarkable and versatile auditorium, a mix of performances, talks, debates, even seminars and, above all, music, where all kinds of hybrid formulae can be invented.

A high-spec documentation center for artists, students, and researchers, centering on the artists and works presented in the collection, will establish the depth of a field in which research must be at the forefront.

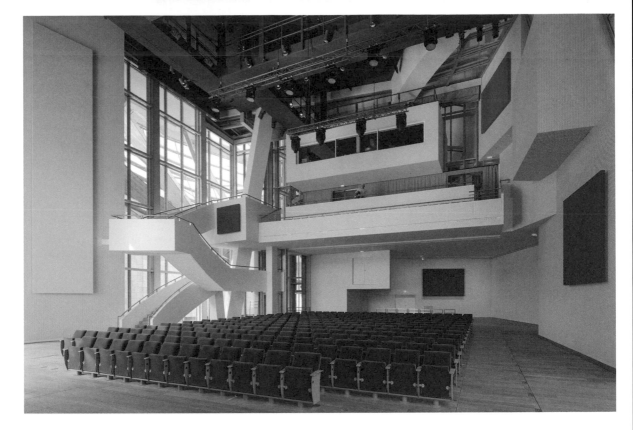

Works by Ellsworth Kelly in the auditorium.

How is the permanent collection of the Fondation Louis Vuitton being constituted?

This essentially contemporary collection is being put together on the basis of far-reaching, in-depth prospection, and is polyphonic in terms of its supports, profiles, and geographical areas. There's no "commission." Decisions are taken by Bernard Arnault, whose personal engagement they reflect. They derive from choices that aim in a sustained way to construct something along lines that are at once determinate and open to the unprecedented and to the emergence of new artists in an eminently changeable world that is to be grasped "in the heat of the action," while maintaining the conditions for a reasoned approach. At this level, curiosity is without limits. As for the choices, they are proactive, along defined lines.

The point of these is less to induce or confirm the concepts of art historians than to reflect, first of all, the emotional approach expected of a private collection. Underlying this, however, there is real scholarly rigor, which seeks to take into account the history in which they are necessarily inscribed. Hence the definition of four directions here, their names deliberately chosen to accommodate the plasticity that is desirable for categories able to encompass creations that, by definition, are as yet unbounded: a "contemplative" line, a "popist" line, a "music/sound" line, and a line linked to a kind of "subjective expressionism." These strands emerged gradually, in the tradition of key works partaking of a modern tendency that threw out the rules.

Also singular here is the very specific importance accorded to "commissions" related to precise points or moments in the architecture, and even to its particular resonance—the auditorium, the Grotto, the terraces—and to the archeology of the place in its relation to the architect and to the players in its realization: promenade, anthropological investigation, decorative ensemble, sound creation. Moving upwards, we find interventions by Ellsworth Kelly, Olafur Eliasson, Sarah Morris, Taryn Simon, Cerith Wyn Evans, Adrián Villar Rojas, and, against the grain of the

sequence, Janet Cardiff. An outdoor project is under way with Daniel Buren.

Must the Fondation be uniquely for living artists? Can it take artistic risks?

Yes, it is primarily a place for initiatives, an experimental terrain, or rather a laboratory. The Fondation is electively a place of expression for living artists and, like them, it is permeable to conditioning factors in a world of extreme mobility, violence, and fragility, a world that they must grasp in order to exercise the power of thought. Obviously, the Fondation must be and is ready to "take risks" alongside artists and allow all kinds of adventures to take wing. Its role is less to be a "protector of the arts" in the conventional sense, than to be a stimulator, an initiator, without safety nets, in a world that, today, is challenging us so bracingly with new questions about time, space, our numerous technological challenges, and, above all, the "human."

Should the Fondation be attentive to the art market? What is its position in relation to art galleries and dealers?

Of course, the Fondation cannot ignore the market, which is an essential and respected partner. By its acquisitions it supports galleries and dealers, which play an essential role in the ecosystem of which it is a part. However, the issues it faces are not the same, and the inflationist, speculative trend in the market is leading institutions like ours to refocus on their specific mission. In this respect, alongside the market, partners such as museums, foundations, associations, and many artistic networks constitute essential interlocutors. By definition, a work that enters the Fondation leaves the market and, freed of any other role, can fully assume its cultural vocation. In the precise context of the engagement that I have mentioned, the primary goal is to bring out the specific vibration of each work when its singularity is revealed, or even exalted, conveying as best possible to the public the unique treasure for thought contained in each creation.

In this way, the museum can play its role as a decisive element in a debate determining the elaboration of a history of art that, long mapped out within a narrow field

233 bringing together art historians,
academics, curators, and critics,
now has to reckon with a market
whose opinion-leading effects can—
provisionally?—have authority in a debate
that cannot be reduced to alarmed or
the submissive responses, but must provoke
independent, lucid analyses.

* Quotations from Frank Gehry come from a number
of conversations, especially our latest Skype conversation,
held on June 26, 2014.

OPENNESS TO DIVERSITY

Sophie Durrleman —Executive director, Fondation Louis Vuitton

To welcome and guide a broad public curious to discover the contemporary art exhibited in the building designed by world-renowned architect Frank Gehry, to elicit questions and answers, emotion and wonder: this is the role of the Fondation Louis Vuitton.

Willed by the visionary director of the world's leading luxury group, this transparent vessel, a new and emblematic monument in the French capital, maps out the contours of a pedagogical and cultural mission founded on the values of rigor and performance upheld by the history of the company and the future of Paris—a twenty-first-century "world city." Visitors here are characterized by the great diversity of their cultural practices and their expectations with regard to the Fondation. Tourists fascinated by the work of Gehry in the wake of the "Bilbao effect," artists and art world professionals, lovers of contemporary art, families used to frequenting the Jardin d'Acclimatation, curious visitors from all over the world attracted by Louis Vuitton: all cross paths and meet in this unique venue that spreads its glass sails here in the Bois de Boulogne.

These new visitors may be new, just as the cultural venue is new and stunning, but they are also demanding, technologically adept, and often digital natives, used to surfing media and channels and accustomed to repeated visual surprises. Their attention constantly solicited by diverse and teeming cultural productions, they are looking for something out of the ordinary, but also expect vital cultural and pedagogical markers.

The better to meet these aspirations, the guiding thread, at once a referent and hallmark, will be the determination to conceive tools of mediation conducive at once to emotion, sensibility and discovery, to knowledge and transmission, thereby expressing the singular configuration of the institution.

GUIDANCE AND EMOTION

Set up as a private foundation that is autonomous and free in its cultural choices, the collection is able to affirm the artistic tastes and positions of its patron. At the same time, Frank Gehry's new building, the Fondation's first work of art, offers visitors architecture that powerfully generates shared emotions (surprise, admiration, wonder) and varied effects: transparency, reflections, movements.

By maintaining this guiding principle and taking into account the power of the building and the variety of its publics, the Fondation Louis Vuitton can develop original forms of visitor reception and cultural mediation.

FREE MOVEMENT THROUGH THE FONDATION

Visiting is a singular experience. It involves exploring two-thirds of the spaces dedicated to circulation and the terraces, discovering the building itself, and also the remarkable panoramas and views over the Bois de Boulogne, Paris, and its surroundings. At various moments, visitors can thus choose freely between continuing their progress from gallery to gallery, discovering the works in a harmonious progression, or breaking off

the sequence and going out to the terraces, the panoramic stairs, the Grotto or the basin, and then back the way they came. There are many possible paths and breaks, and intersections are frequent.

THE ARTICULATION WITH THE JARDIN D'ACCLIMATATION

Ticketing is designed to encourage visitors to the Fondation and the Jardin to mix, to combine viewpoints and cultural and leisure practices. Admission to the Fondation thus gives access to the Jardin d'Acclimatation and allows visitors to move around freely, to explore the building and appreciate the different facets of Frank Gehry's architecture, as well as the surroundings and their landscaping: the great clearing, the rockery, the outcrop with deer (Rocher aux Daims).

ANTICIPATING VISITOR NEEDS

Founded on the values upheld by LVMH in its stores, centering on rigor and excellence in the reception of customers, the Fondation combines attentiveness and quality in its response to visitors. It thus provides:
— An electric shuttle (a responsible, green mode of transport), which picks visitors up at Place de l'Étoile, one of the most emblematic locations in Paris, and carries them along Avenue Foch, one of the most handsome streets in Paris, directly to the concourse outside the Fondation.
— Highly trained visitor services personnel, and clear signage designed with international visitors in mind.
— Comprehensive and clear online ticketing to facilitate reservations.

— A smartphone app integrating all the codes of movement, new services, and immediate information.

FOR YOUNG VISITORS AND FAMILIES

For many years now, the desire to share has been a driver of LVMH's patronage policy. The group strongly encourages cultural education, setting up numerous classes to accompany the major exhibitions it has supported. Quite naturally, then, and given the popularity of the Jardin d'Acclimatation with families, the Fondation Louis Vuitton aims to extend and develop this pedagogical mission with art workshops for children, special tickets for families (not only parents and children but also grandparents), tablet-based edutainment apps for eight-to twelve-year-olds, pop-up books for the youngest visitors, special loyalty programs, and activities for families.

THE USE OF TWENTY- FIRST- CENTURY MEDIATION TOOLS

As if echoing the variety of the disciplines and practices of contemporary art, the devices used to enhance visitor experience combine human contact, new technologies, and irreplaceable printed supports to take home. Given the cultural and geographical diversity of the visitors, a selection of tools has been put in place to speak to

236 different sensibilities, to hold
 the attention and the gaze,
 but also adapted to new uses and
practices. In this way the Fondation hopes
to encourage dialogue and impromptu
encounters around the works, thanks
to the presence of mediators in the rooms,
and by providing apps that can play
the role of the traditional audio guide
on their cell phone.

 Adapted to contemporary cultural prac-
tices and inspired by the exceptional charac-
ter of the architecture and the power
of the program built around the collection
and the exhibitions, the interactive and
modular reception and mediation proposals
are designed above all to engage a dialogue
between the Fondation and its visitors,
so that they can construct its future
together.

Study for the inside signage at the Fondation Louis Vuitton.

Our thanks to all those who contributed to the creation of the Fondation Louis Vuitton:

Dominique Alba, Grégoire Alessandrini, Chiara Alessio, Sari Al Khayer, Pierre-Jean Alquier, Jose Alves, Philippe Alves, Jean Angelini, Philippe Angot, Sébastien Anne, Roxana Aquize, Joseph Attias, Simon Aubry, Frédéric Auclair, Christophe Aumonier, Marie Ausseil, Jean-Michel Autissier, Joseph Bakalé, Nathalie Bakhache, Alain Balengondji, Romain Ballu, Guillaume Barbaroux, Alain Barge, Philippe Barion, Jean Barthélémy, Leo Baschiera, Julien Bastet, Mélanie Beaugelin, Alexandre Beaussier, Terry Bell, Philippe Bellonde, Alia Ben Ammar, Hélène Bensoam, Mouna Ben Yahmed, Etienne Béranger, Pierre Berger, Olivier Berjonneau, Caroline Bernard, Olivier Bernard, Carine Bernède, Federico Bertini, Didier Bertrand, Benoît Beslay, Cédric Besnard, Marc Bianchi, Jacques Bietry, Benoît Bignon, Sys Bisgaard, Hans Blass, Eric Blanc, Nicolas Blanc, Pascal Blanchard, Jean-Marc Blanchecotte, François Blondeau, Damien Bodin, Jean-François Bodin, Philippe Bompas, Guillaume Bonhomme, Nicolas Borel, Michel Borjon, Elisabeth Borne, François Borrelli, Aurélien Boubennec, Youcef Boukhari, Khalid Boulaid, Etienne Bouleau, Patrick Boulet, Eleonore Bourgeois, Alain Boursin, Patrice Boury, Emmanuel Brelot, Antoine Brengues, Annabelle Brizou, Matthieu Broncel, Aurélien Bros, François Cadilhac, Olivier Cael, Denis Caillet, François Calais, Tony Camuel, Mickael Cano, Nuño Carneiro, Patrice Carnevale, Cyril Cauvi, Jean-Armand Calgaro, Emmanuel Cayla, Cristiano Ceccato, Xavier Cespedes, Reda Chaffi, Amandine Chailloux, Marc Chalaux, Edwin Chan, Anne-Laure Chappat, Manar Chatain, Thibault Chavanat, Nathalie Chazalette, Philippe Chotard, Gouneau Chung, Dorothée Citerne, James Clarisse, Arnaud Clavreuil, Tara Clinton, Frederick Cocatrix, Jean-Yves Cojean, Roberto Coniglio, Suzanne Constantine, Richard Copans, Freddy Corredor, Eric Correia, Mickael Coutinho, Stéphane Couturier, Ougau Couvreux, Michel Cova, James Cowey, Michèle Cros, Brigitte Cuignet, Régis Cusinberche, Pierre Cuvilliers, Ilanit Dahan, Thomas Daneels, Bénédicte Danis, Rahim Danto-Barry, Jean-Bernard Datry, Daniel Decaen, Thomas Depin, Arthur de Fougeroux, Annalisa De Maestri, Armand de Montleau, Thomas De Sainte Marie, Constance de Batz, Nicolas Debeney, Jacques Dectot, Lucia Delacoste-Grino, Marion Delaigue, Olivier Delaporte, Magali Delecour, Philippe Deliau, Jean-Jacques Demoersman, Ludovic Denne, Aurélien Denonfoux, Pablo de Rabago, François Deruytter, Hervé Descottes, Alain Desmarchelier, Aldo de Sousa, Paul Deteix, Christopher Devals, Frédéric Devenoge, Jean-Patrice Dibon, Bao Phi Diep, William Dodé, André-Marie Dogbo, Maxime Dorel, Jorge Dos Santos, Marc Drouet, Arthur du Hamel de Fougeroux, Matthieu Dubois, Xavier Dubois, Guillaume Duché, Pascale Dumont Hérivaux, Lionel Dupeloux, Benjamin Durand, Elise Duriez, Clément Duroselle, Marc Dutoit, Félicien Duval, Gérald Duvallet, Inaki Echevarria, Borja Edo Cebrian, Mitsu Edwards, Paul Ehret, Amine El Bounaamani, Mohamed El Shikby, Pascal Ellena, Laurent Escaffre, Manuel Esteves, Cécile Fabre, Renaud Farrenq, Luis Farreras, Aliénor Faucher, Jacques Faure, Elisa Fedrizzi, David Ferment, Ana Fernandes, Franck Fernandes, Denis Ferrazzano, Paolo Ferreira, Matthieu Ferrua, Heloise Ficat, Thiemo Fildhuth, Maryana Fleurov, Kelly Floch, Olivier Flottes, Maxime Foucault,

Clément Foullon, Eric Fourn, Lisa Fraisse, Rino Franceschina, Angelo Franco, Charles Fréger, Bertrand Frezza, Alex Fripp, Marketa Furthova, Mihaela Galliot, Roland Galmiche, Africa Garcia, Manuel Garcia, Antoine Gardess, Sébastien Garreau, Frédérick Garrigues, Benoit Gars, Pierre Gébarowski, Franklin Gedalof, Arnaud Geenens, Ana-Maria Ghita, Claudia Giangreco, Olivier Girondin, Christel Giry Deloison, Stephan Gladieu, Daphna Glaubert, Laurent Goas, François Godard, Pierre Godé, Nicolas Gombault, Bernadette Gonçalves, José Gonçalves, François-Xavier Gonnot, Stéphane Gorczyca, Vincent Gossard, Thomas Gouthy, Claude Grava, Clément Gravier, Mathieu Grelier, David Guichard, Emmanuel Guillemet, Yves Guilleminot, Emmanuel Guillini, Alain Guilloux, Jean-Jacques Guiony, Julien Guyot, Adeline Hadet, Pierre Haesebrouck, Juliette Hafteck, Alain Hage, Abdou Hamada Zakia, Claude Hartmann, Michael Hasse, Nathalie Heidgen, Nathalie Helpin, Sébastien Hemon-Laurens, Nadège Hérembourg, Emilie Hergott, Christian Hernandez, Eric Herzog, Jorge Hidalgo, Eckard Hofmeister, Solveig Holzinger, Philippe Hostalery, Jacques Huillard, Xavier Huillard, Christopher Hung Han Yun, Vincenzo Iovino, Julien Ischer, Stuart Jacobson, Alain Jacquet, Augustin Jacquety, Marc-Antoine Jamet, Patrick Janson, Christophe Jarreau, Baptiste Jasnin, Florence Joubert, Daniel Joyeux, Mehdi Khelif, Johan Khols, Thomas Kim, Matt King, Marissa Kretch, Shriram Kulkarni, Alex Kunz, Alexandre Labasse, Eric Labry, Gérard Lacroix, Gael Lafon-Garnier, Alain Lagesse, Lionel Lambourn, Xavier Lambours, Jean-Paul Lamoureux, Simona Lanfranchi, Marc Laniray, Amandine Lasvacas, Guillaume Lecat, Paul Lecomte, Charlotte Leconte, Anne-Cécile Ledanois, Nicolas Leduc, Philippe Lefevre, Béatrice LeGal, Florent Lely, Sophie Lemaire, Aurélien Lemasson, Sebastian Lemny, Gabrielle Leroi, Laurent Le Saux, Philippe Lissajoux, Meaghan Lloyd, Sebastiano Lomba, Thomas Londero, Valentin Louzeau, Giovanni Lunelli, Jean-Michel Luxin, François Macquart-Moulin, Thomas Maigne, Darius Maïkoff, Claude Maisonnier, Alain Majcherczyk, Axel Mak, Jean Malbec, Eric Mangini, Magali Manuel, Fabrice Marchisio, Pierre Margier, Ana Maria Bordas, Ana Marques, Eric Marti, Guillermo Martinez, Gilles Marty, Caroline Maufrais, Pascal Mazé, Anna-Belle Melun, Marie Melun, Derek Metz, Philippe Meunier, Ludovic Mevel, Dat Miechielsen, Alex Miller, Franck Moine, Xavier Molin, Jean-Pierre Monsch, Paul Montegut, Abby Mookien, Luc Moraillon, Bernard Moreau, Sina Nabaei, David Nahmani, Minh Nguyen, Tobias Nolte, Louis-Michel Nourry, Denis Obrecht, David Olson, Aurèle Orsetti, Emily Ottinger, Piotr Paciorek, Pierre Paquie, Catherine Parant, Edouard Pascual, Pierre Pastellas, Bruno Pastor, Daniel Patrault, Loïc Penel, Miquel Peiro, Franck Percet, Thomas Pereira, Ewa Perzyk, Pierre-Antoine Peschaud, Aurore Phan, Anne-Laure Philibert, Gilles Pichot, Laurent Piersond'Autrey, Sylvain Planche, Lorenzo Ponzo, Caroline Poreaux, Jindrich Potucek, Jacques Pouilhe, François Poupard, Loïc Poupot, Taina Primaux, Angel Prol, Françoise Prunier, Julien Puyhardy, Marc Quiquerez, Patrick Rachet, Victor Racodon, Armel Ract-Madoux, Julie Rademaker, Michel Raoust, James Ratti, Laurent Ravat, Denis Raynard, Jacques Raynaud, Patrice Raynaud, Dominique Remolu, Ahmed Reyad, Joël Richard, Odile Rignault, Philippe Robert, Isabelle Robert-Védie, Camille Roblin, Jean-Claude Roi,

Hélène Roncerel, Denis Roscian, Jean Rossi, Julien Rouel, Pierre Rougié, Catherine Roumegoux, Mazen Saggar, Rokhaya Sagna, Nadia Sahmi, Cyril Sailly, Astrid Saint-Cast, Marc Salette, Leonardo Salles Cunha, Philippe Saparelli, Léa Sattler, Jacques Saulnier, Roel Schierbeek, Sybil Schmautz, Matthias Schuler, Jean-Christian Seguret, Cécile Semery, Mohammed Senoun, Alexander Simpson, Christian Soliva, Jean Somodevilla, Rémi Spédo, Luca Stabile, Benoit Stehelin, Patrick Steingruber, Mariangela Stricchiola, Pawel Strzelinski, Frans Swarte, Eric Taillardat, Xavier Talarmain, Julien Tanant, Stéphane Tapsoba, Fabrice Tareau, Sabine Teisseire, Marguerite Thion, Dawn Thomas, Larry Tighe, Luciano Tosini, Peter Toth, Amin Touati, Sébastien Touzeau, Norito Toyama, Yasuhisa Toyota, Daniel Trevette, Clothilde Tribou, Armelle Trotin, Mairie-Odile Vaissié, Jean-François Vallet, Pascal Van Hulle, Philippe Vancapernolle, Bernard Vaudeville, Arancha Vega, Simon Vellut, Christel Verchelle, Thomas Vérine, Jean-Marie Vernat, Anne Sophie Verniest, Mathilde Vilmart, Xavier Wilmet, Andrew Witt, Thomas Weisse, Creighton Willis, Jean-Michel Wilmotte, Christophe Zuber

and to all the companies who took part in this adventure under the supervision of QUADRATURE INGÉNIERIE:

VINCI CONSTRUCTION FRANCE, VINCI CONSTRUCTION GRANDS PROJETS, AMG FECHOZ, AUSTRAL, BALAS, BONNA SABLA, BONNARDEL, COFOR, COTRASOL, COSTA , CYB STORES, EDL, EDM, EIFFAGE CONSTRUCTION METALLIQUE, EPLS, ETH, FACE IDF, GESOP, GERRIETS, GIROUD, GREISCH, HENRYOT, HESS, HOFMEISTER, IDFP, IEMANTS, ILDEI, IMBERT SOLFIX, ISOLATION 2000 , ID VERDE, JAMES, MAES, METALESCA, METRANOR, PARQUETERIE DE LA LYS, PINTO, POLTRONA FRAU, PREZIOSO, PRUGENT, RUBEROID , SAGA AGENCEMENT, SANTERNE, SEGEX ENERGIES-AD POMPES, SEPT RESINE, SERAPID, SFCC, SIDF, SIEGEAIR, SIPRAL, SPIE FONDATIONS, STAFFISSIMO, SUNGLASS, TAMBE, THYSSEN KRUPP, URSSA, VULCAIN, WEREY, ZOONTJENS.

Special thanks to: Louis-Marie Dauzat and Nicolas Paschal, the very talented engineers who worked throughout this project to make the impossible possible.